# 101 Nudes

## For Art Students

A Book

By

# Carney Malone

Copyright 2015 by Carney Malone

All Rights Reserved

# Preface and Introduction

*101 Nudes For Art Students* is the third book that I have created expressly for art students. It is the first that is in a six inch by nine inch format.

My goal has been to produce books containing pictures of many nude models in interesting poses in an inexpensive format. To keep costs down I have eschewed publishing hard cover books with color pictures printed on expensive paper.

If this book is successful it is due to my many wonderful models. Any faults are mine alone.

# 101 Nudes For Art Students

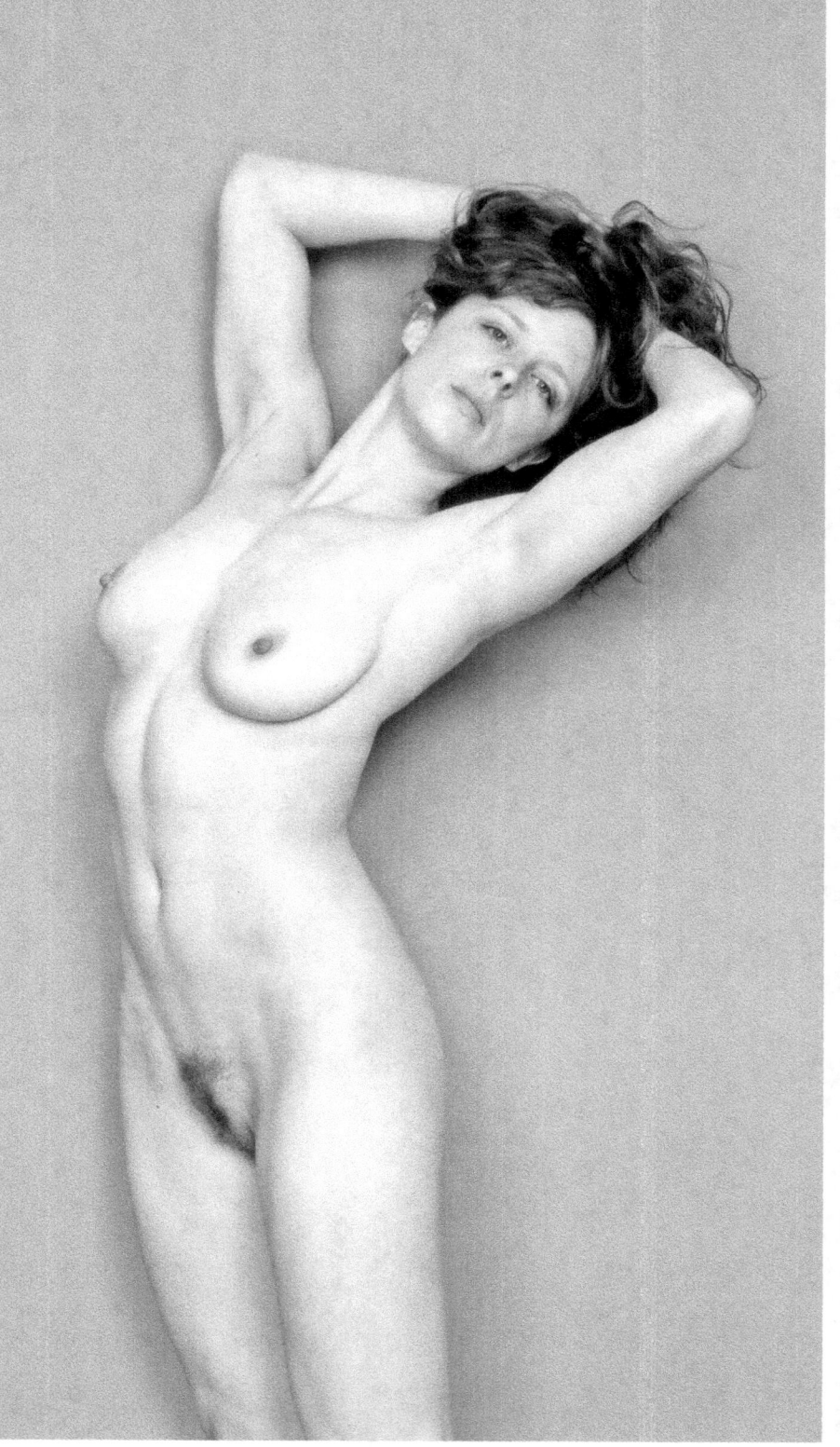

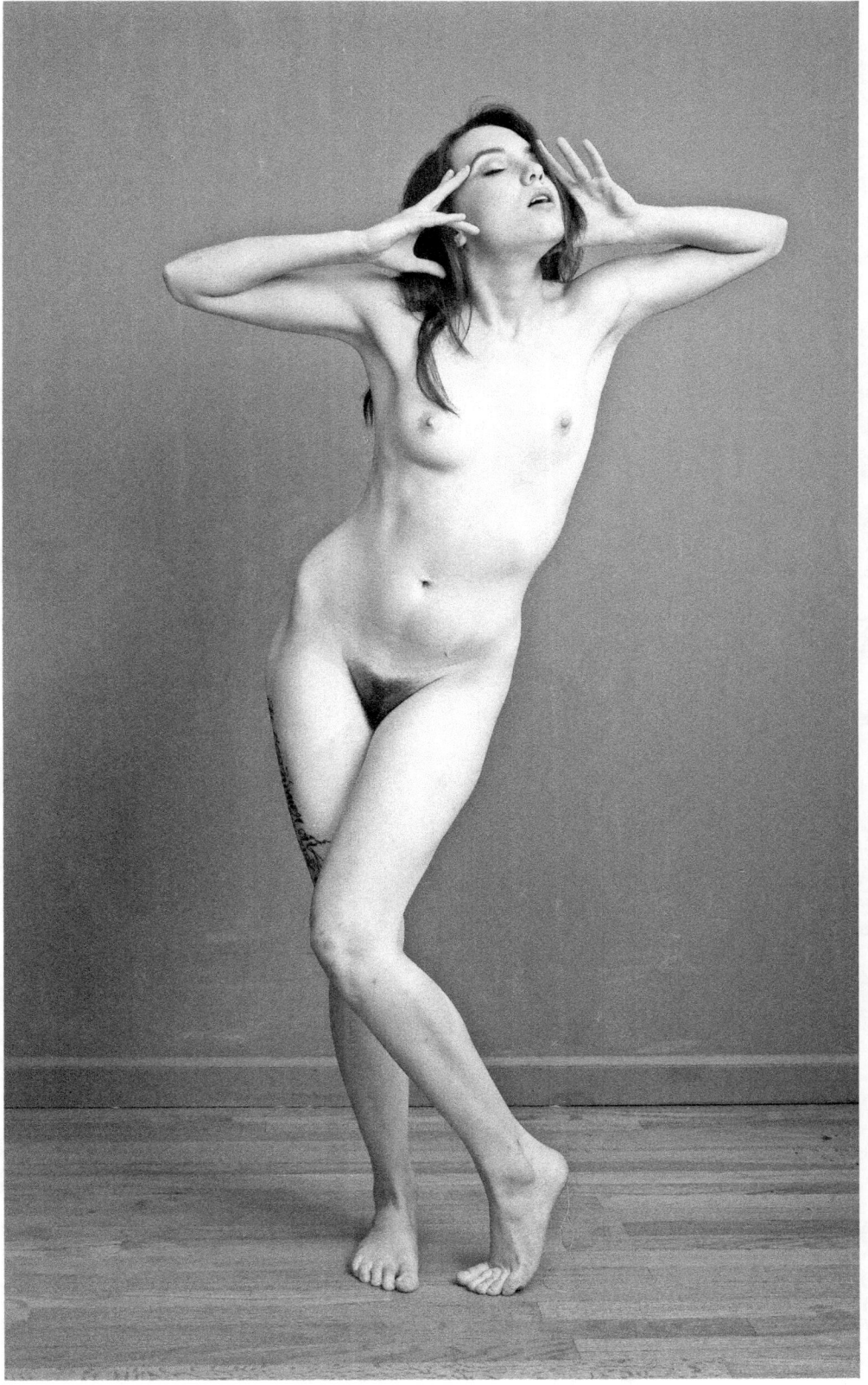

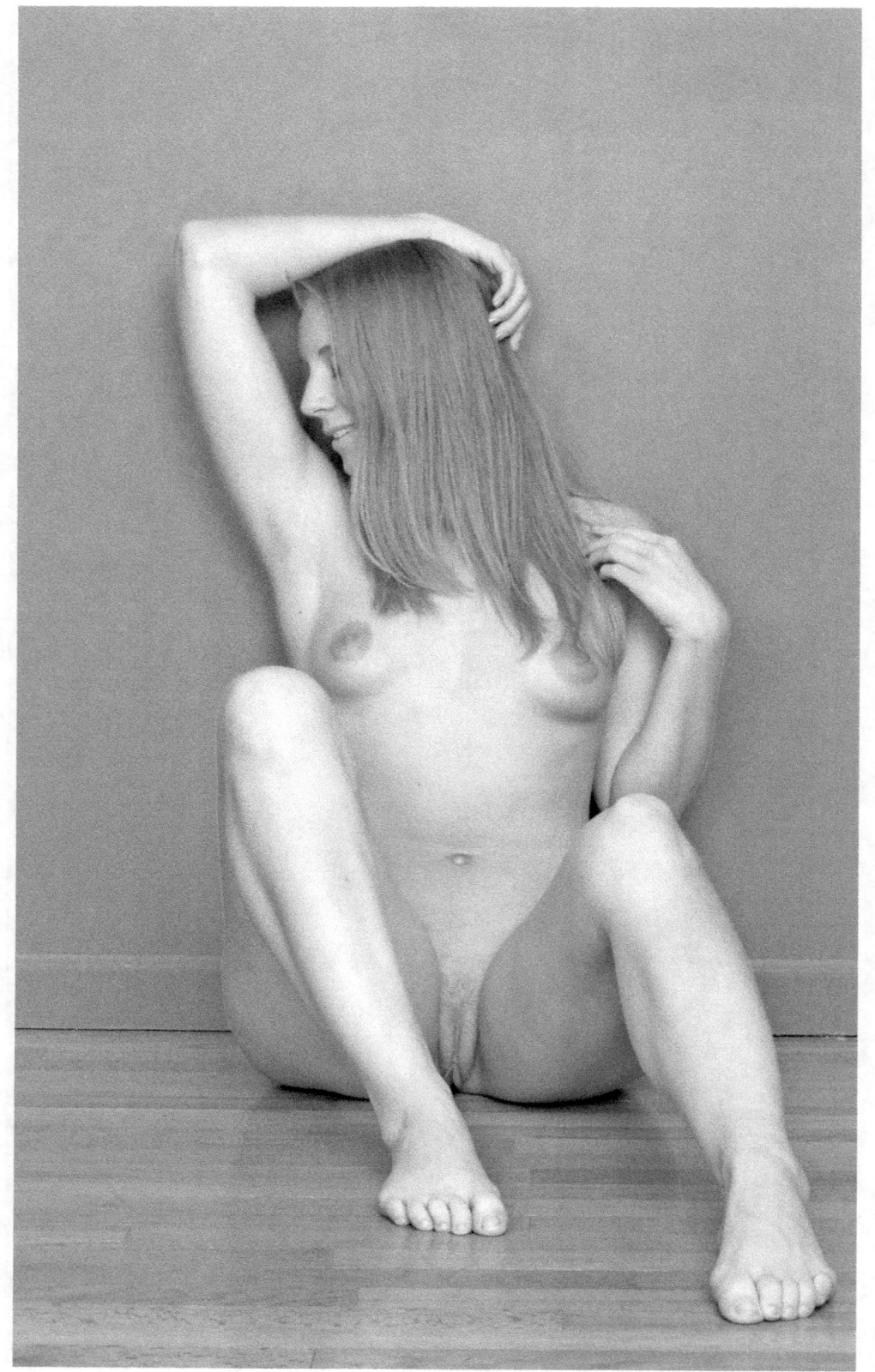

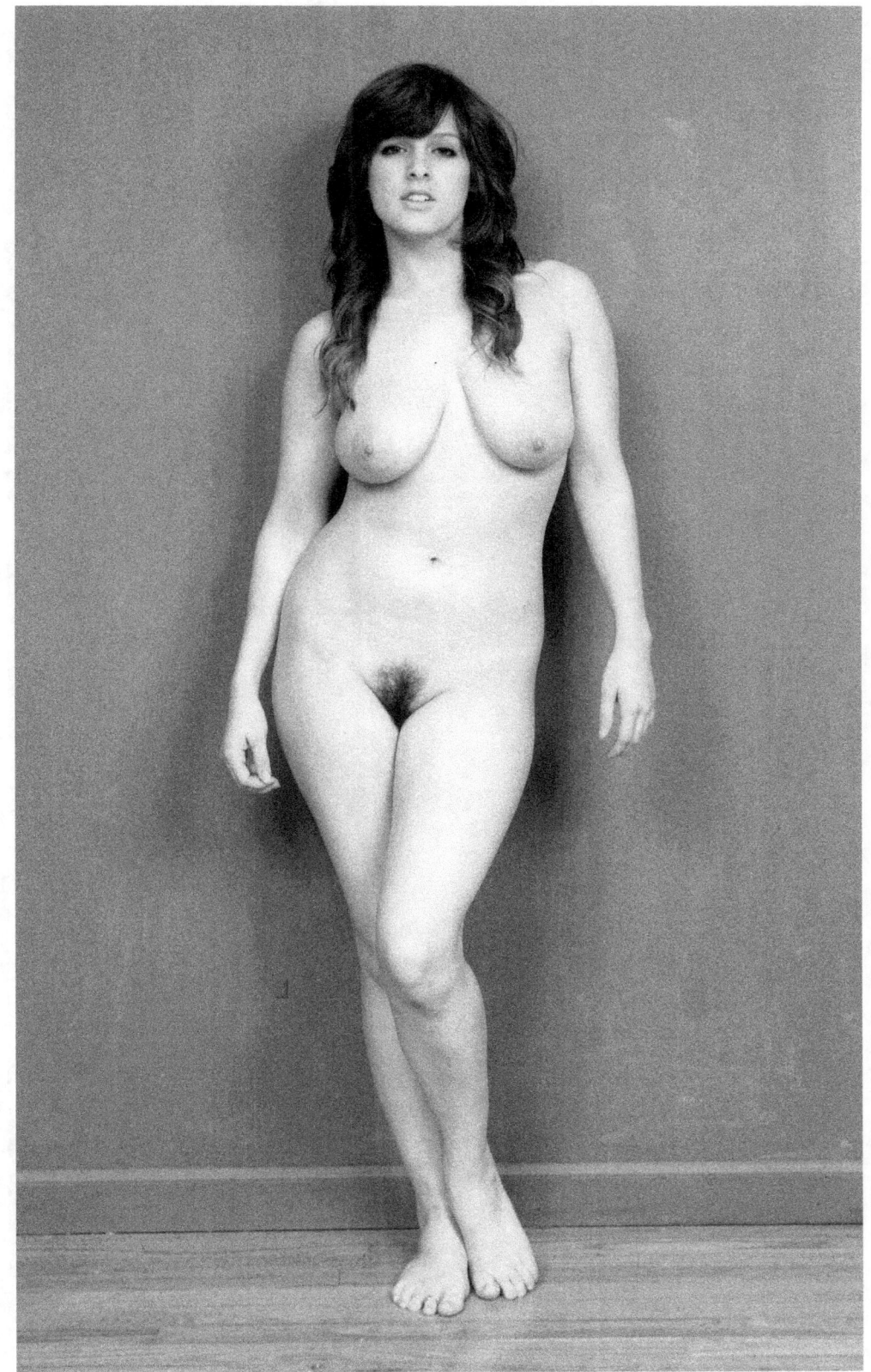

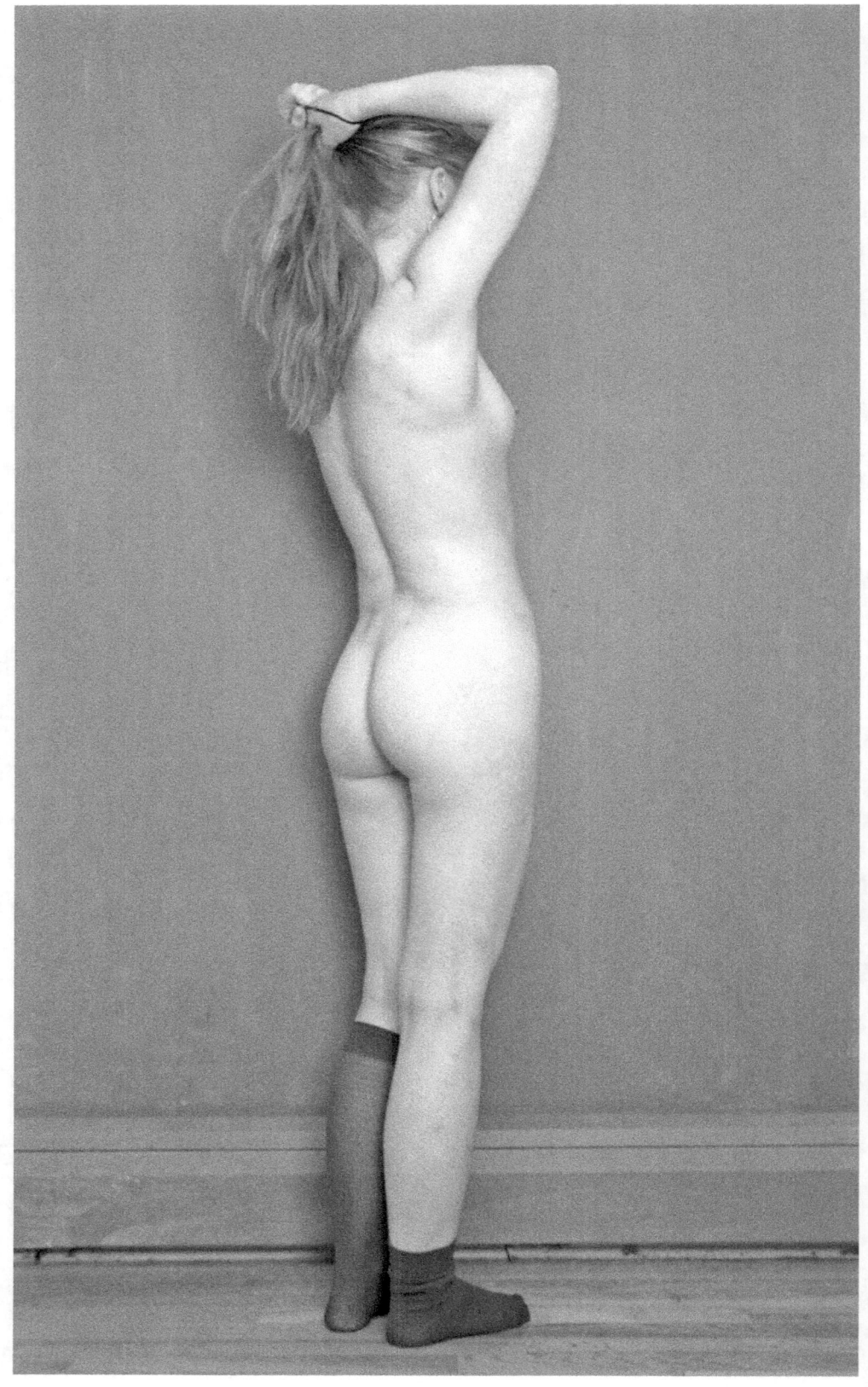

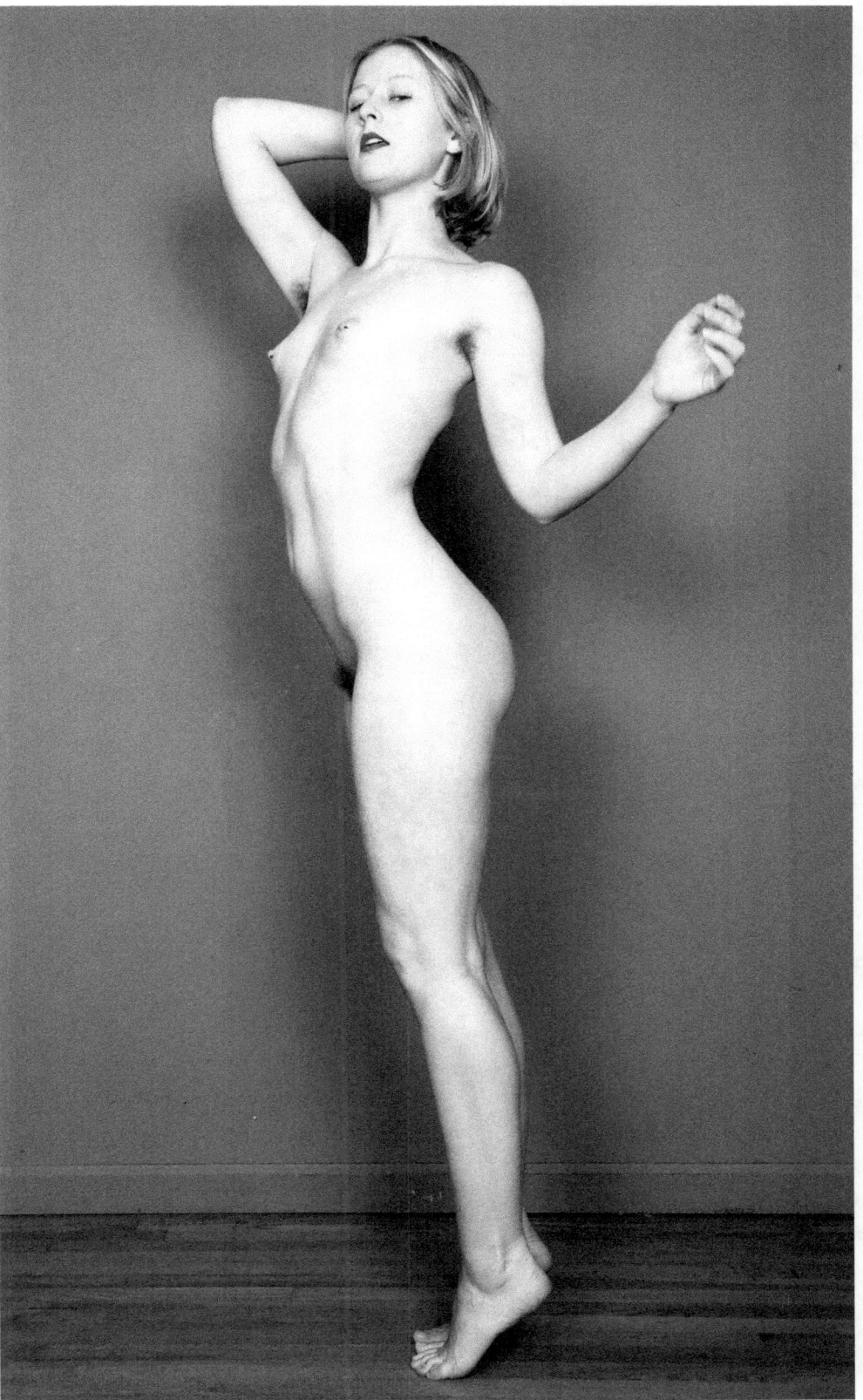

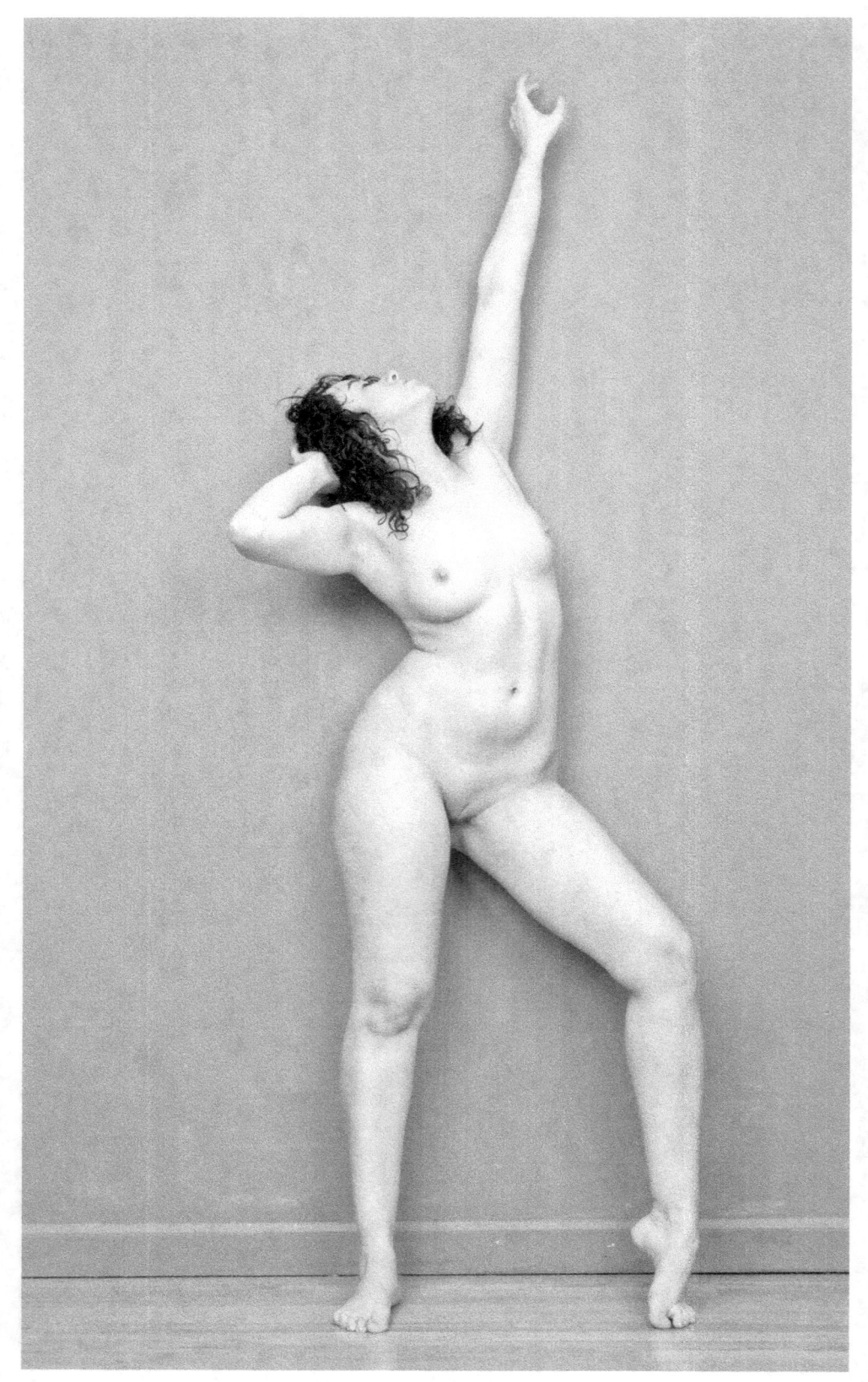

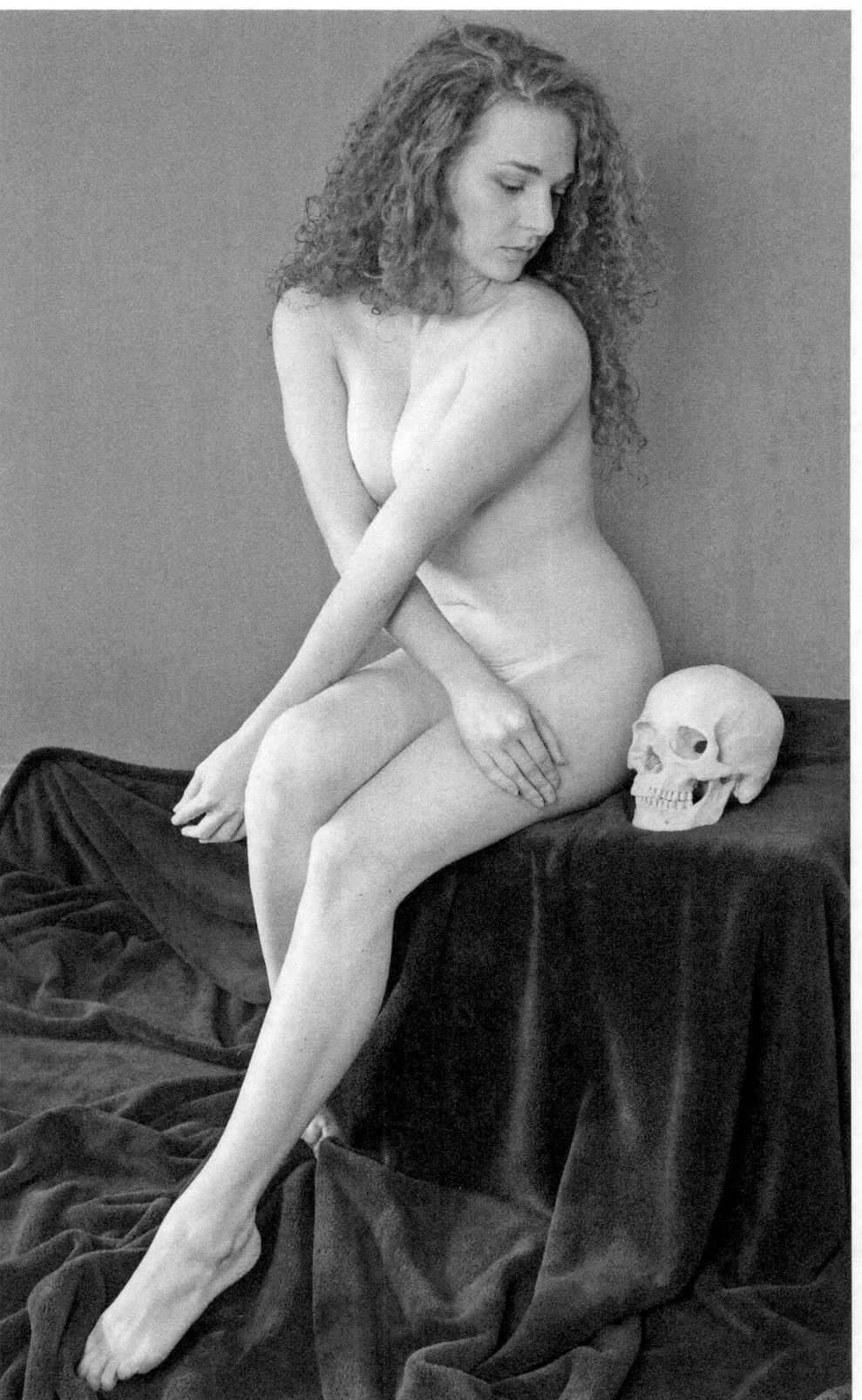

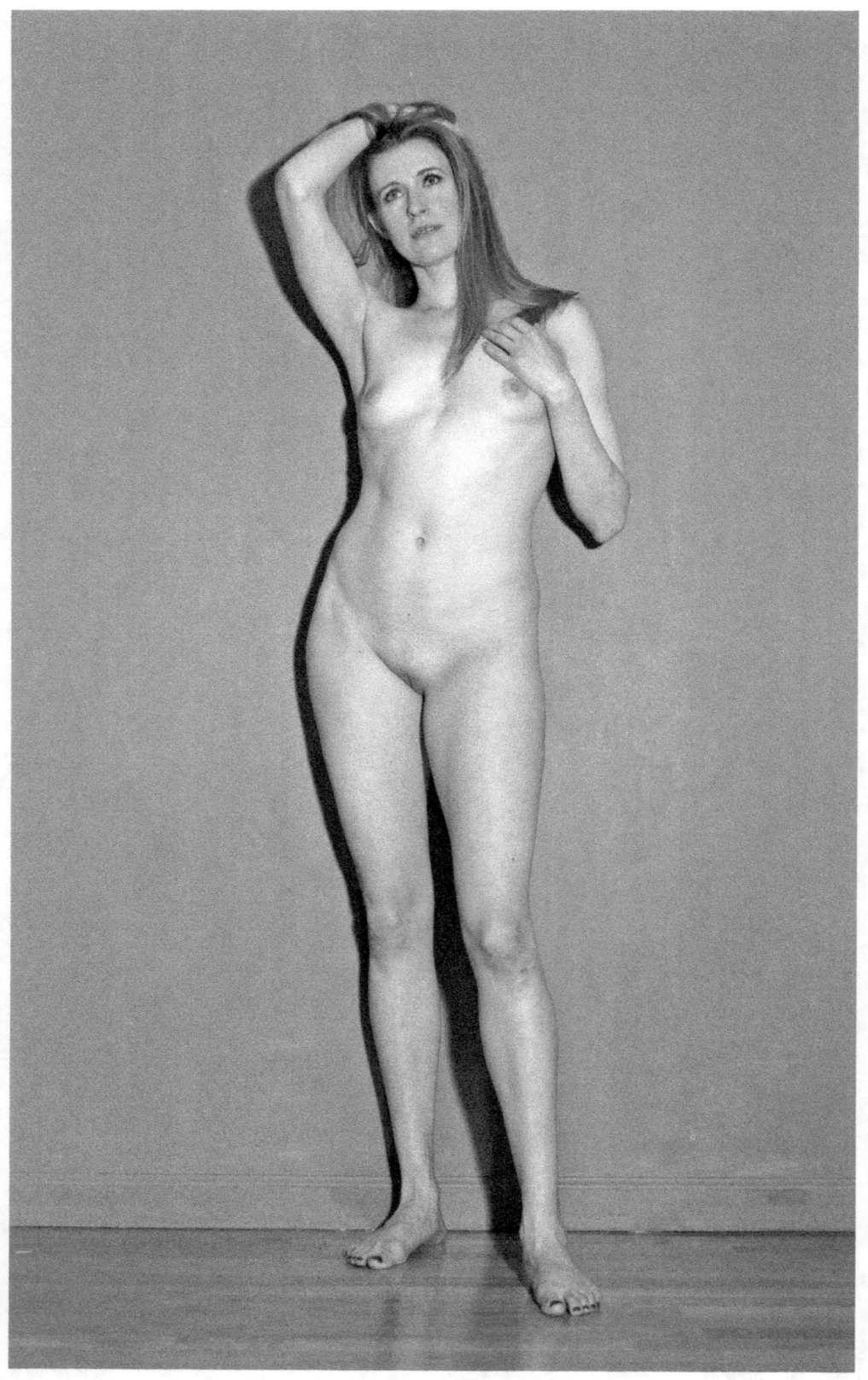

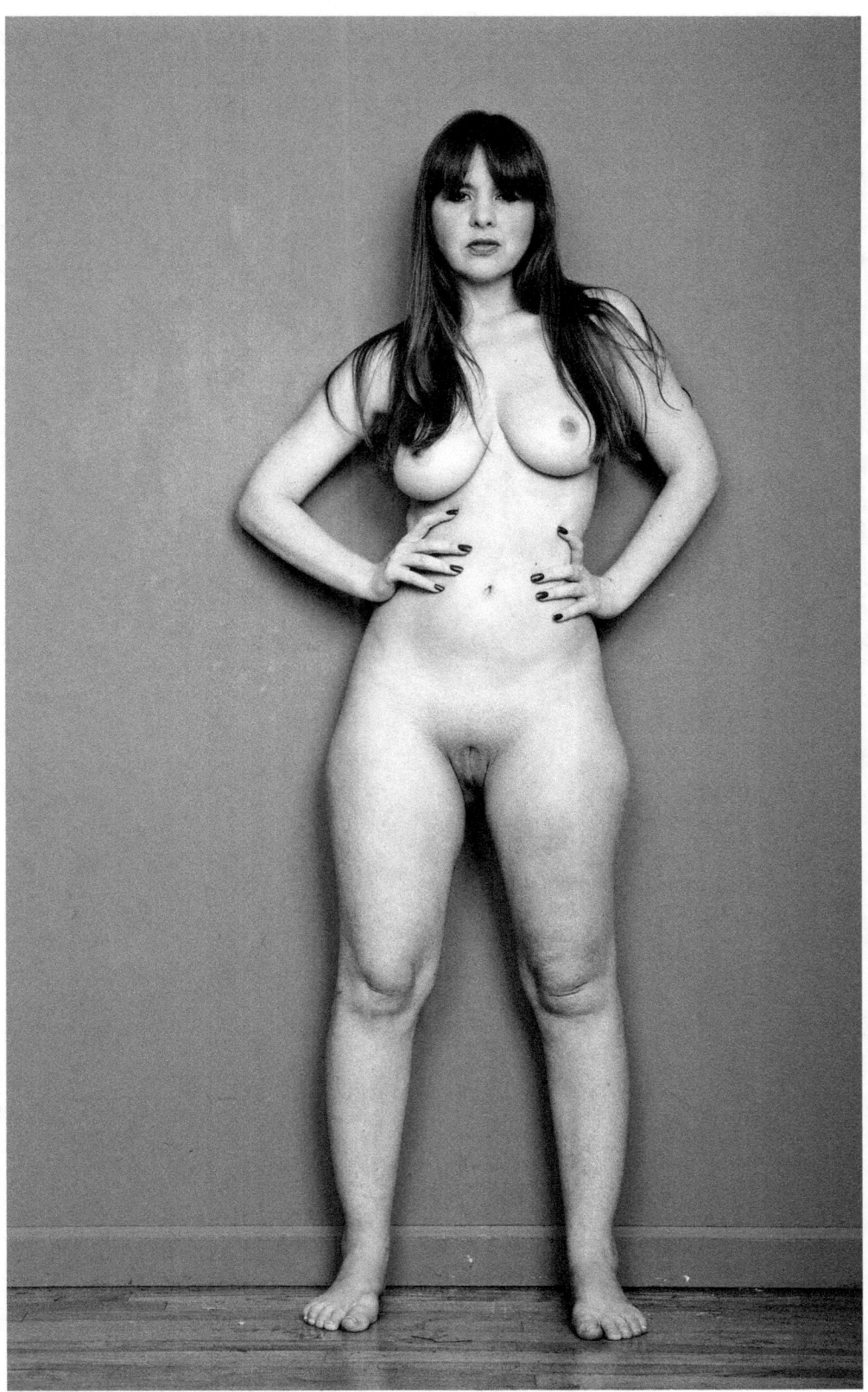

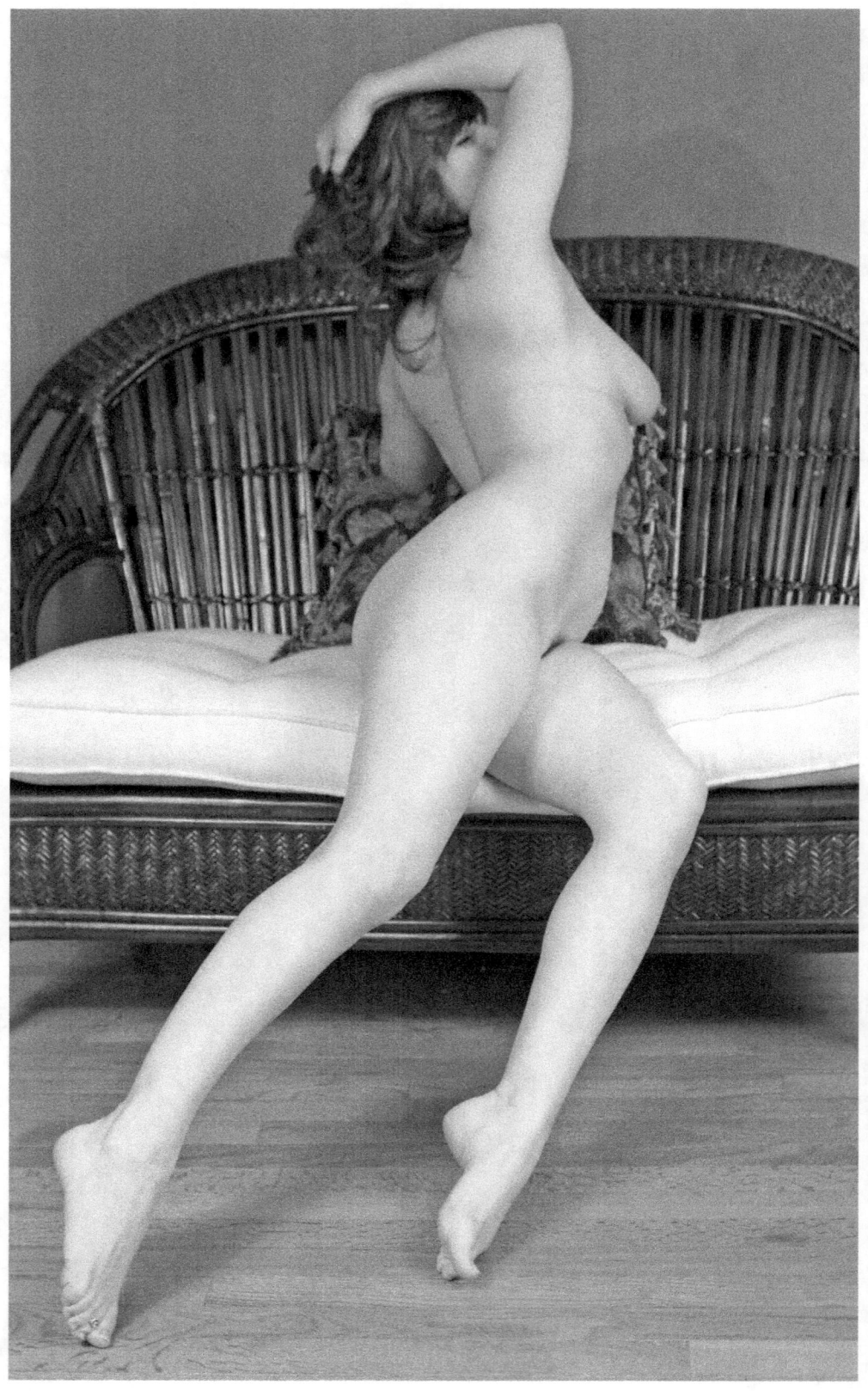

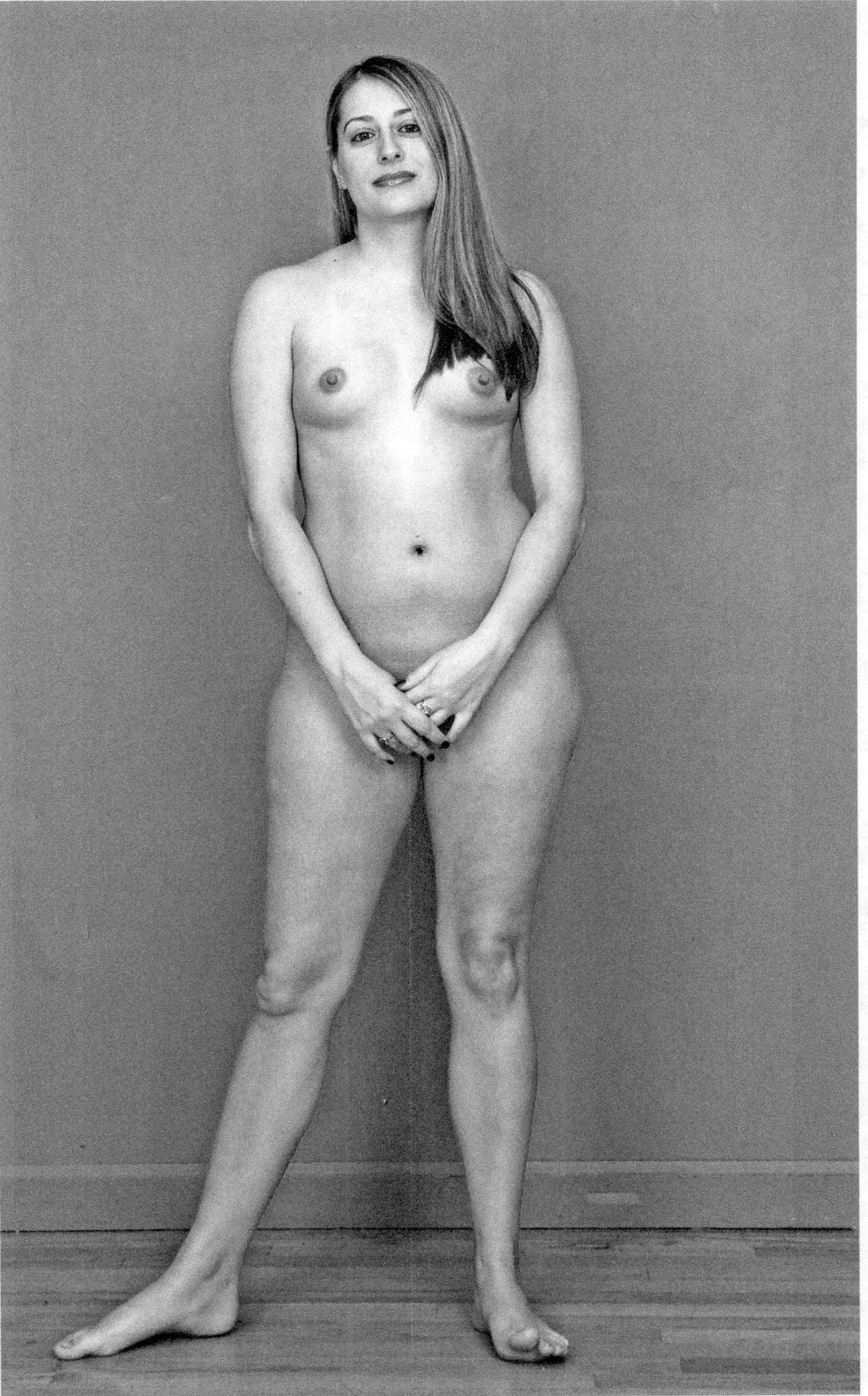

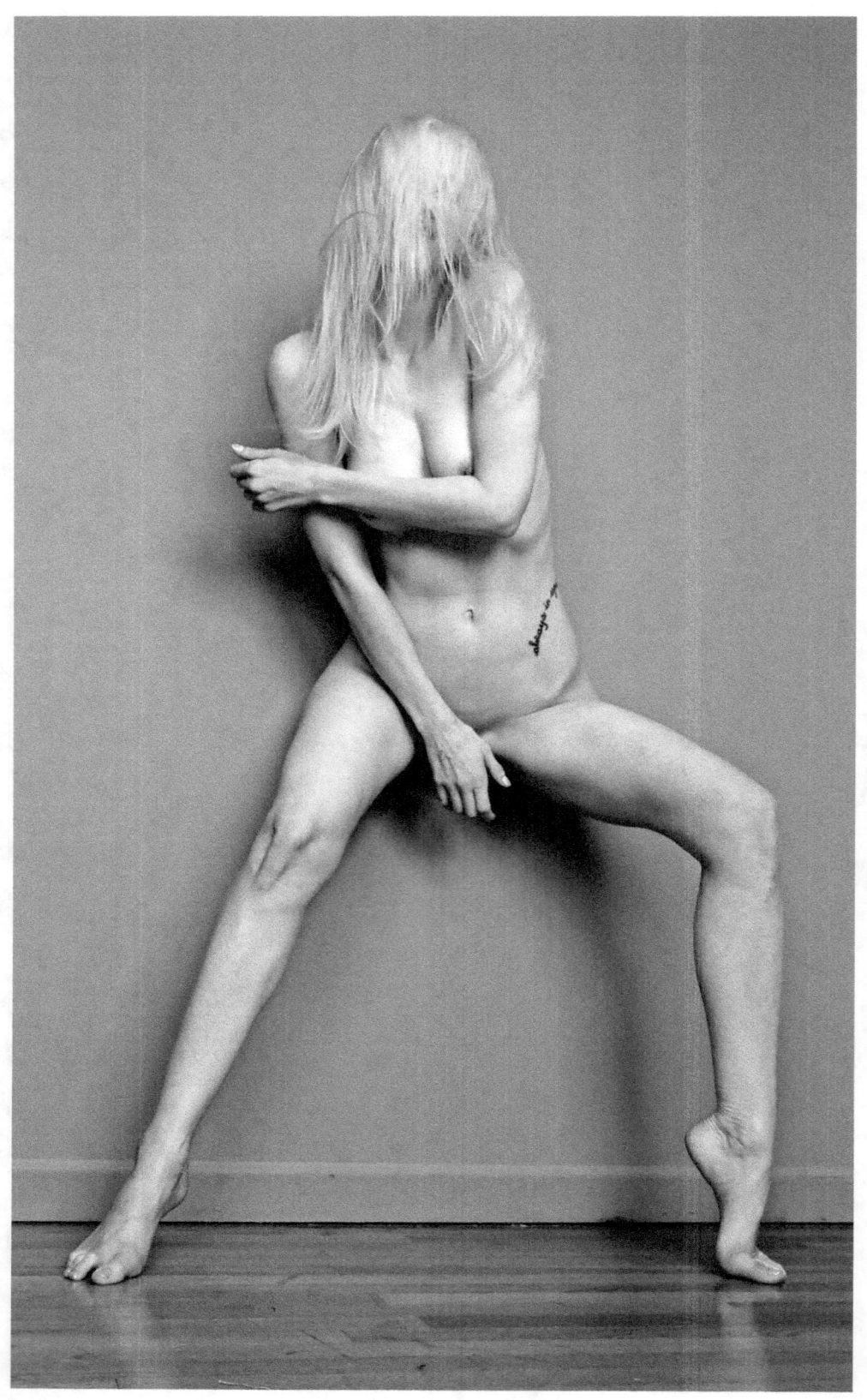

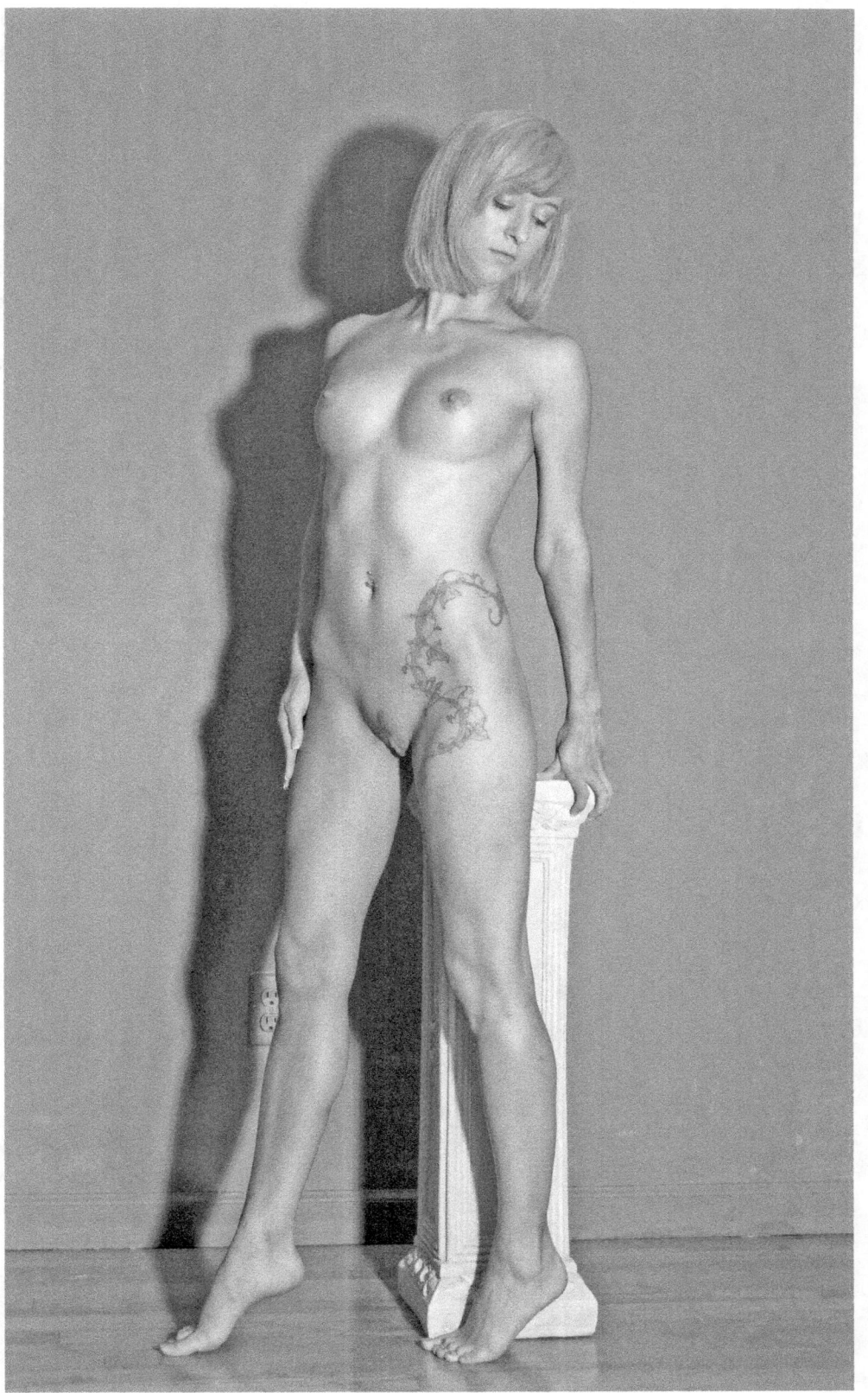

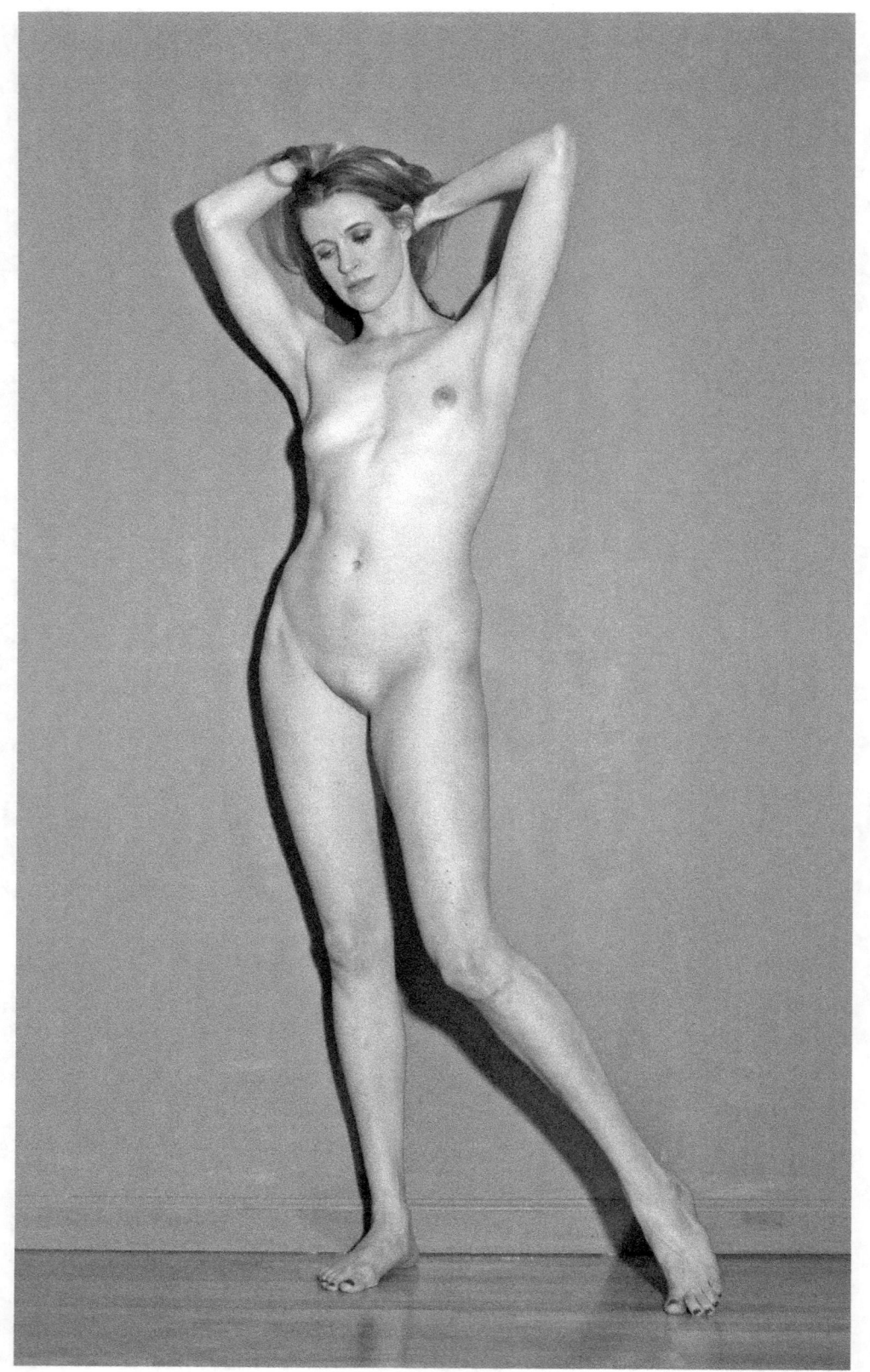

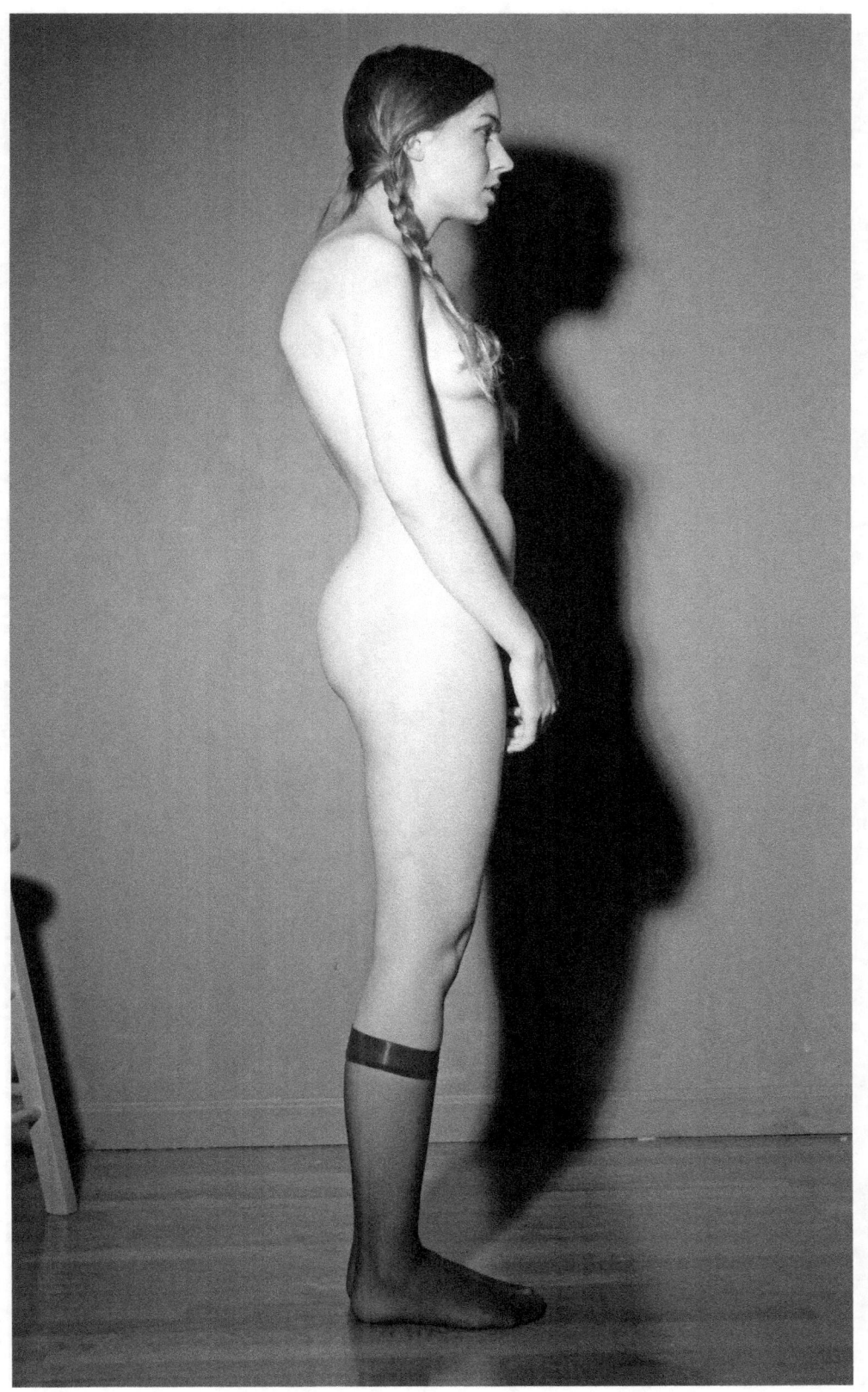

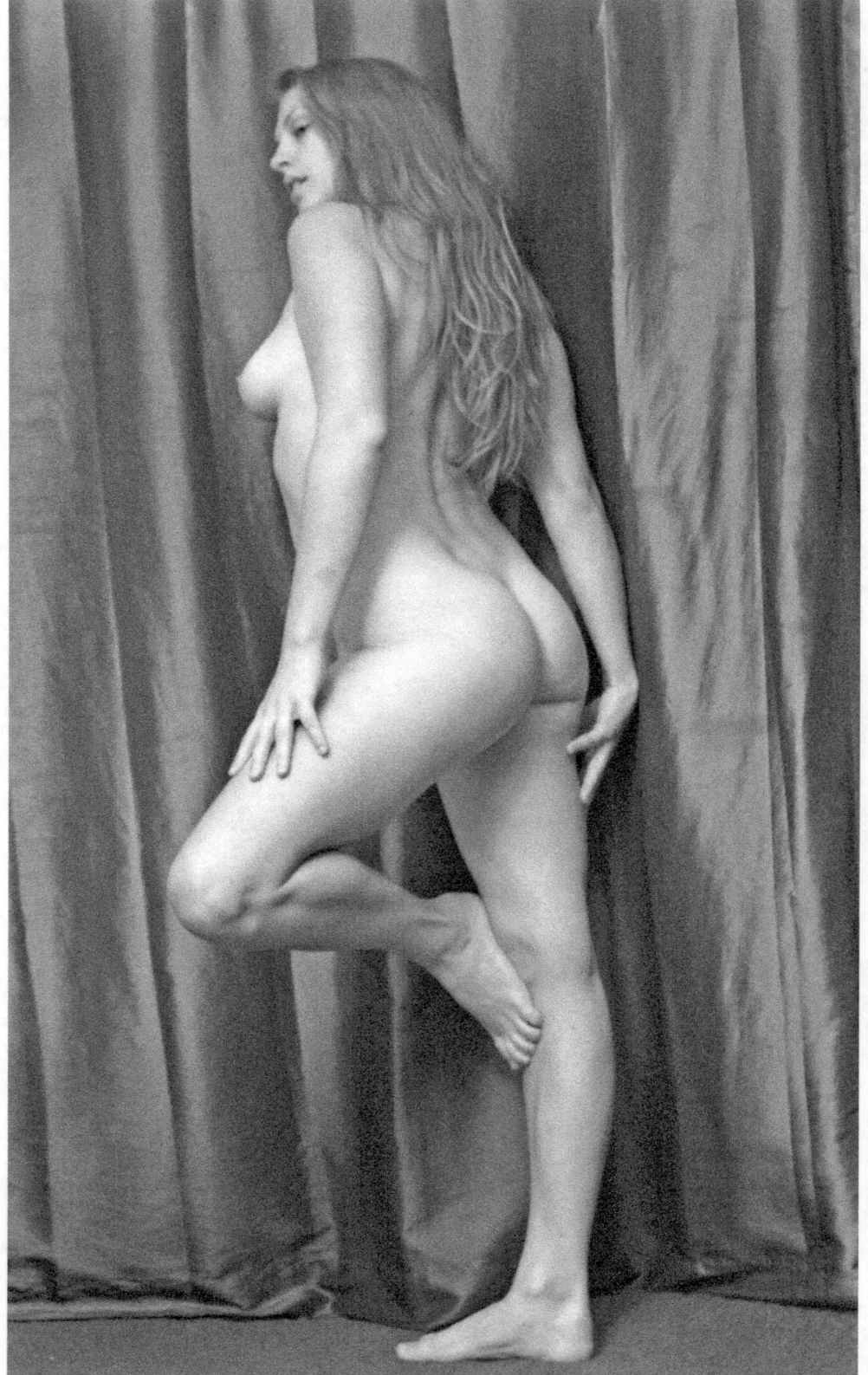

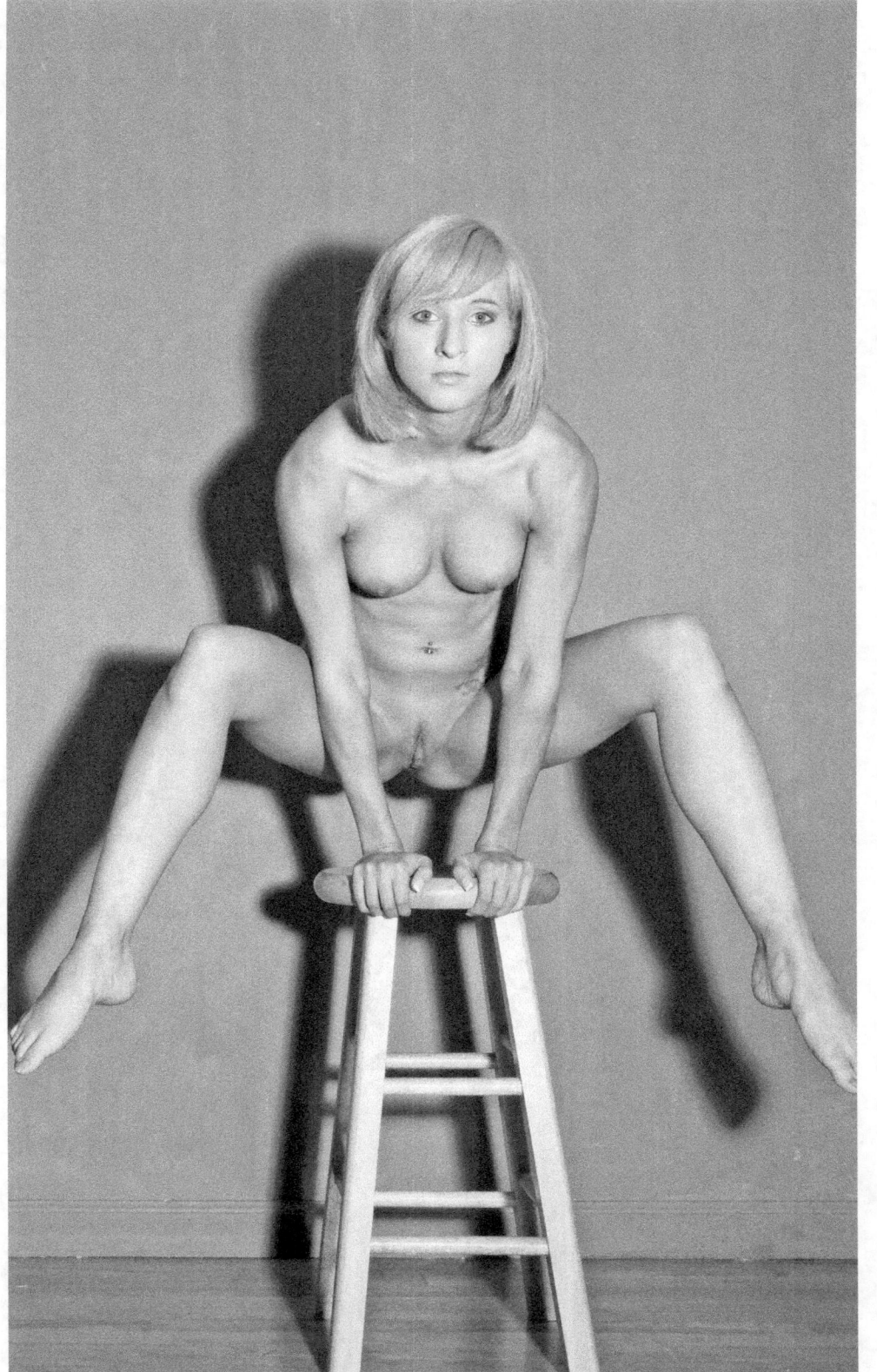

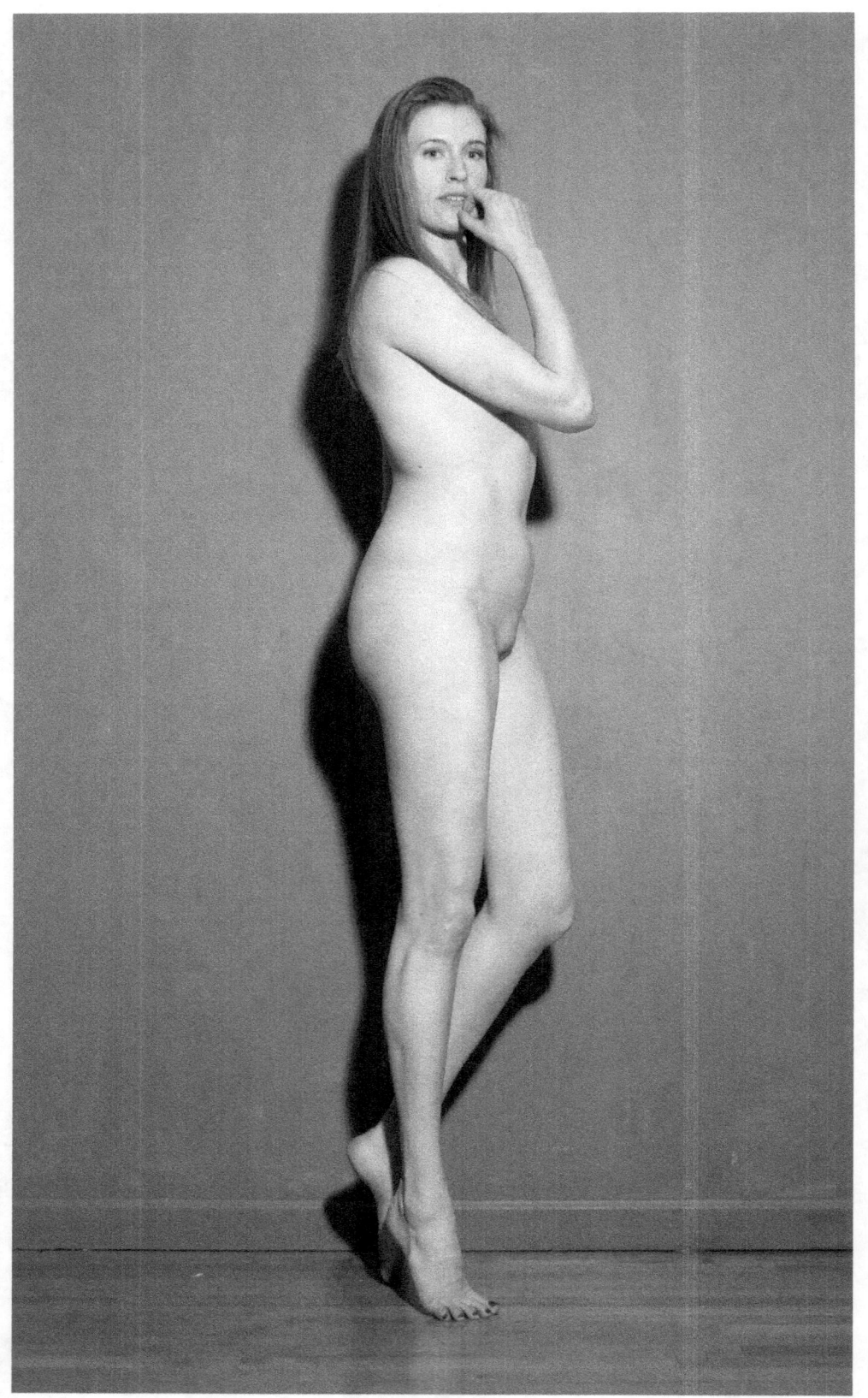

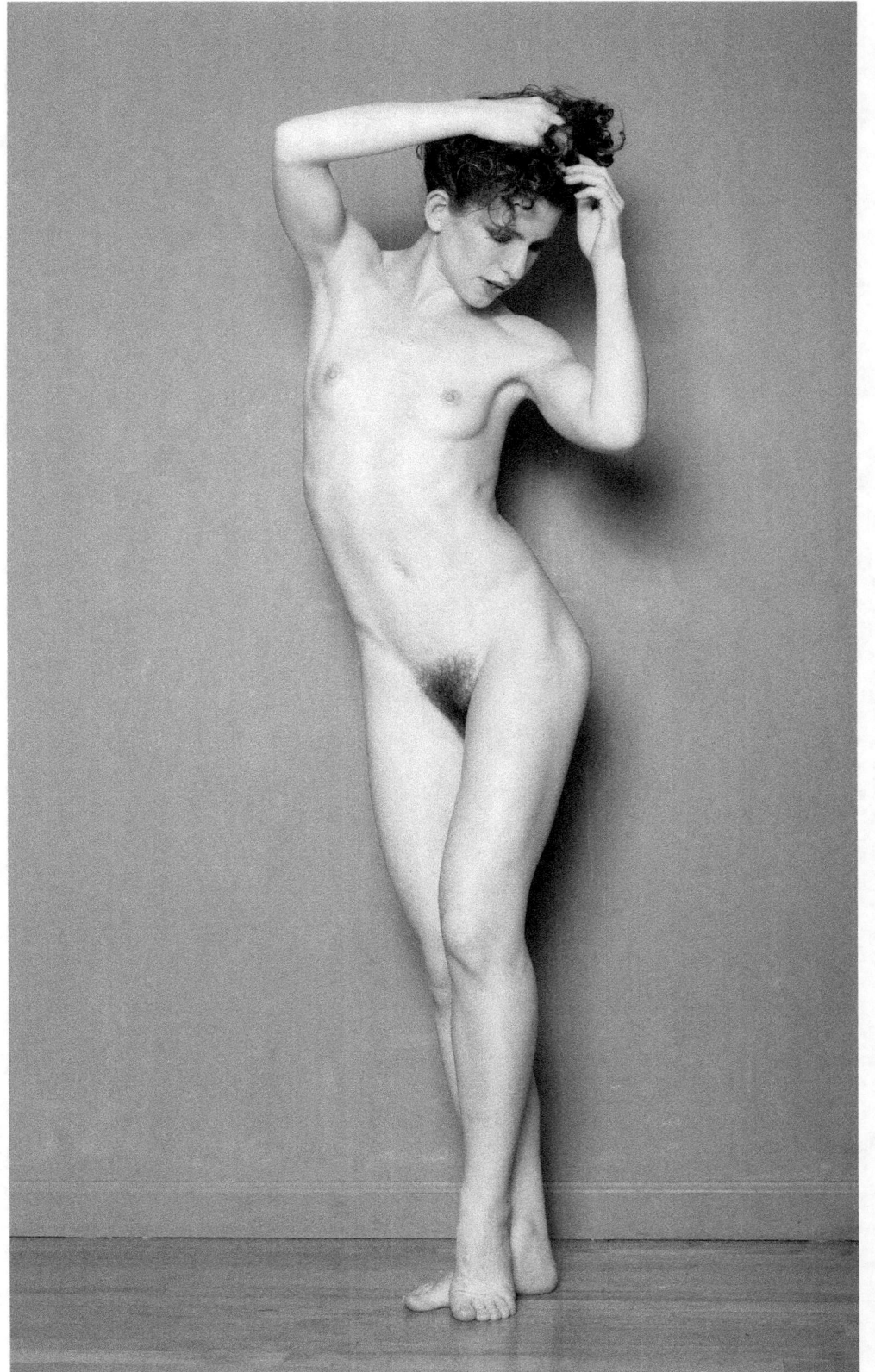

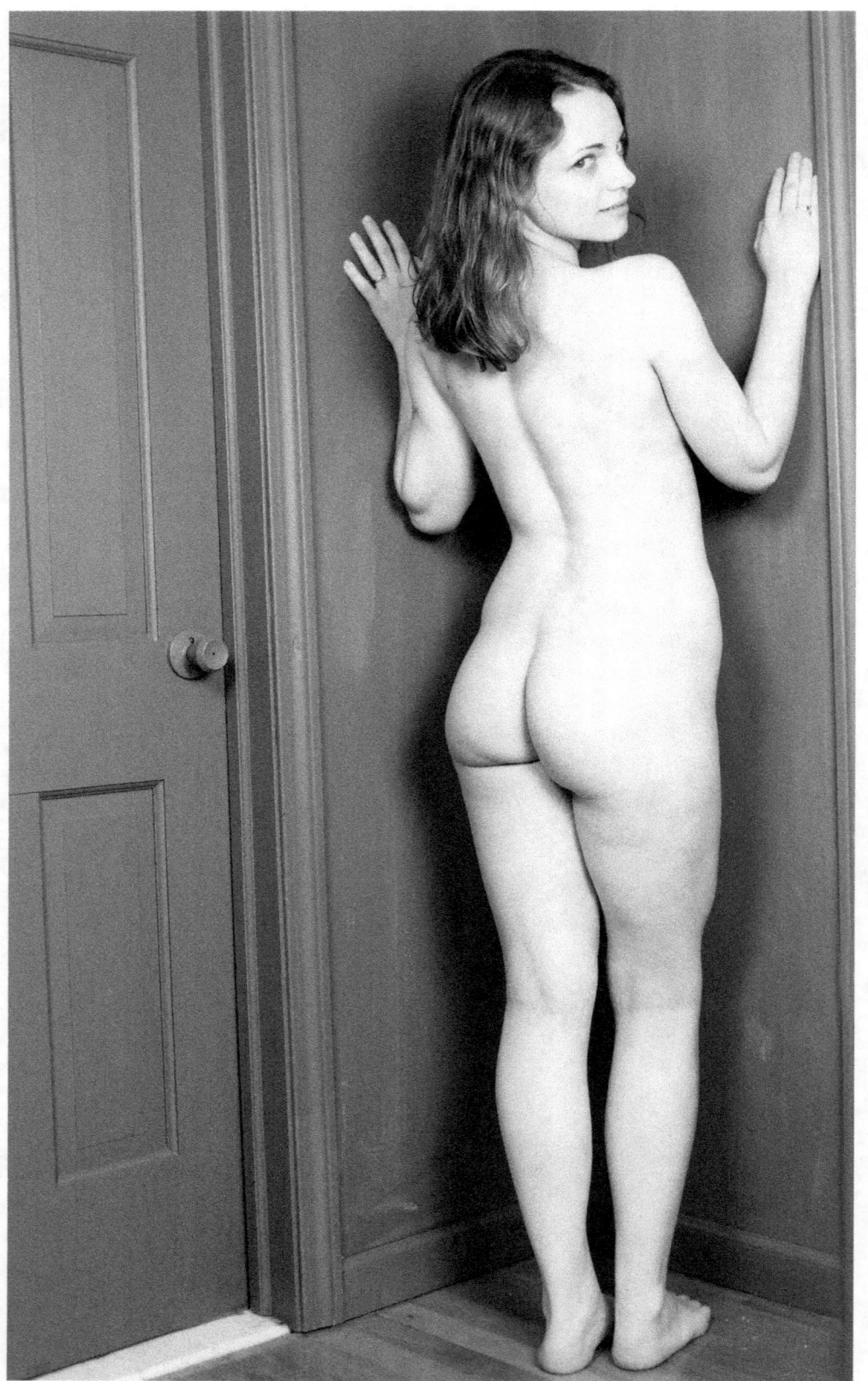

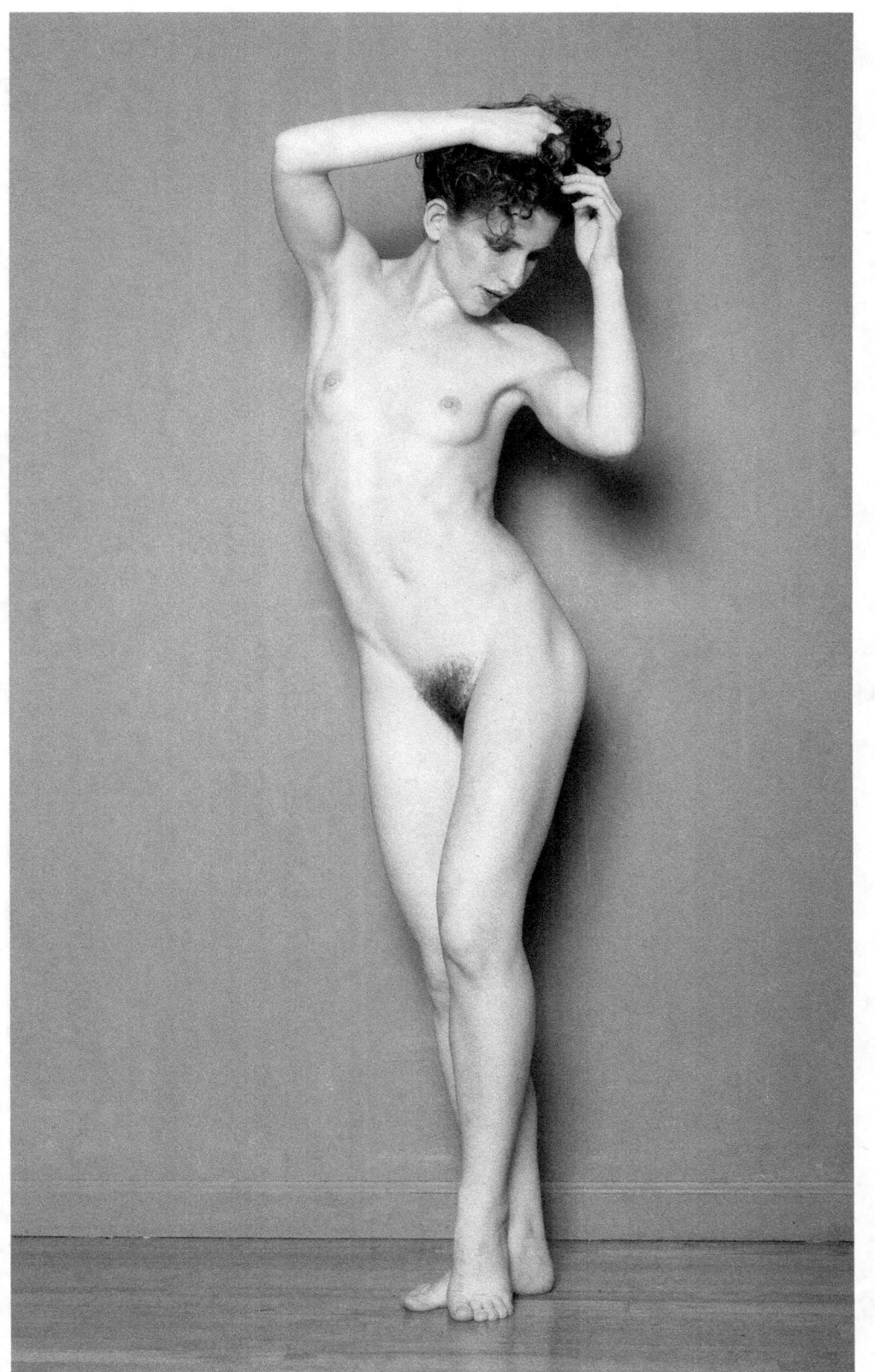

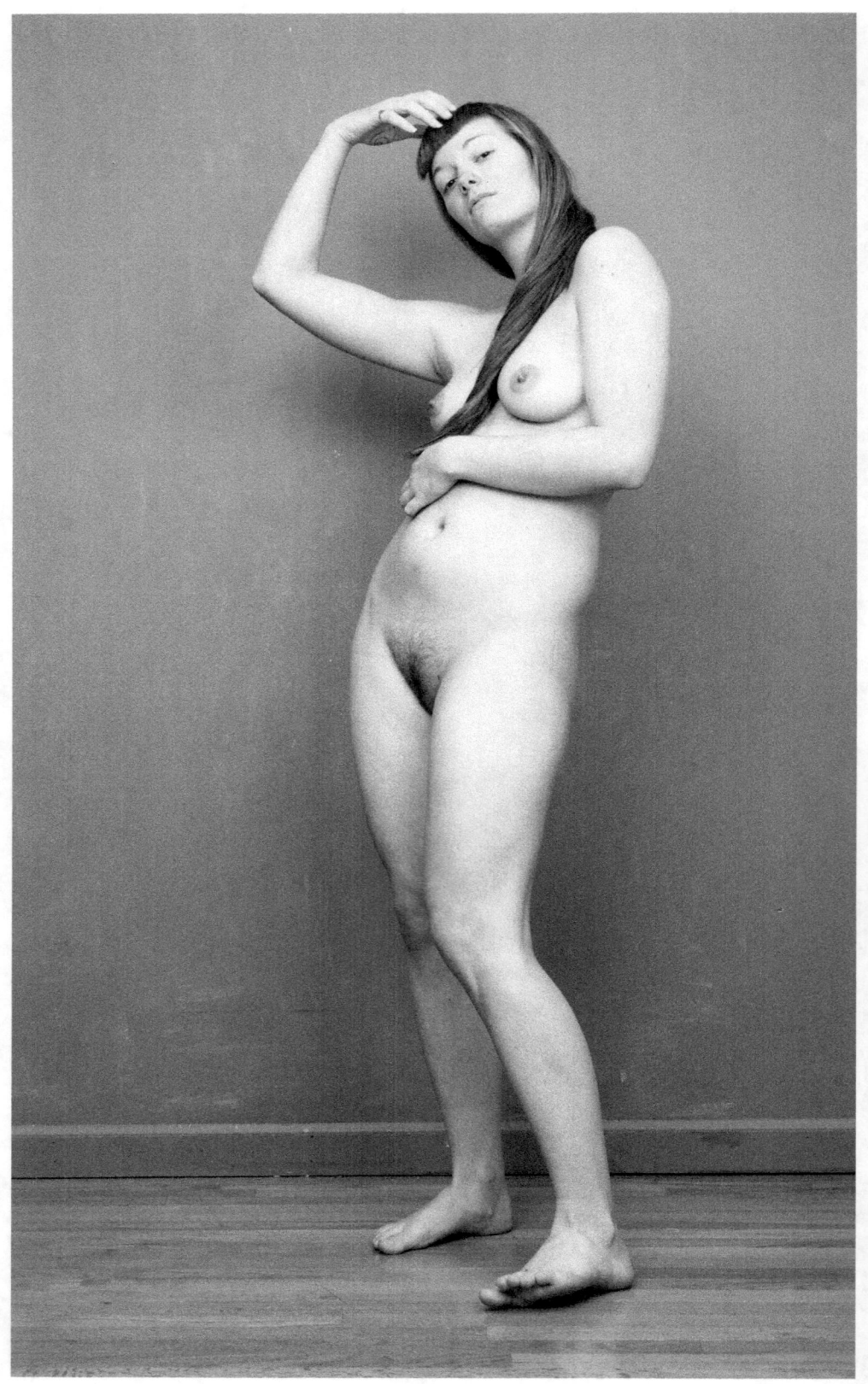

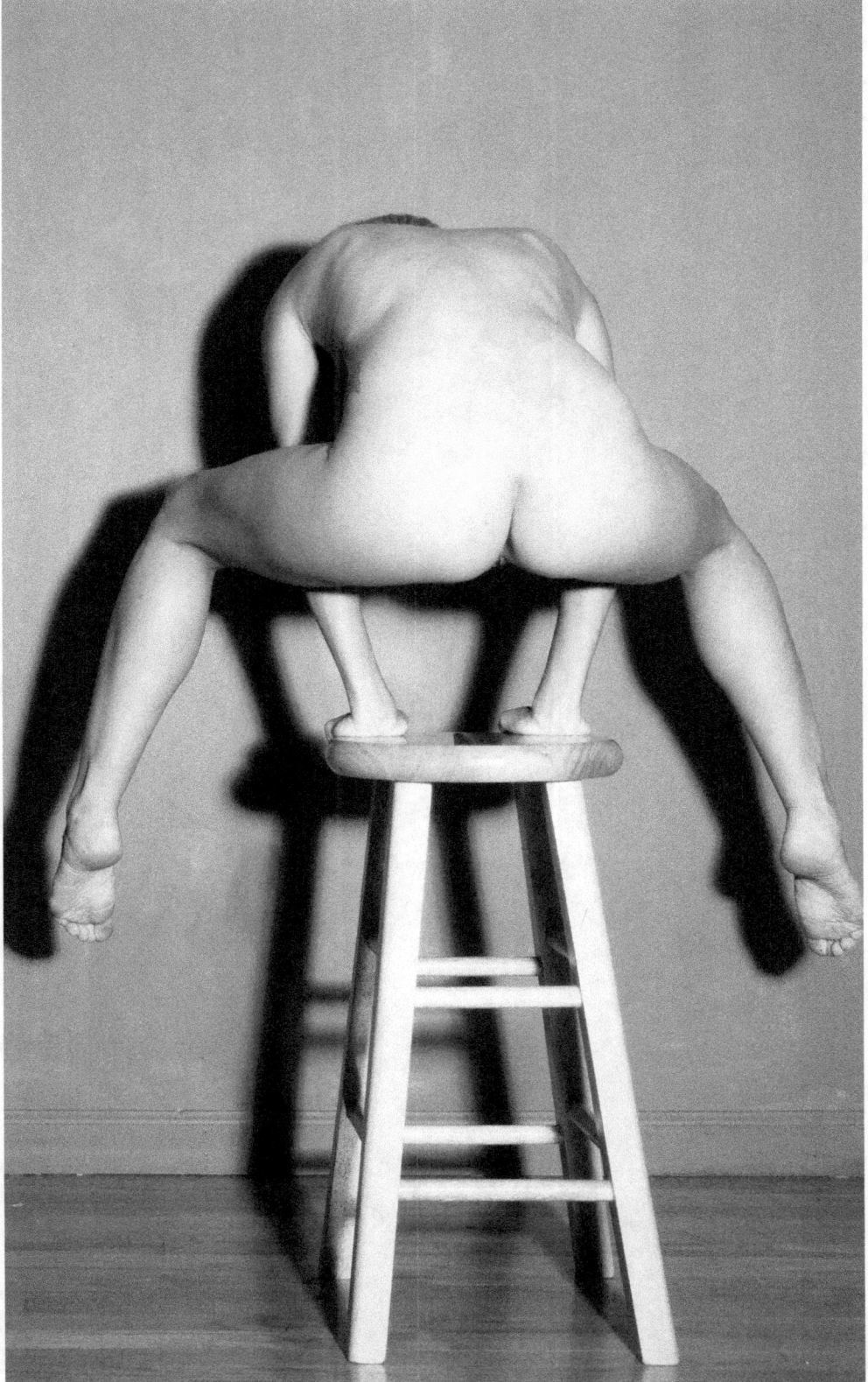

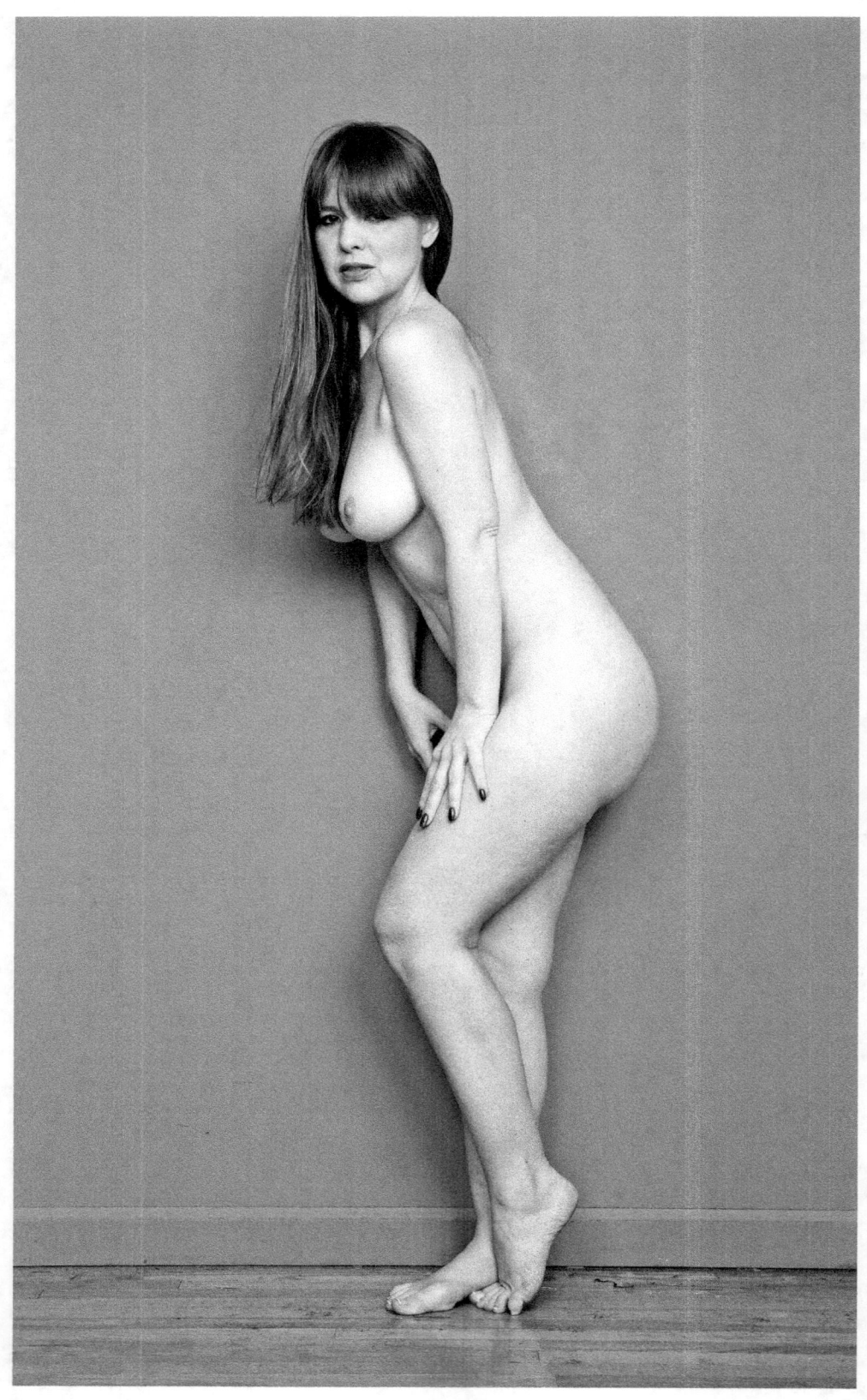

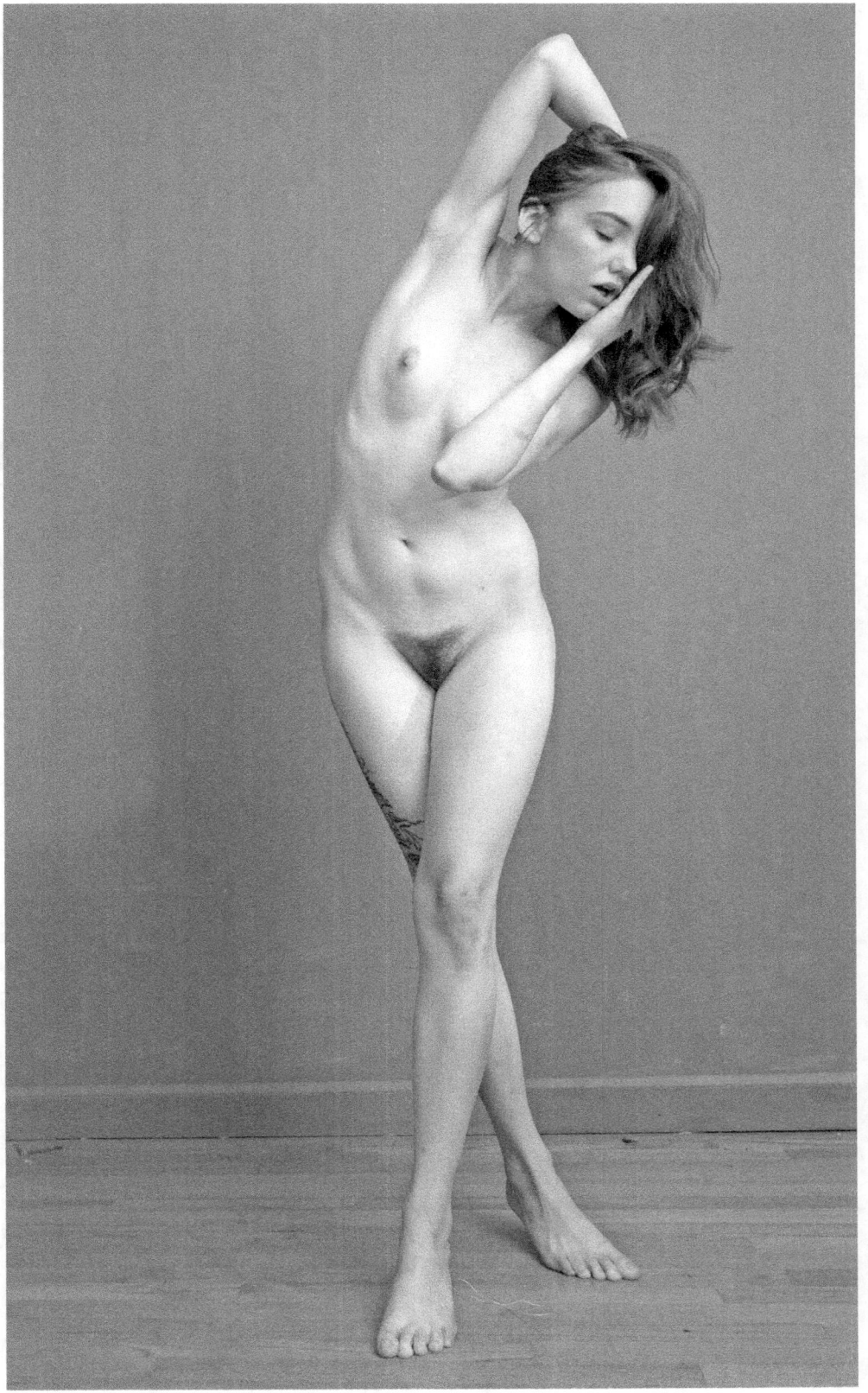

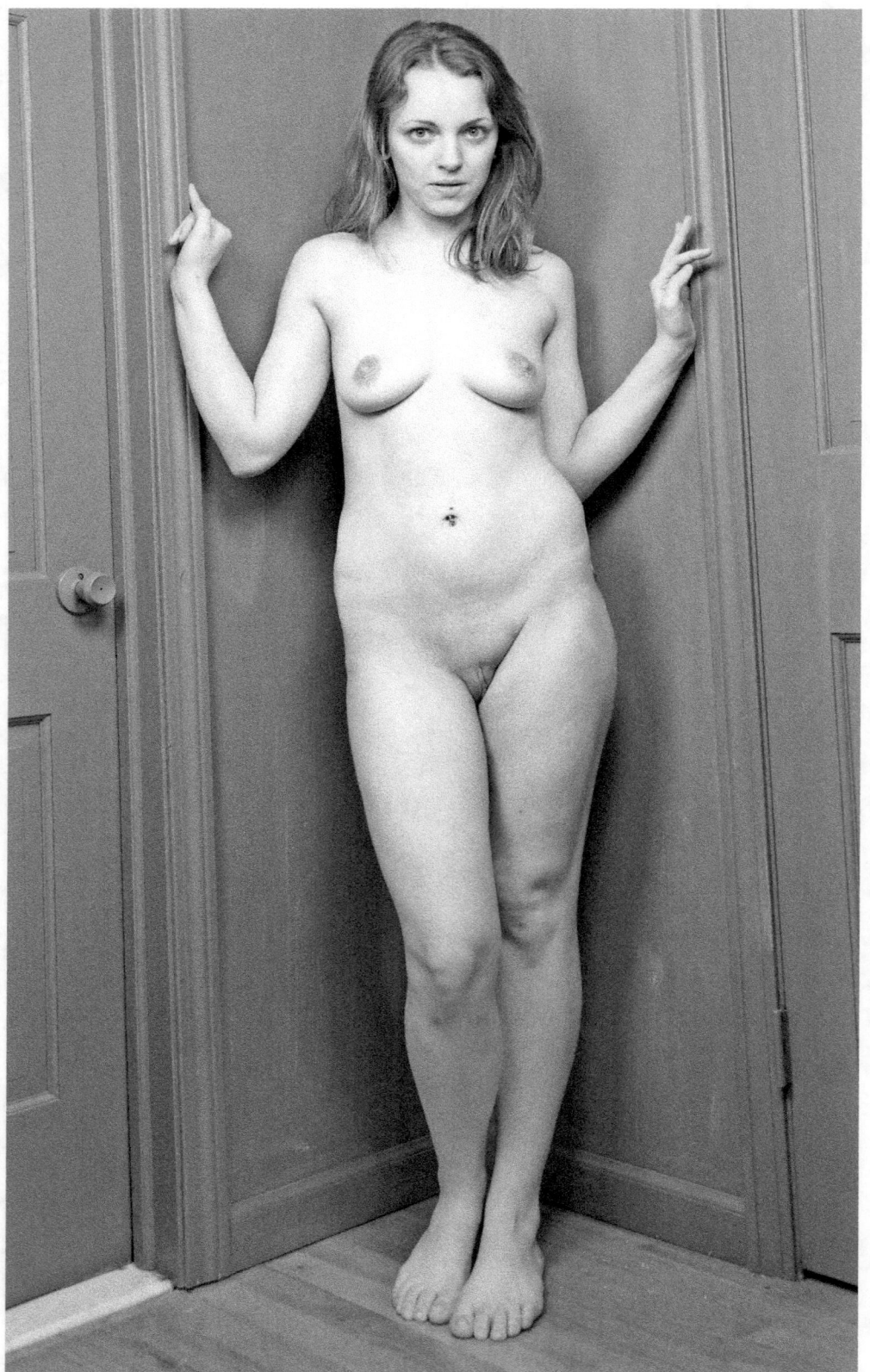

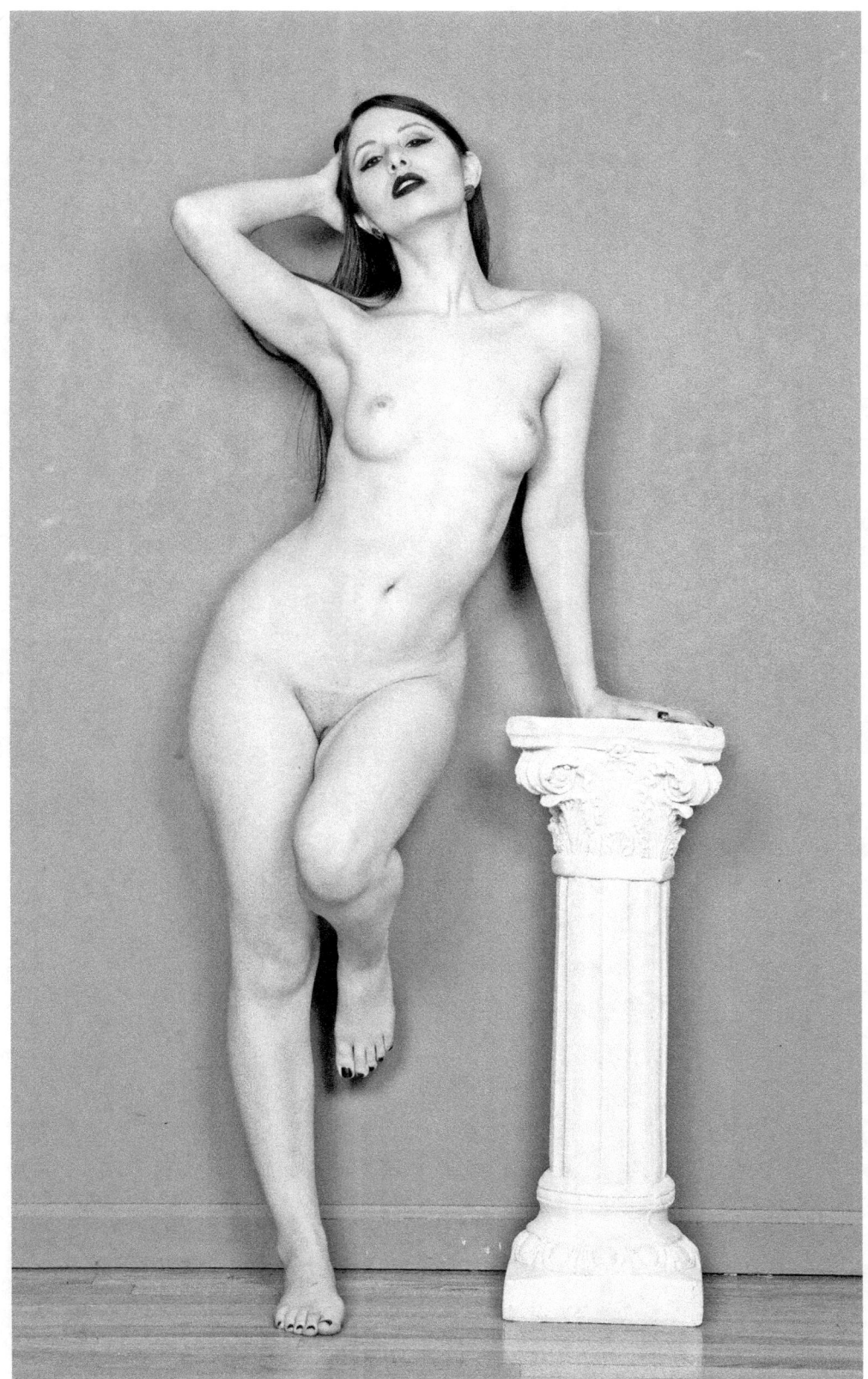

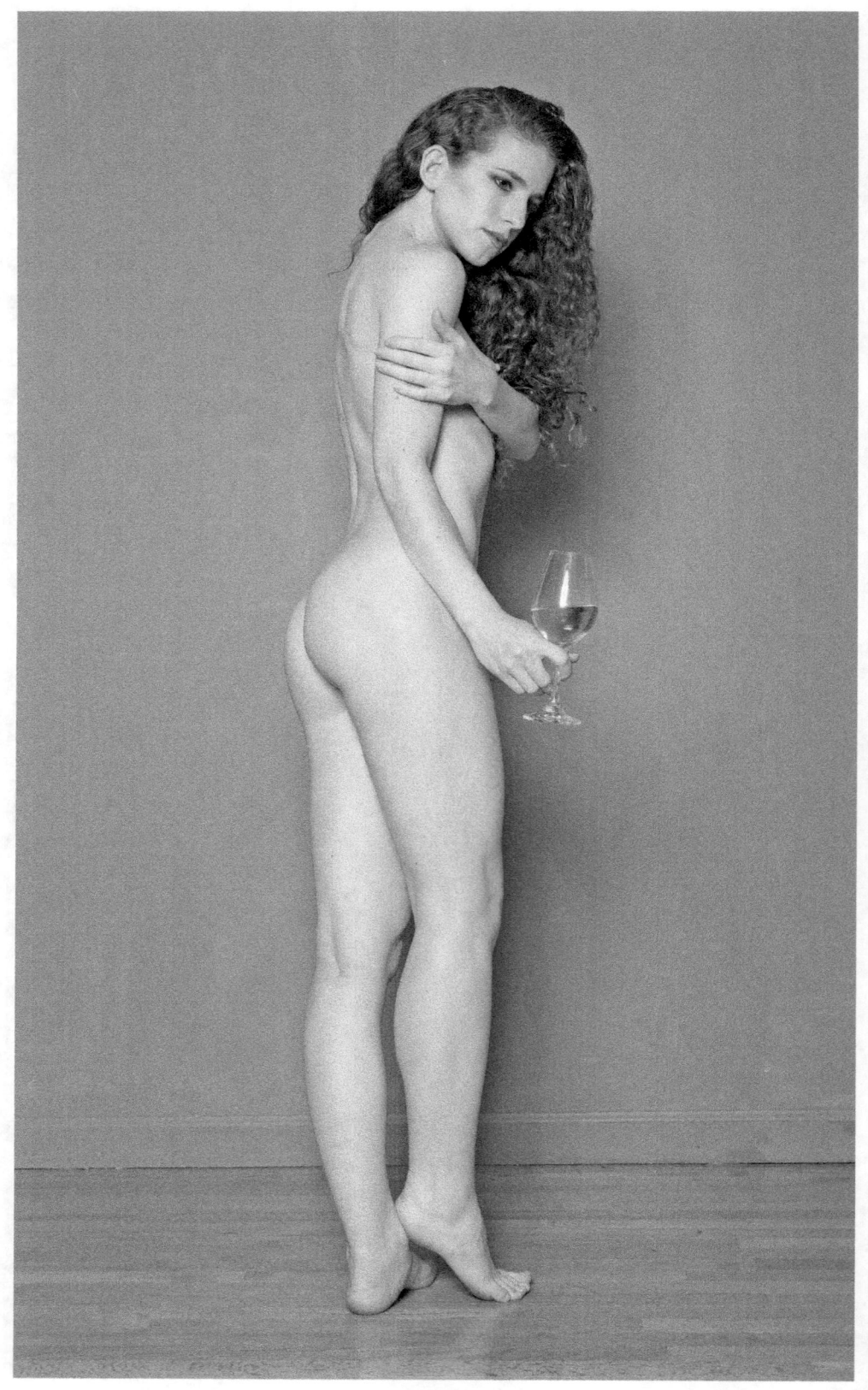

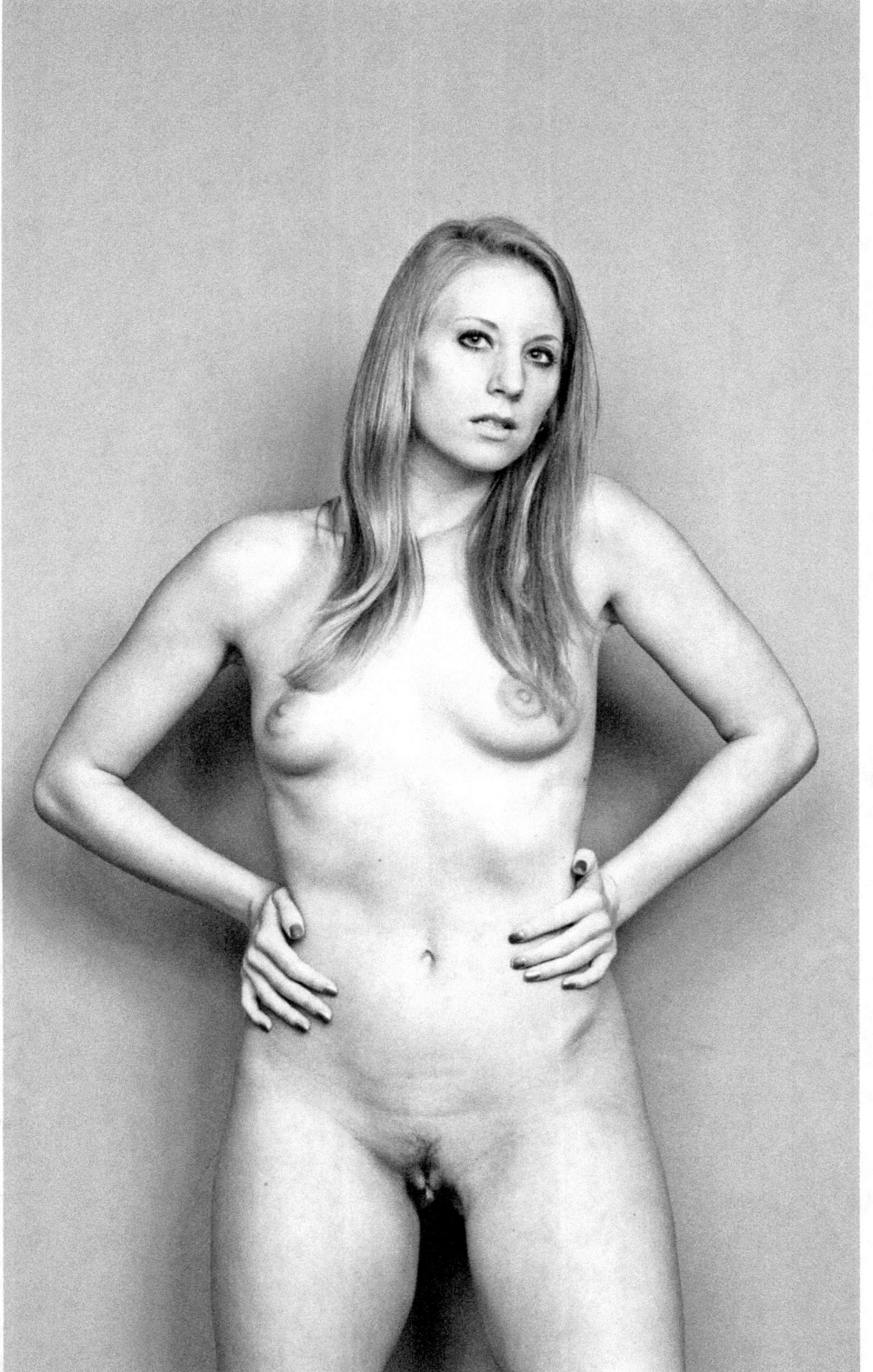

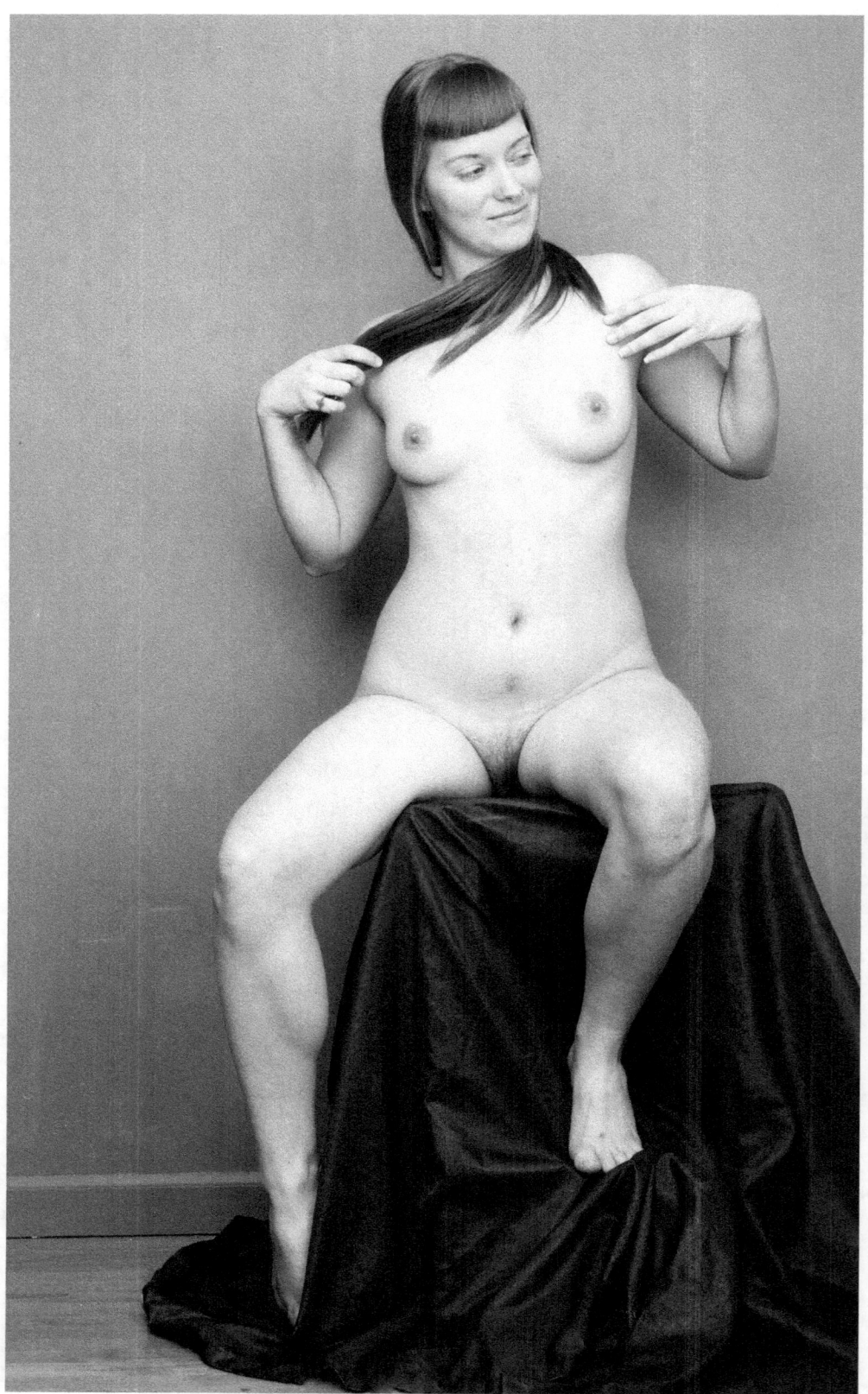

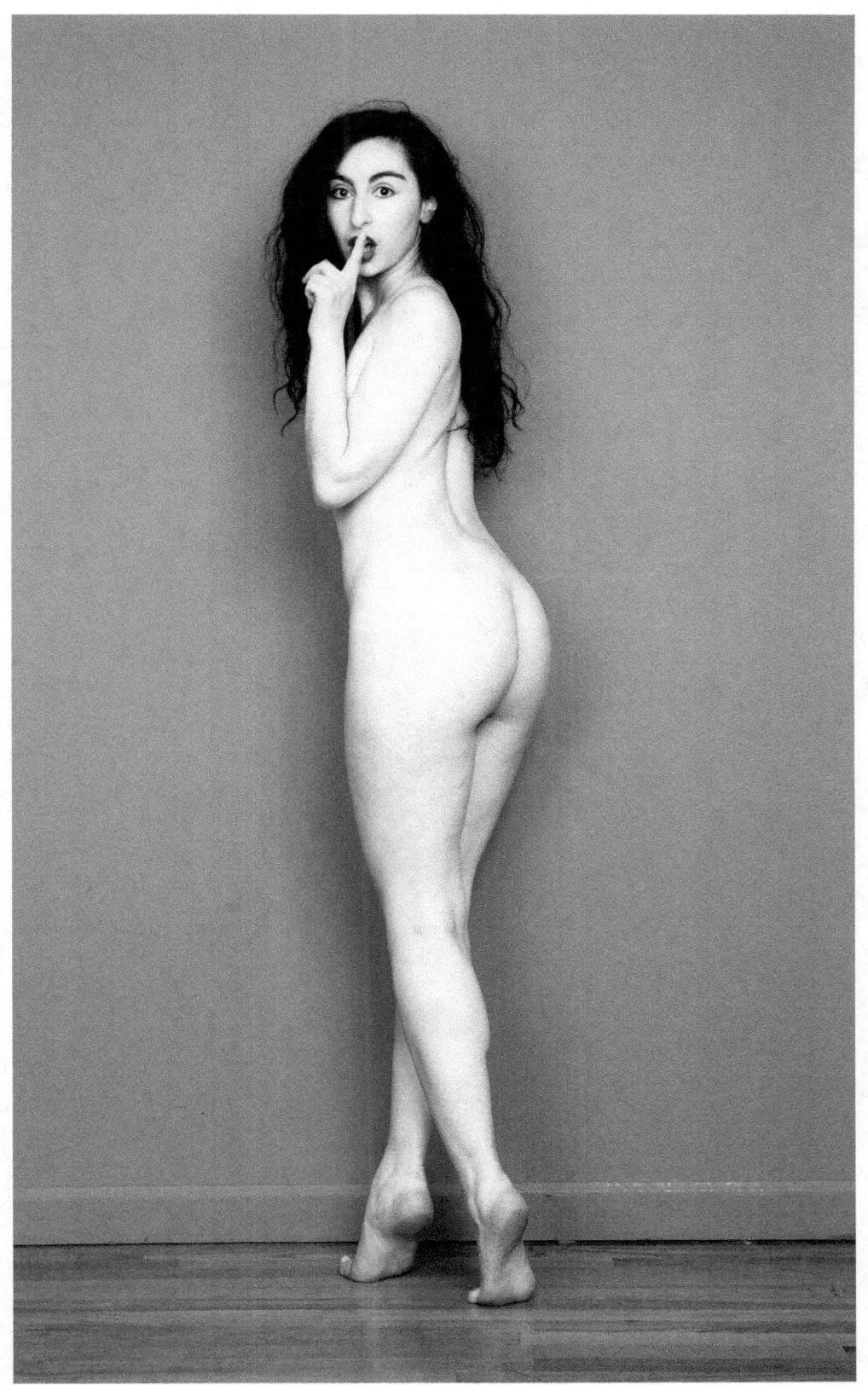

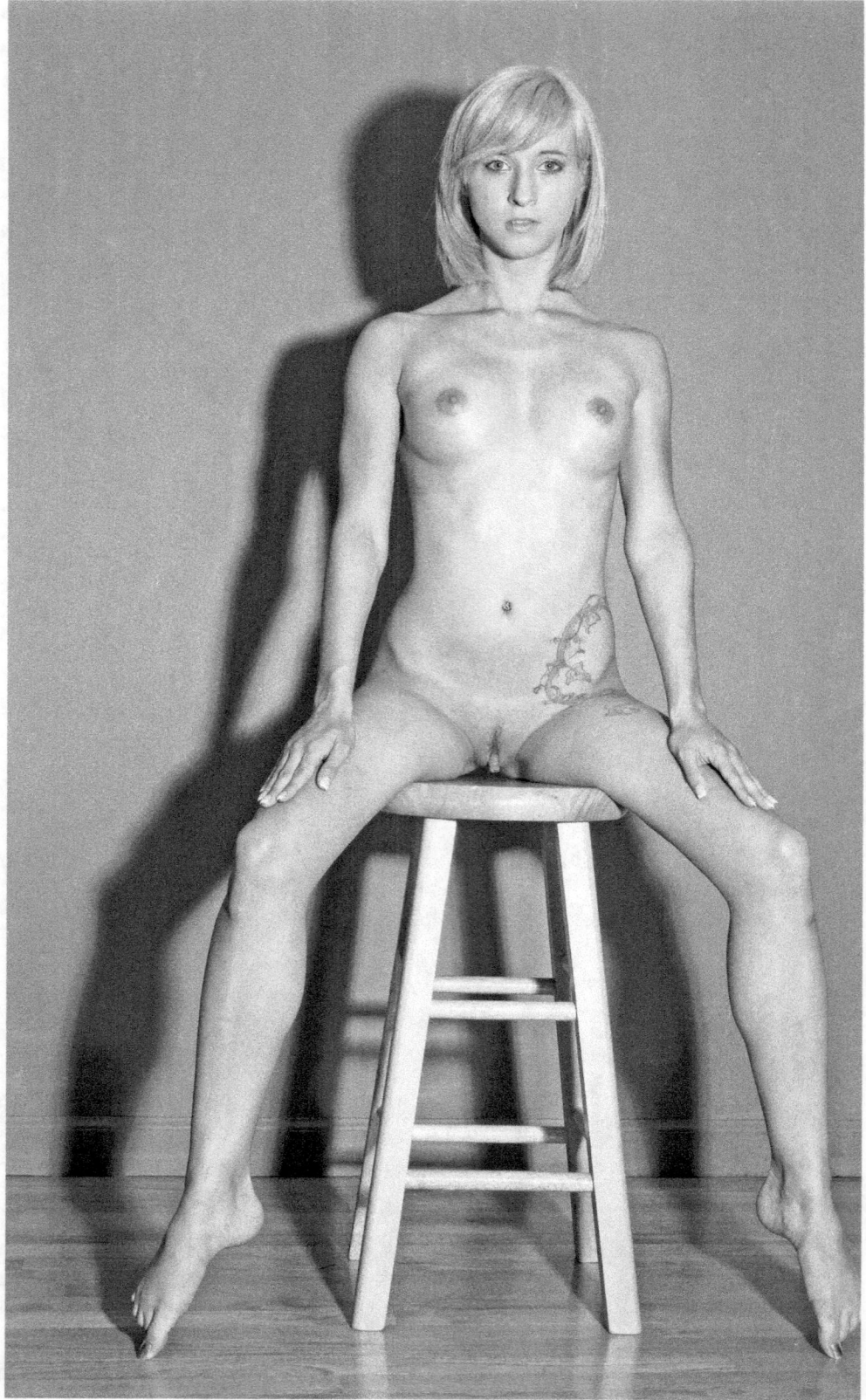

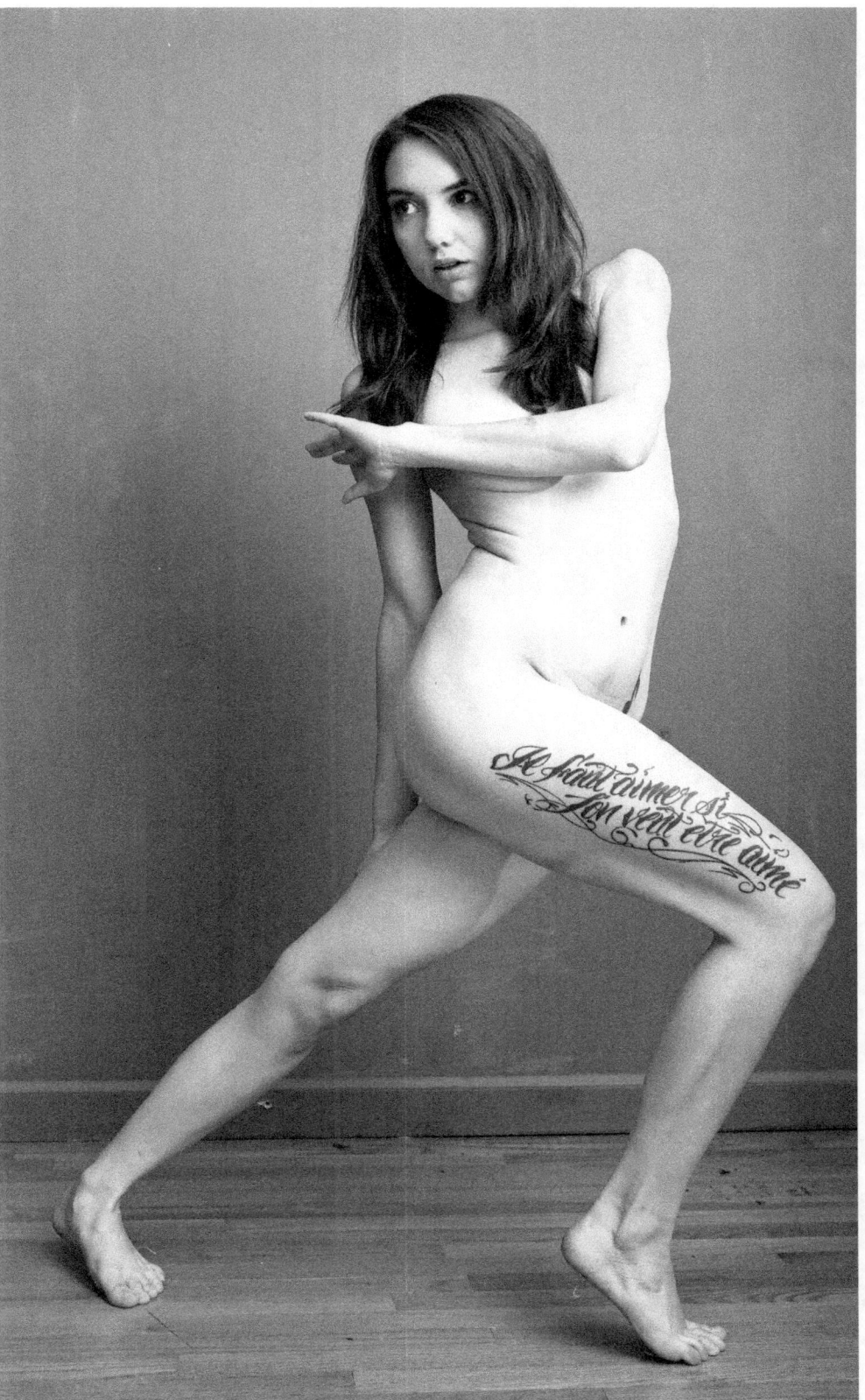

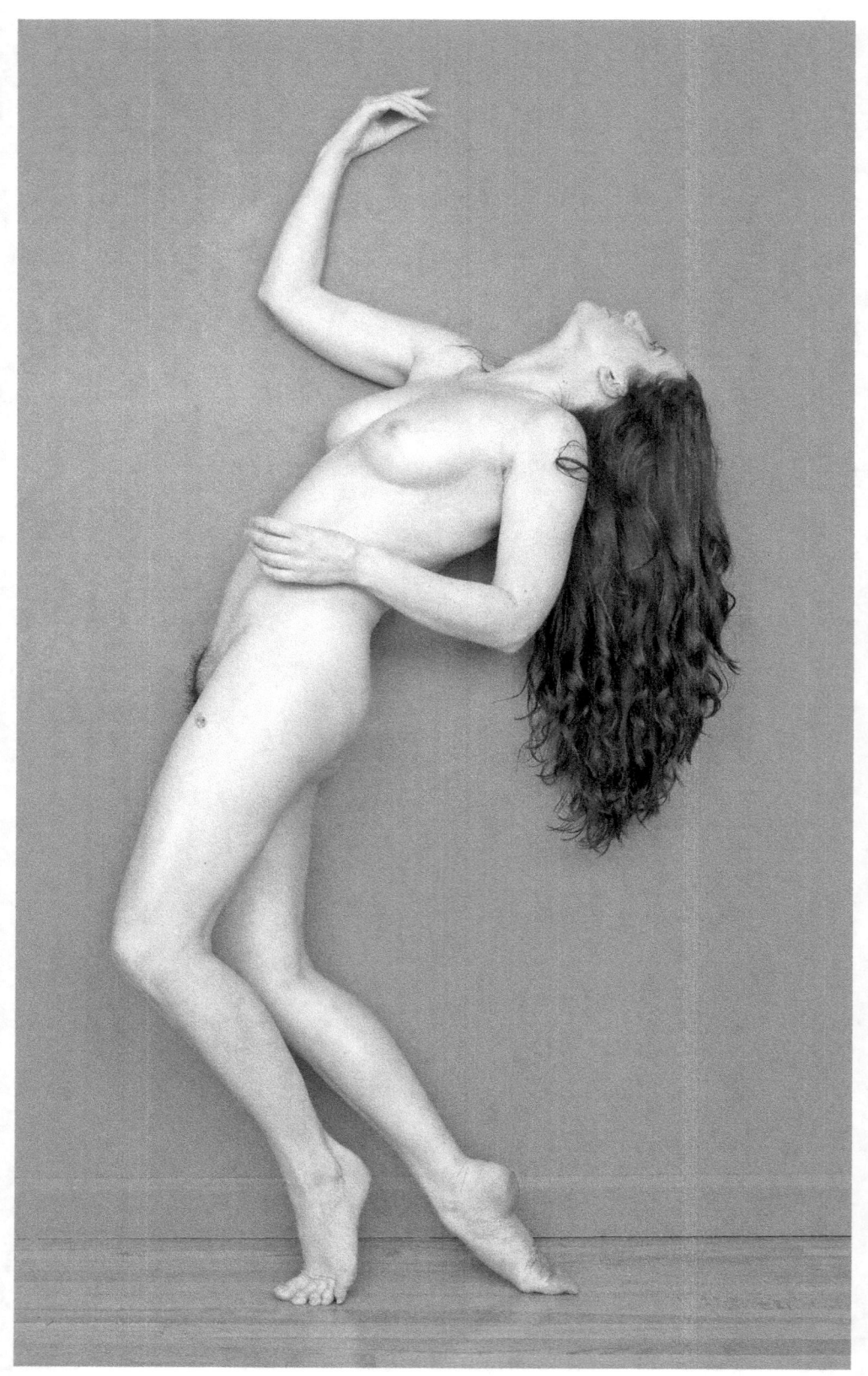

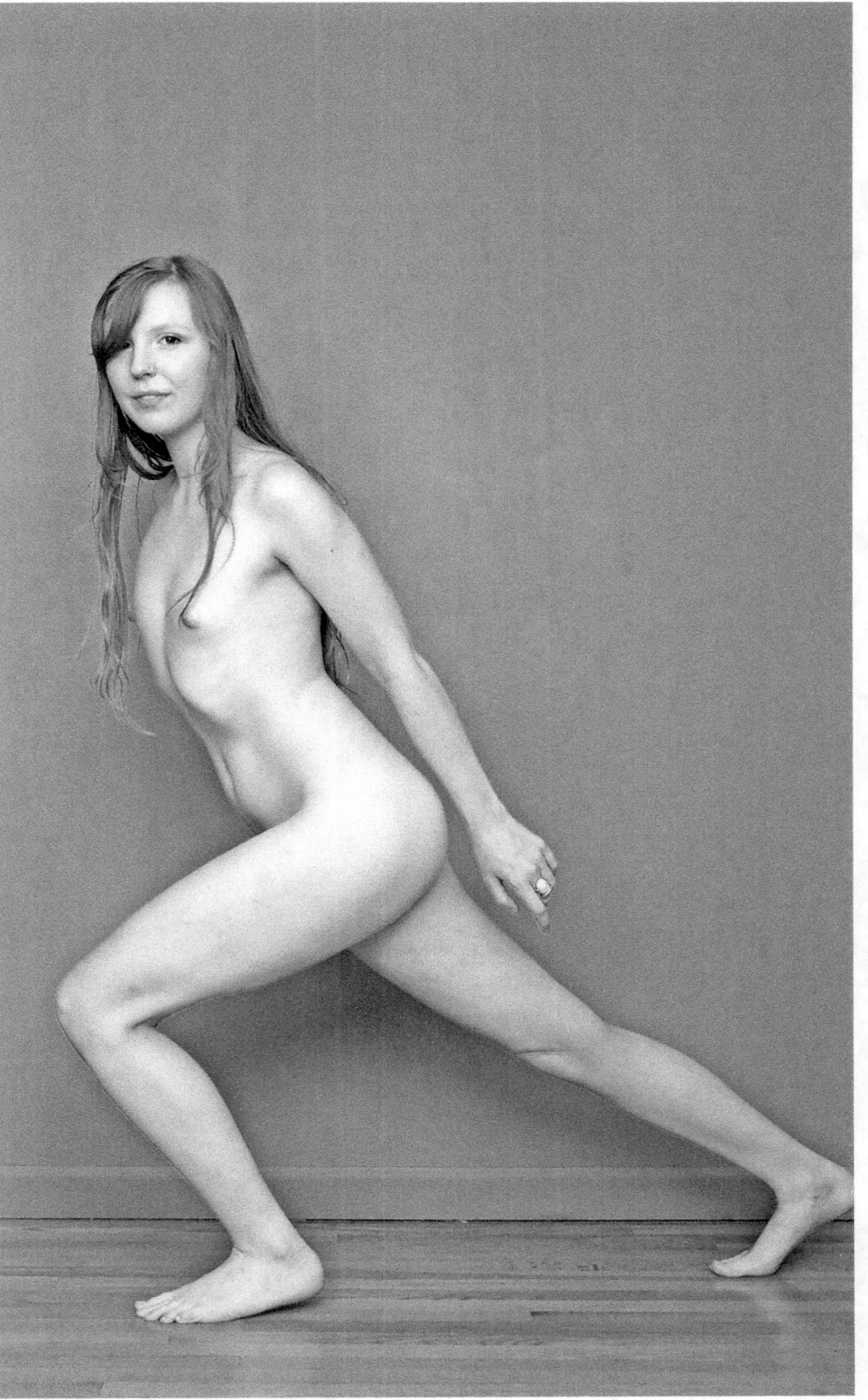

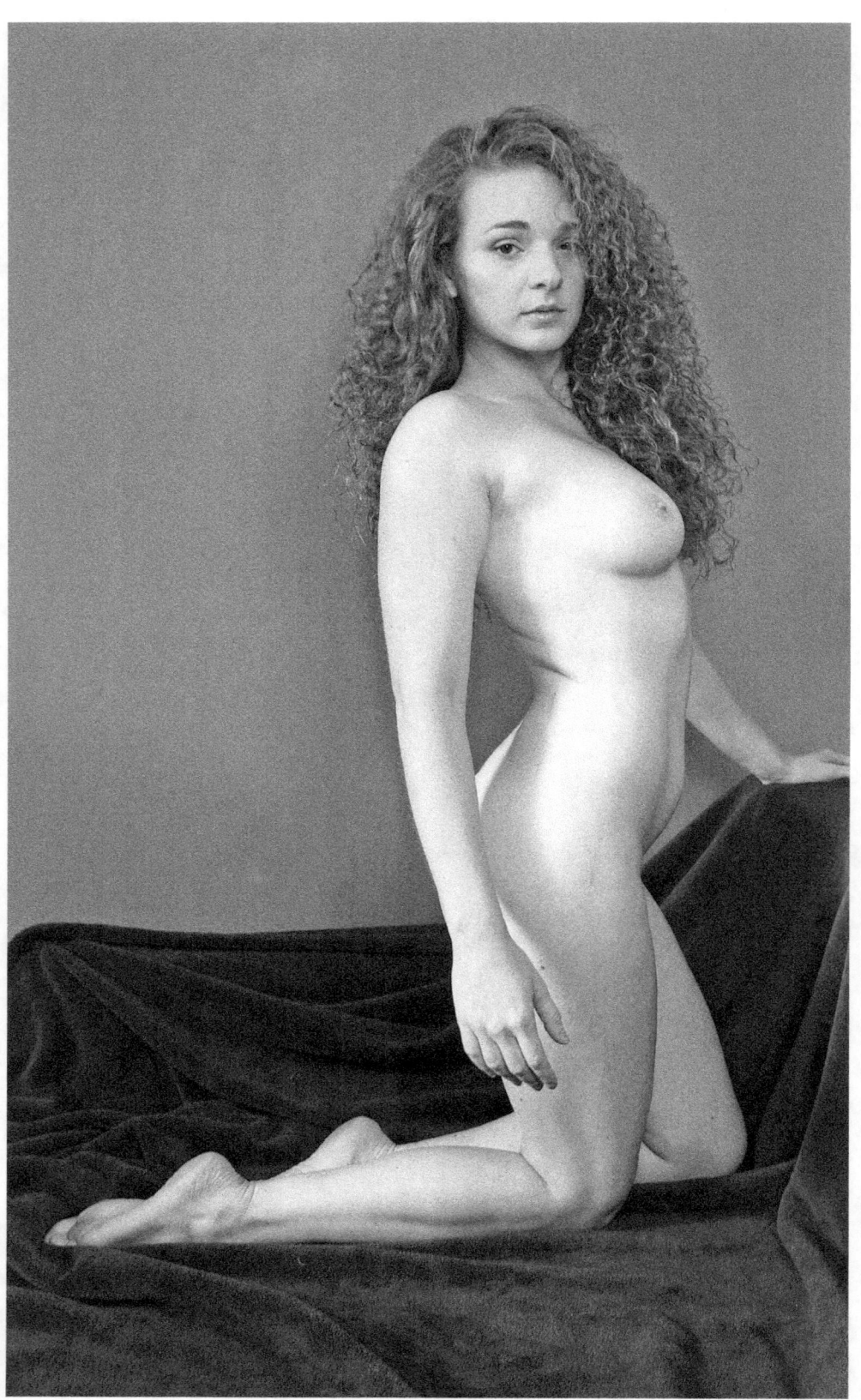

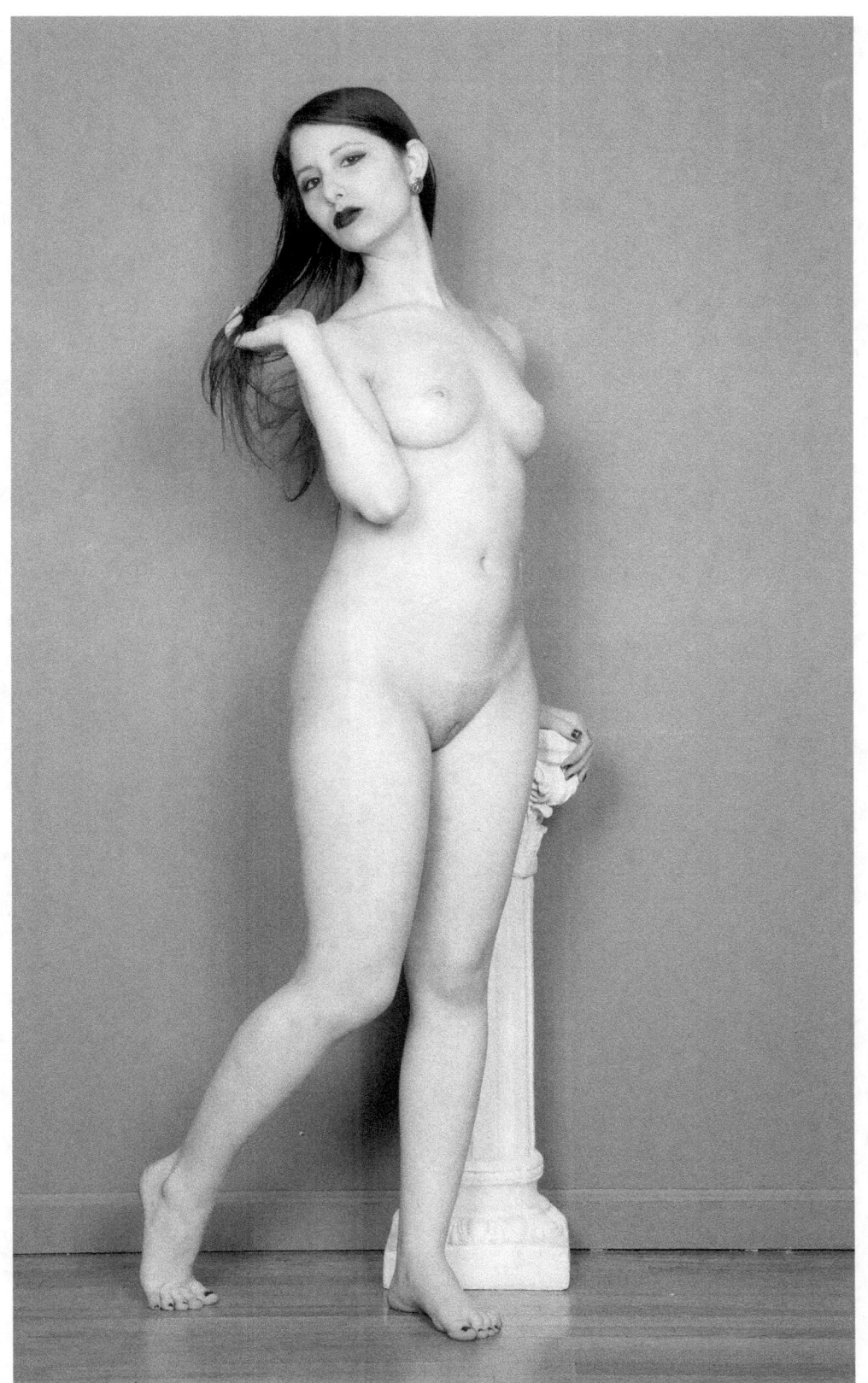

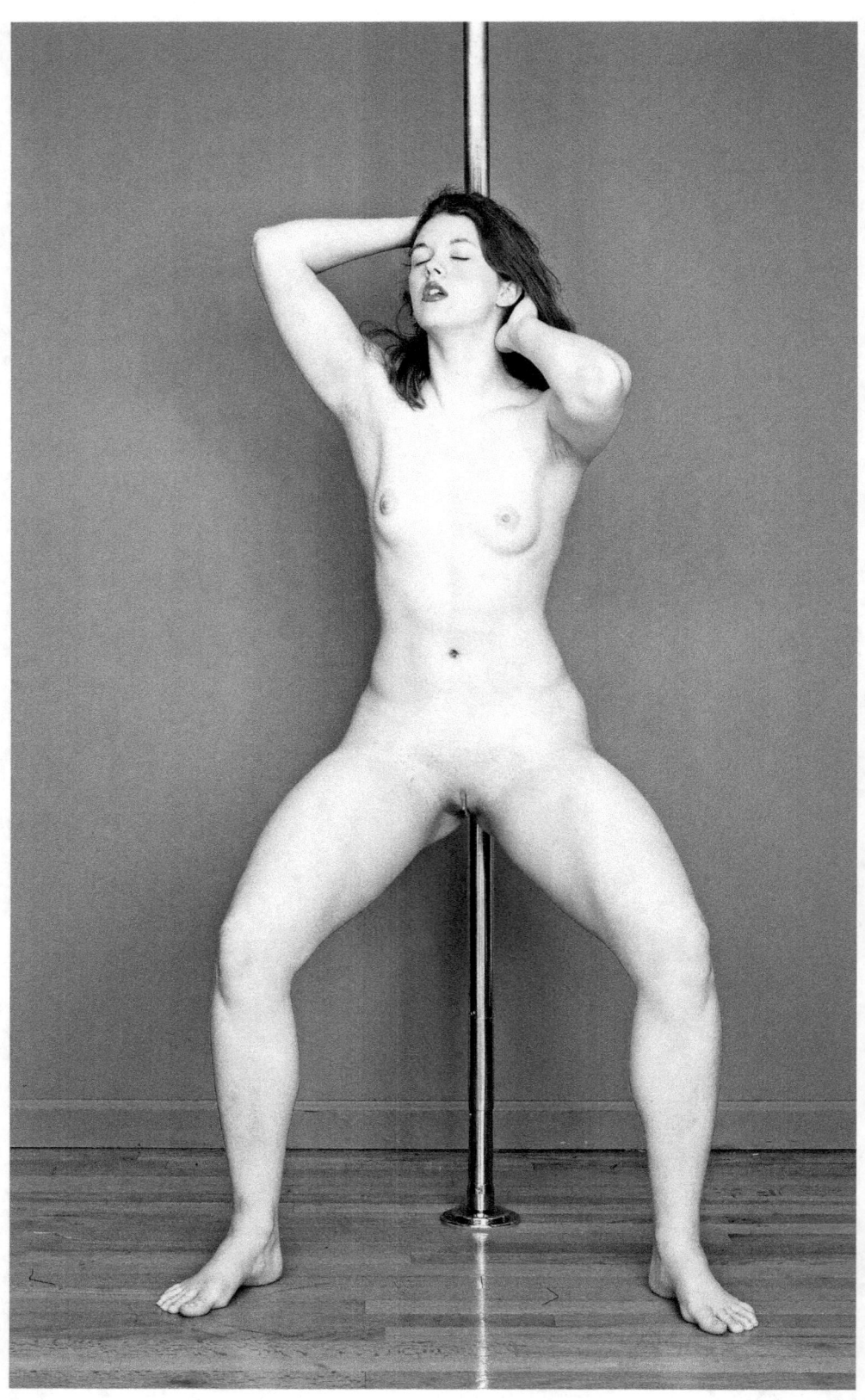

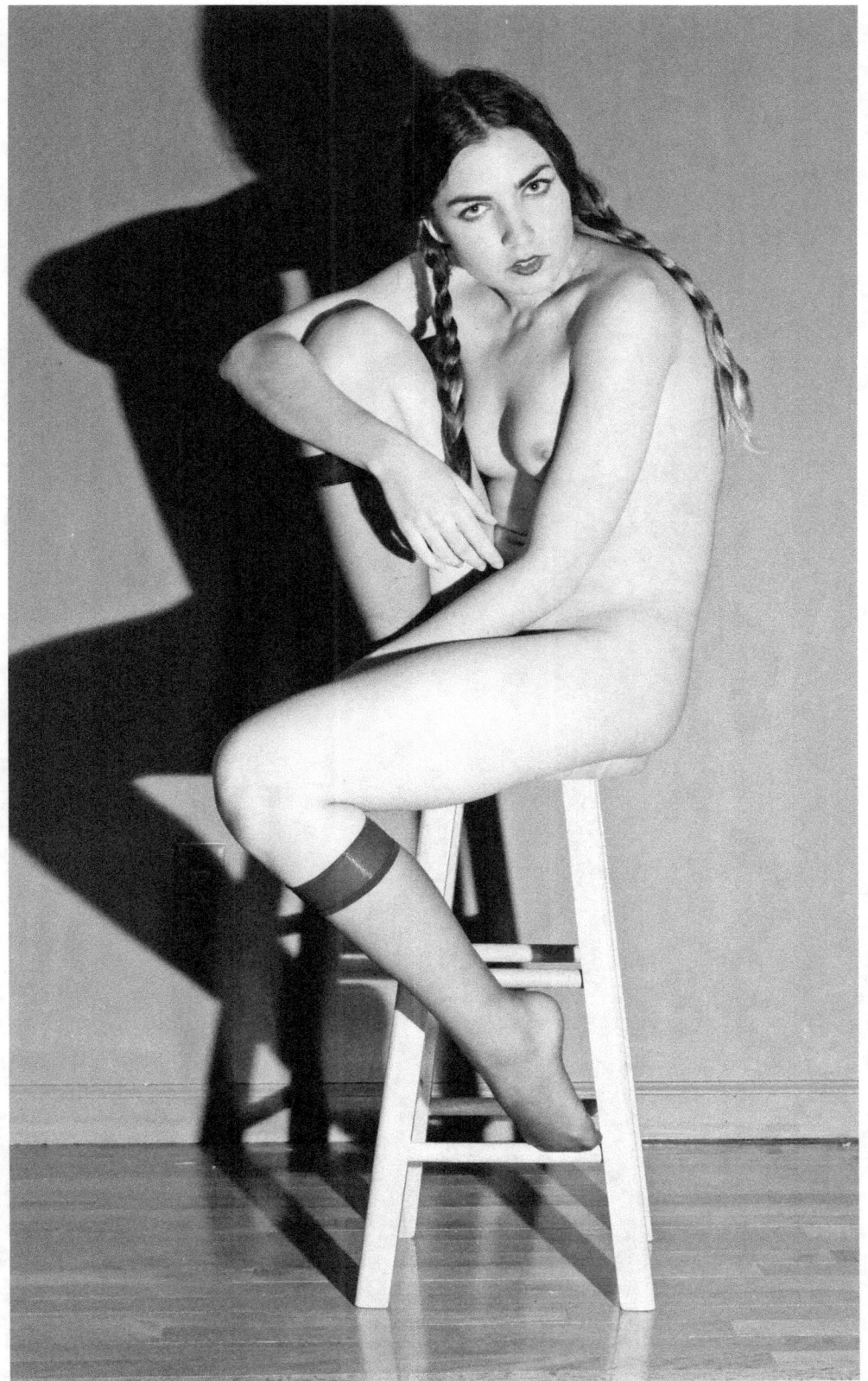

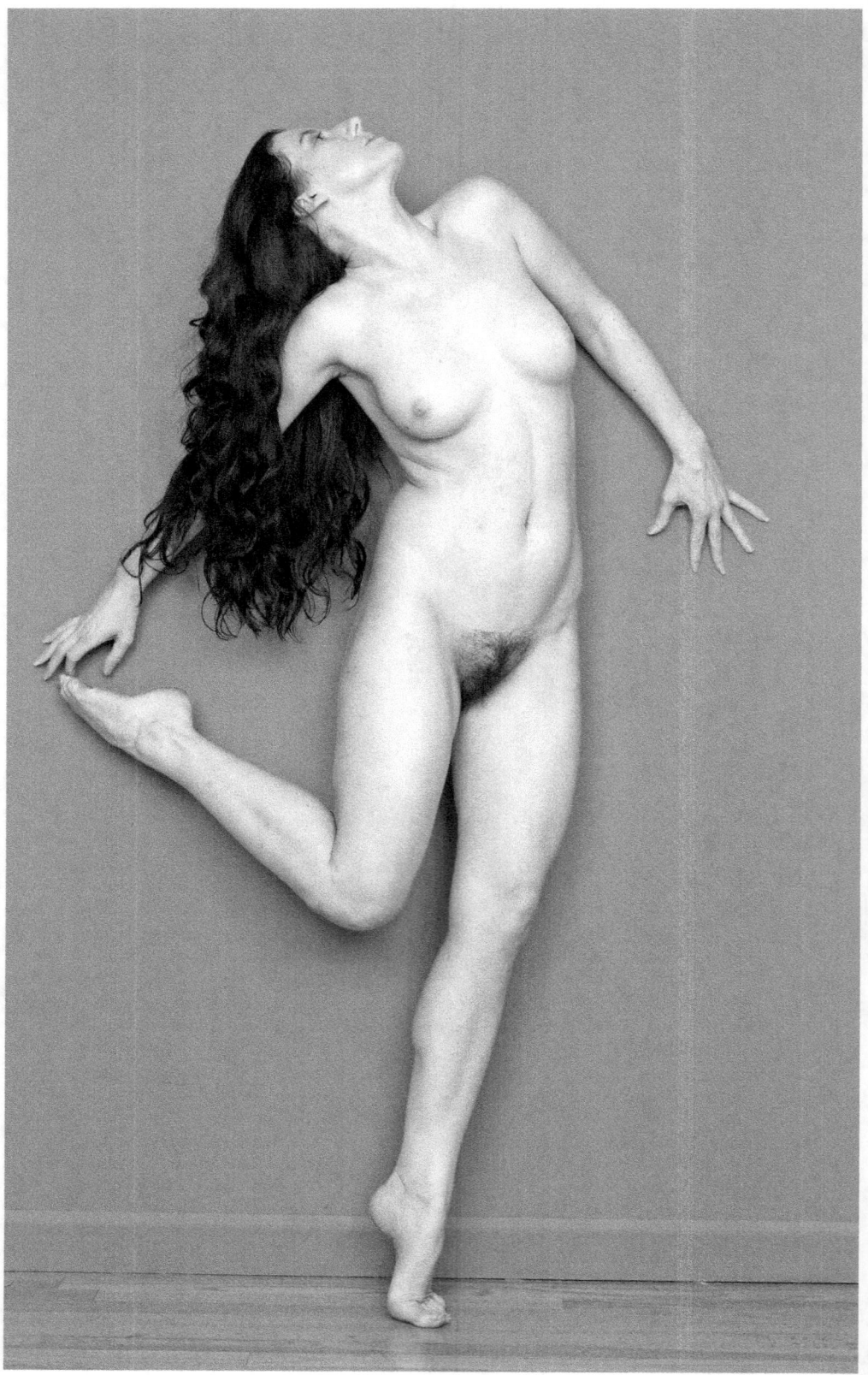

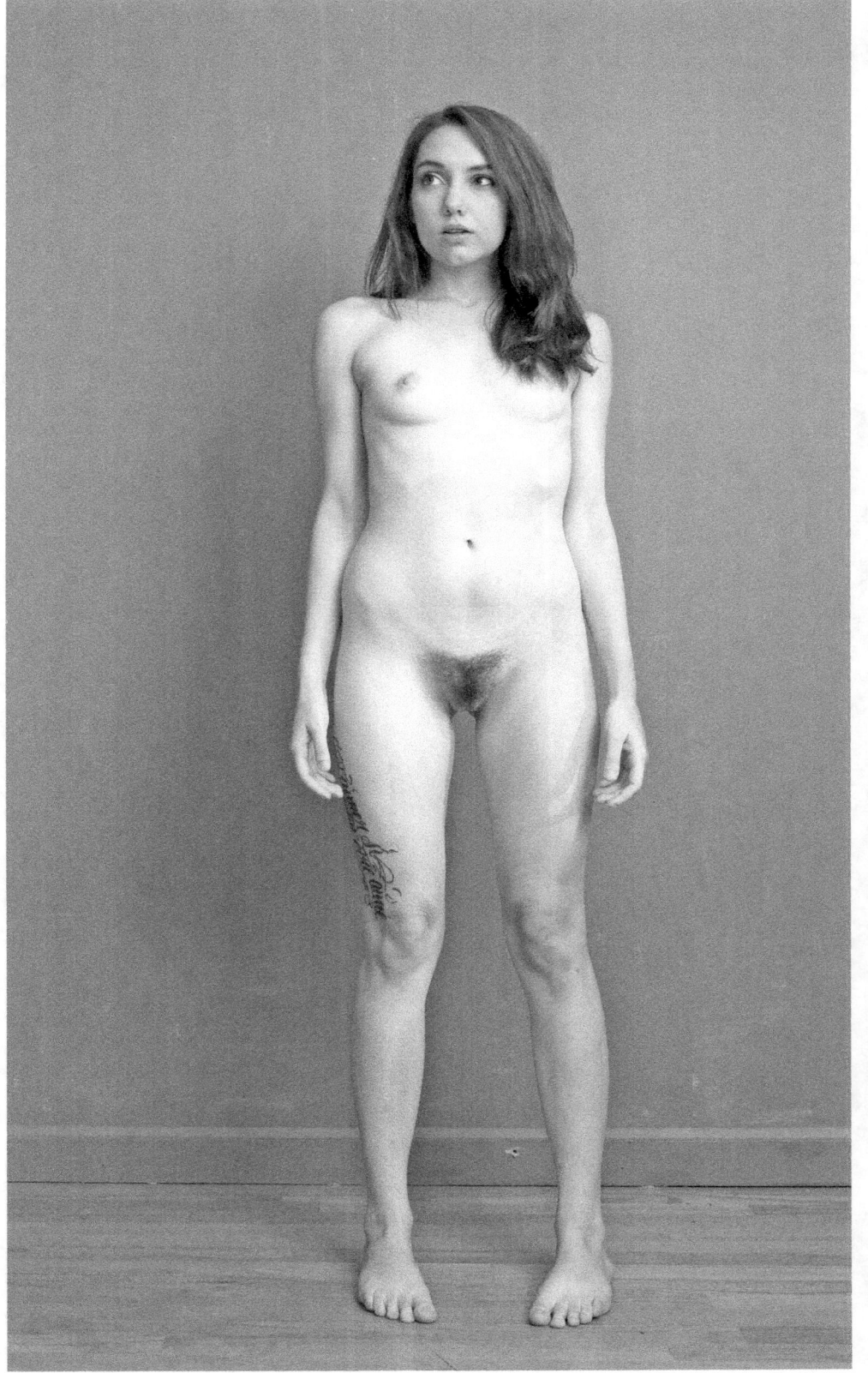

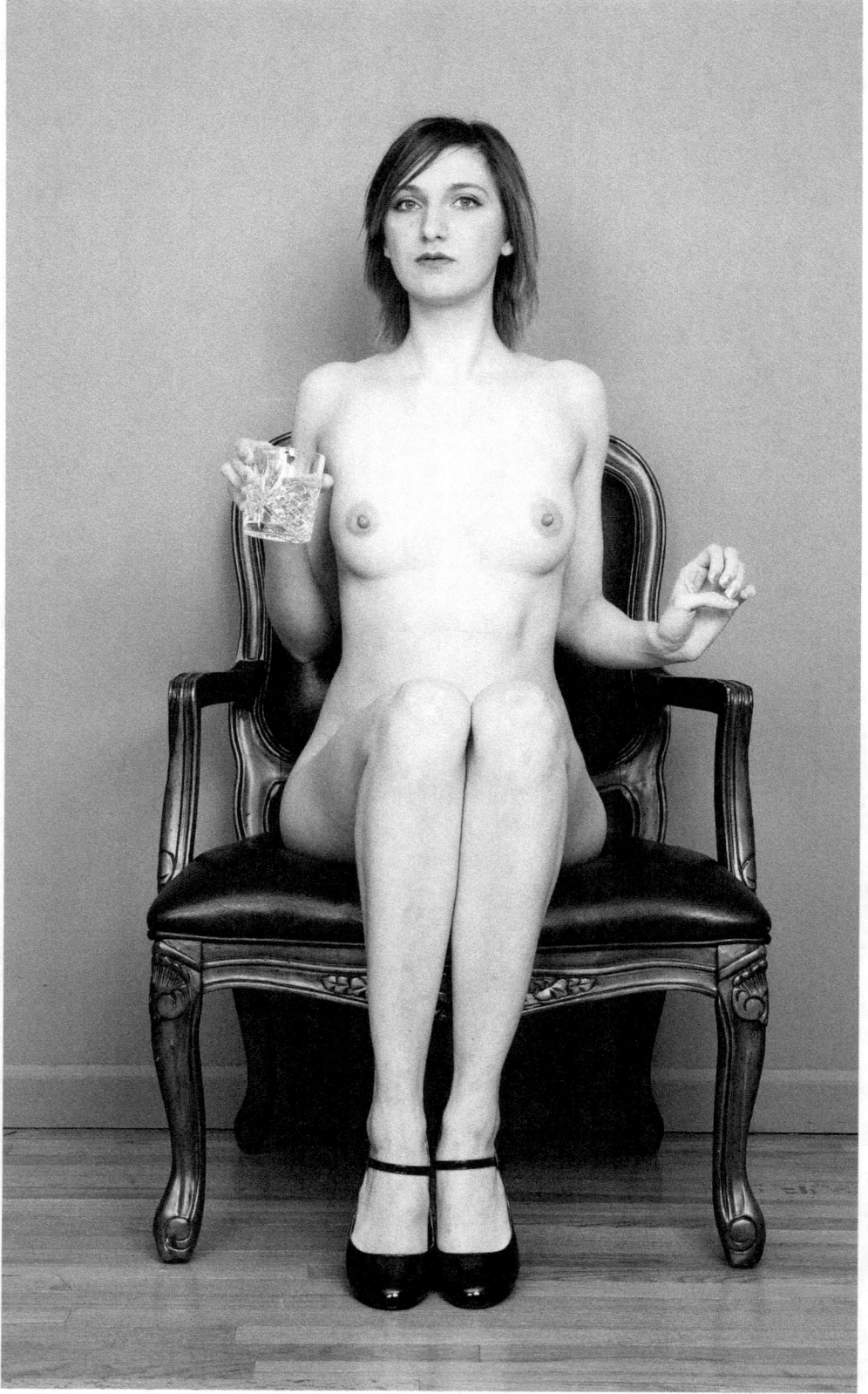

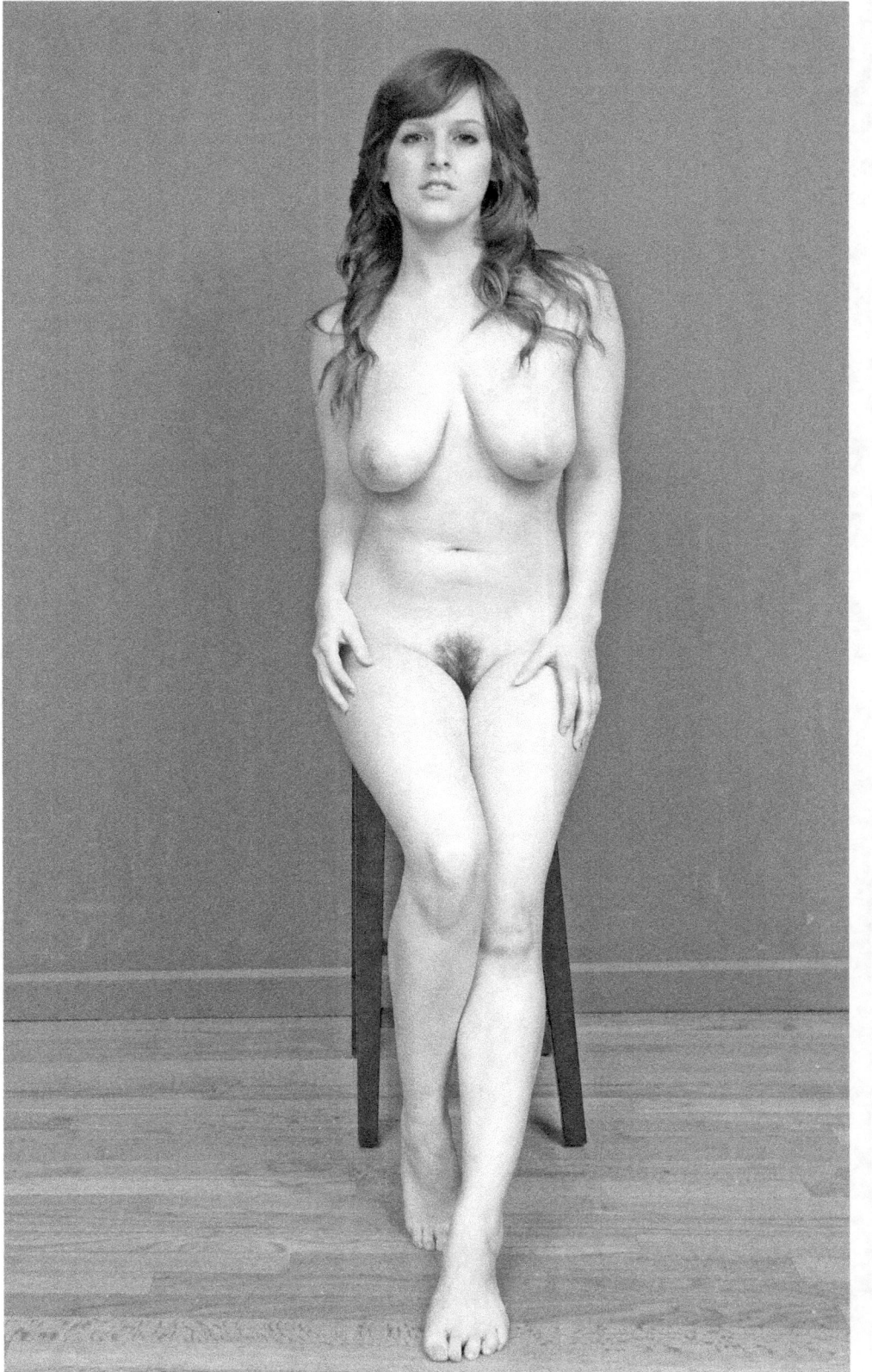

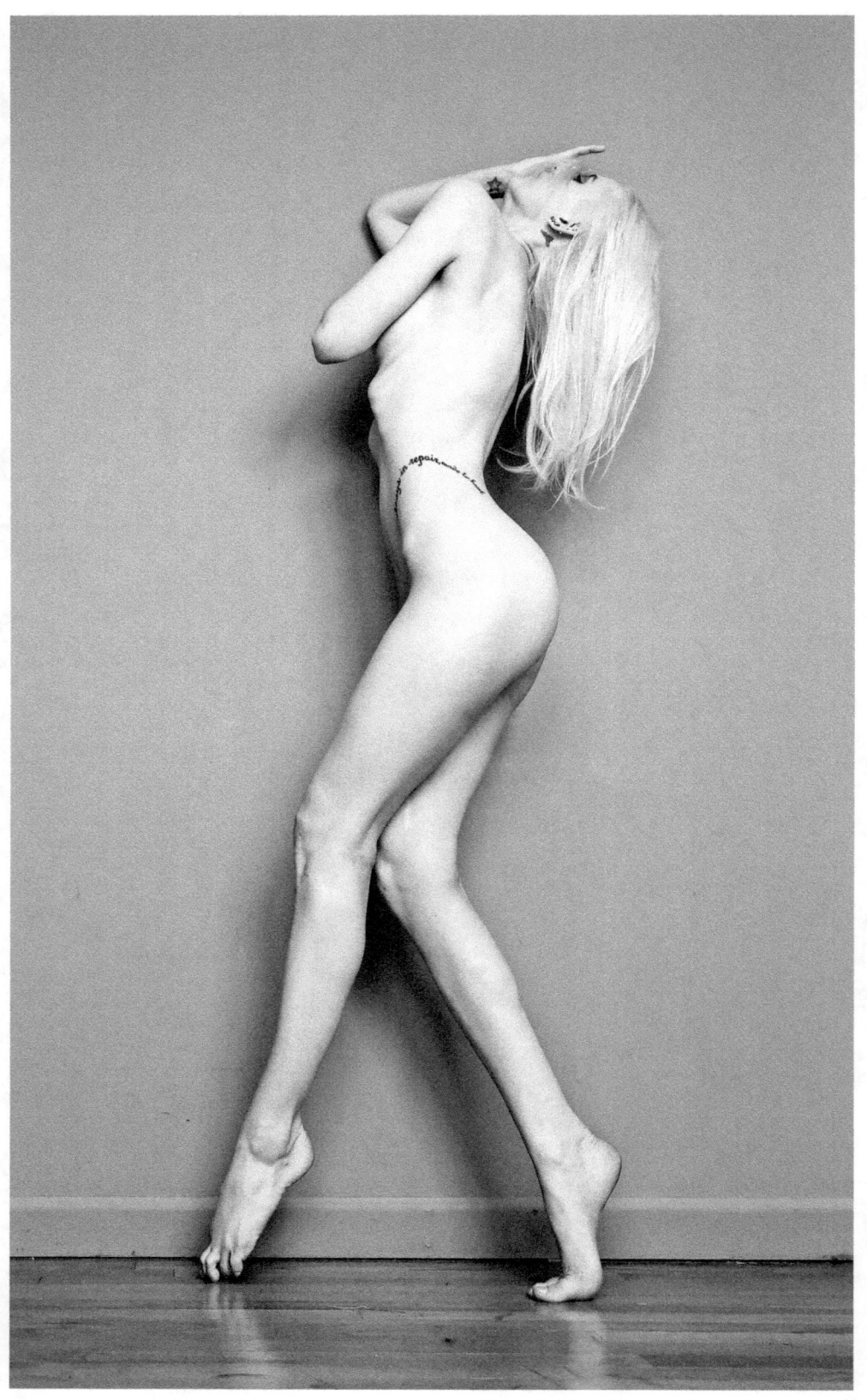

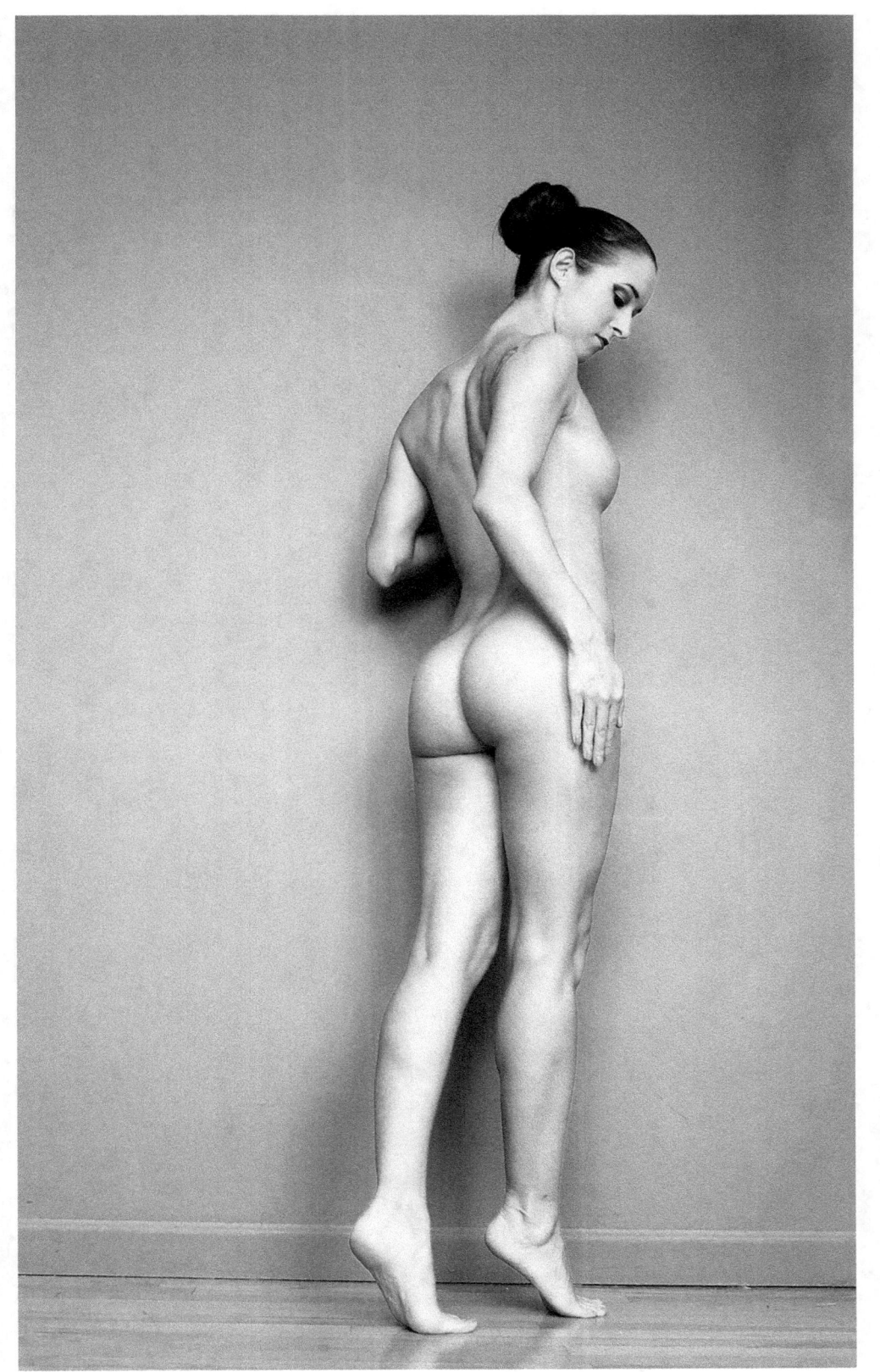

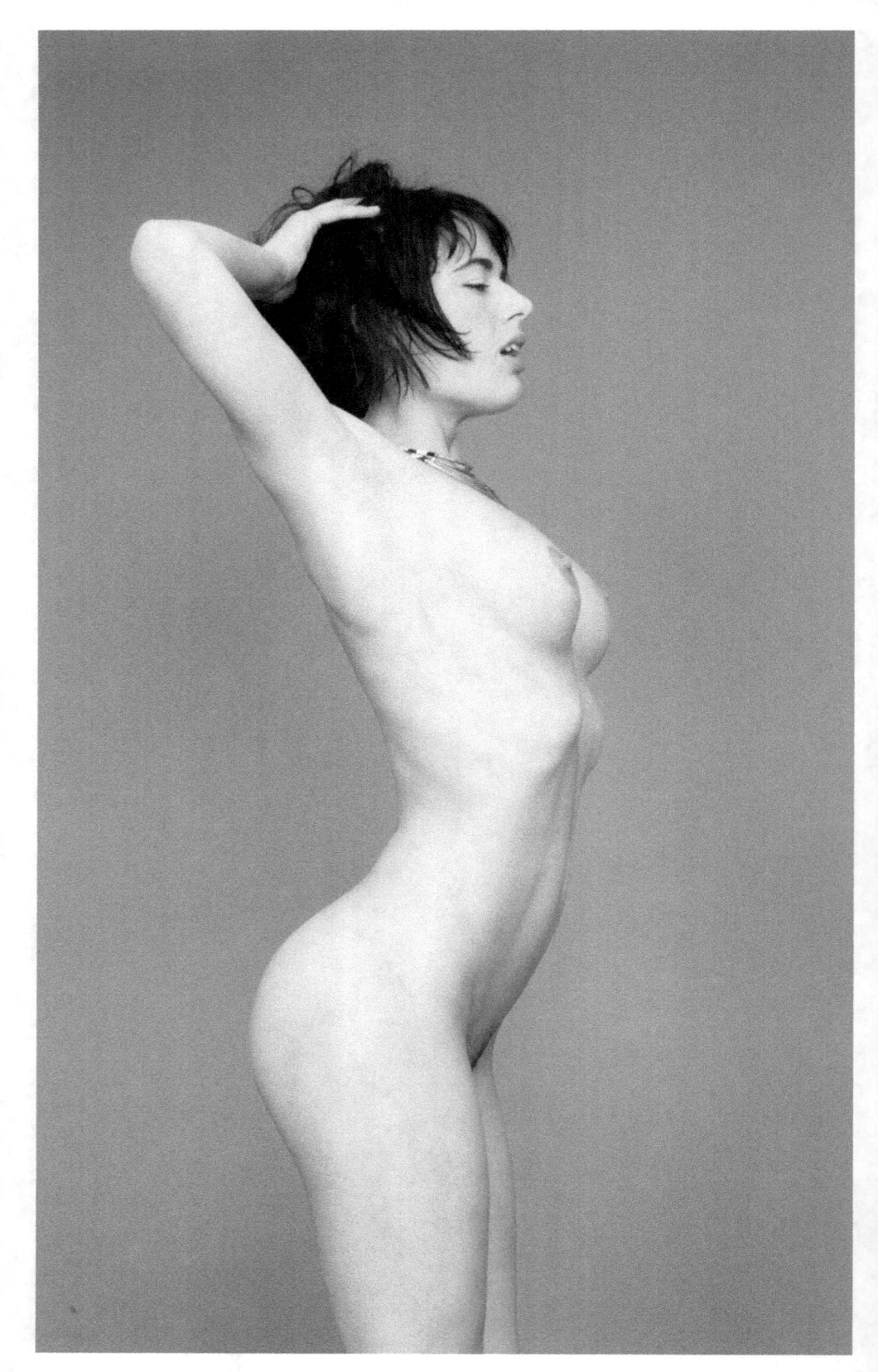

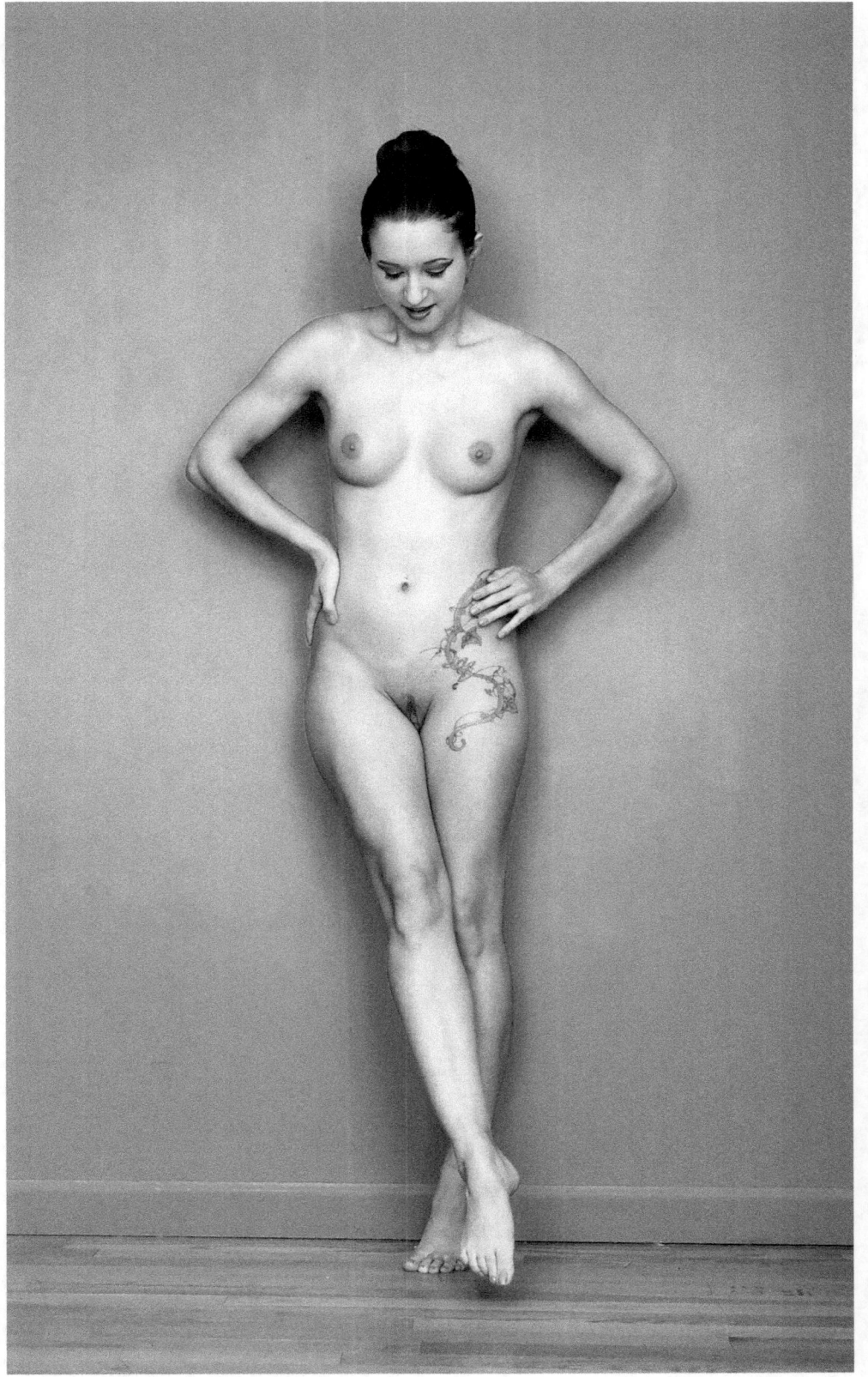

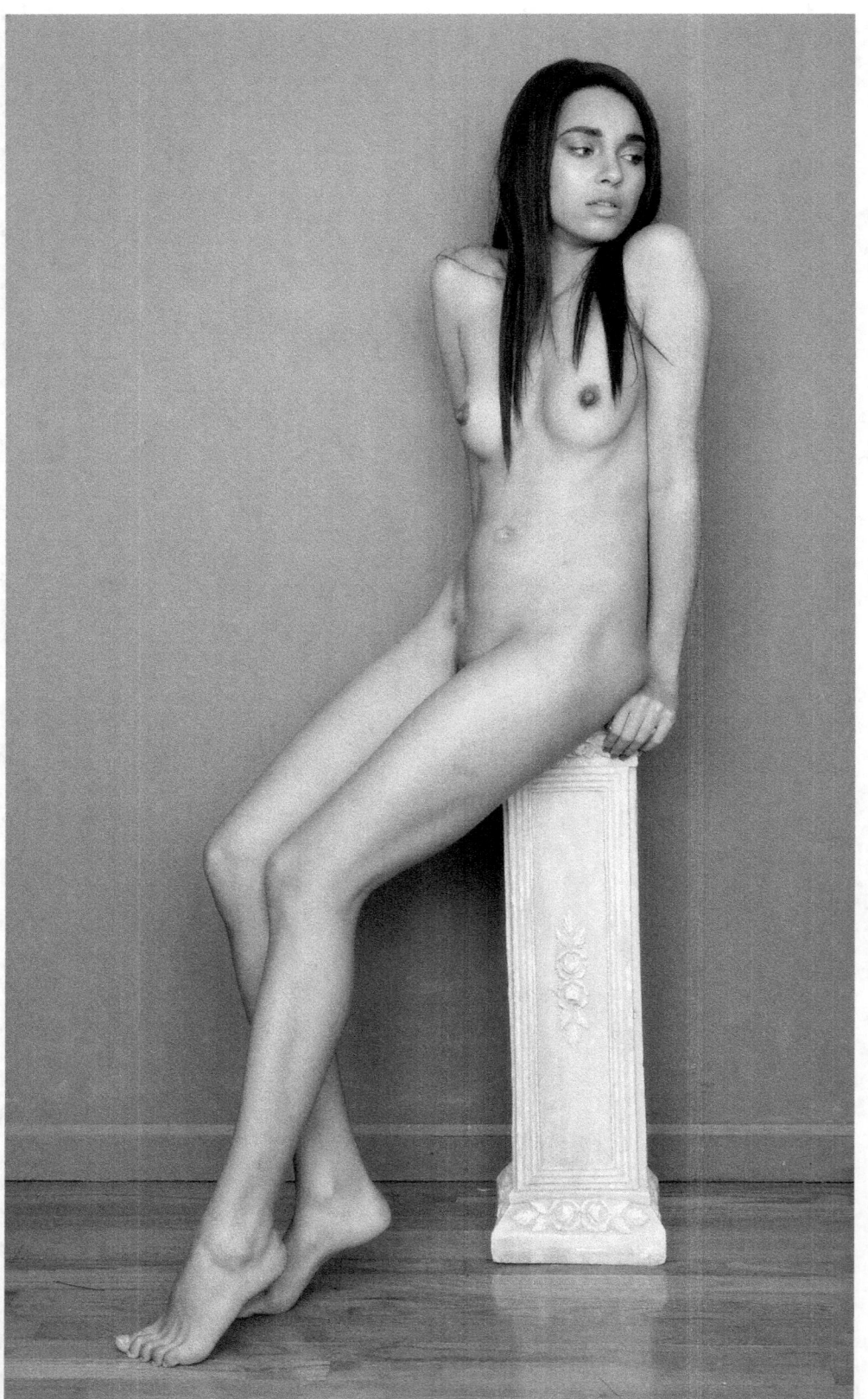

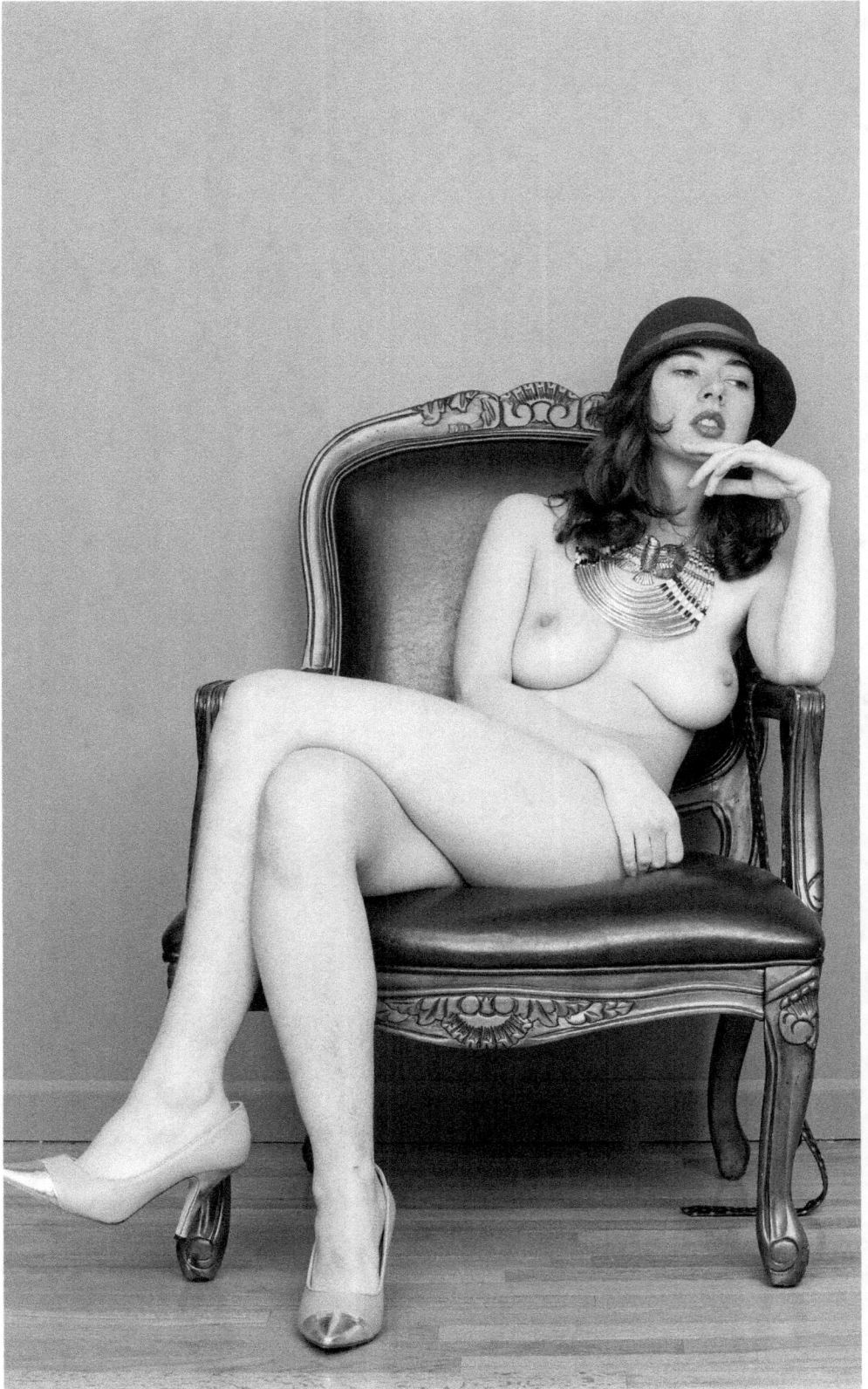

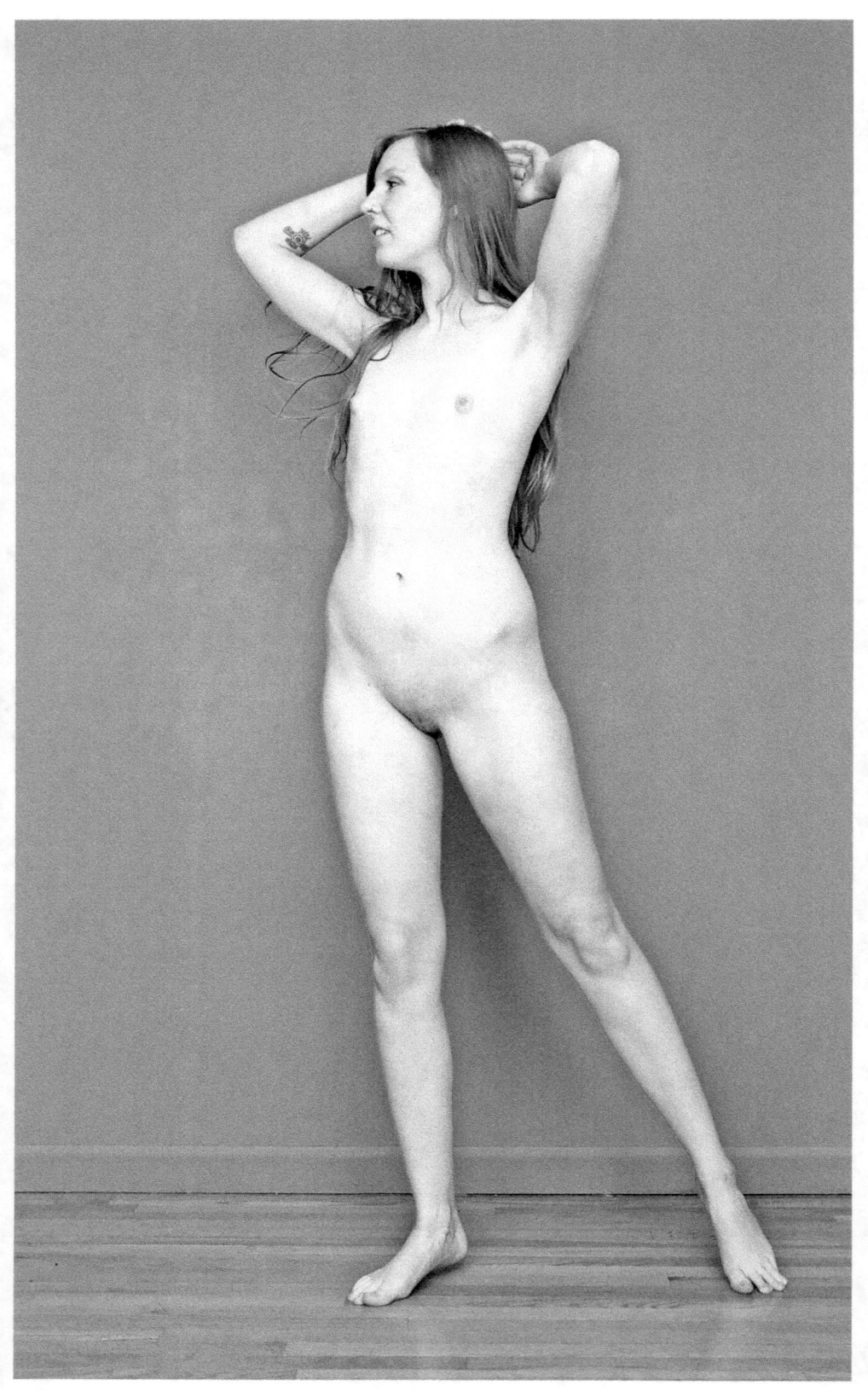

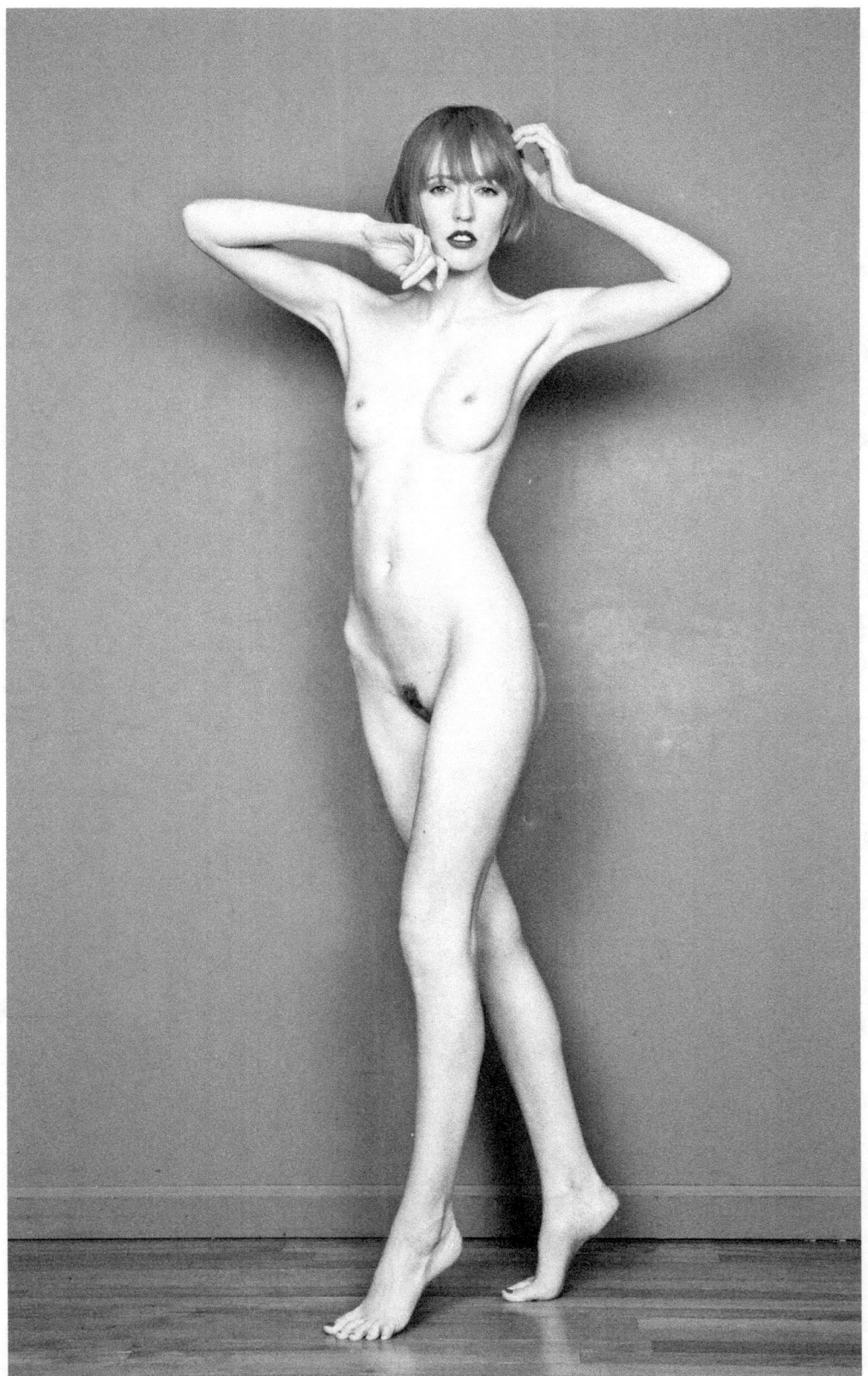

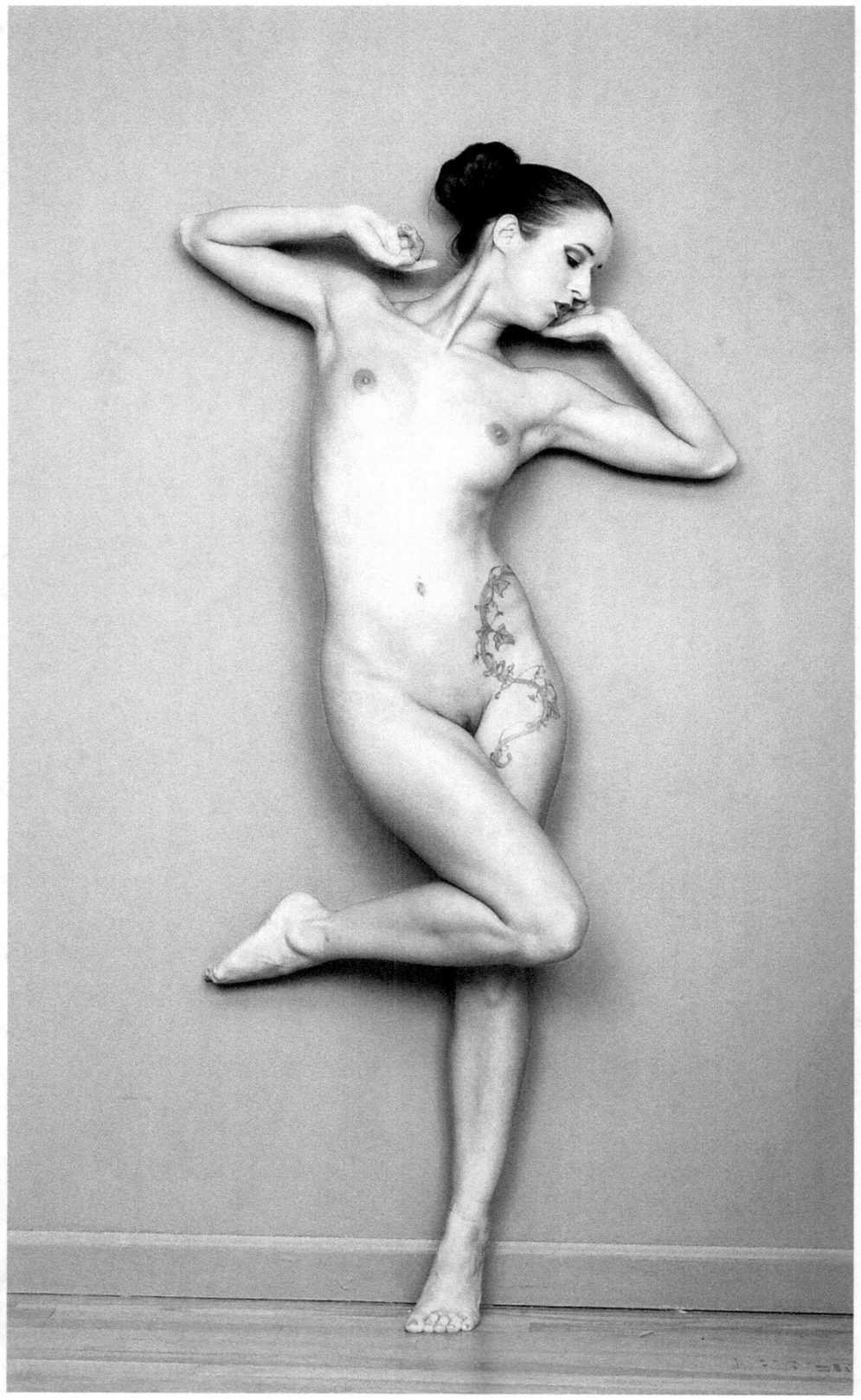

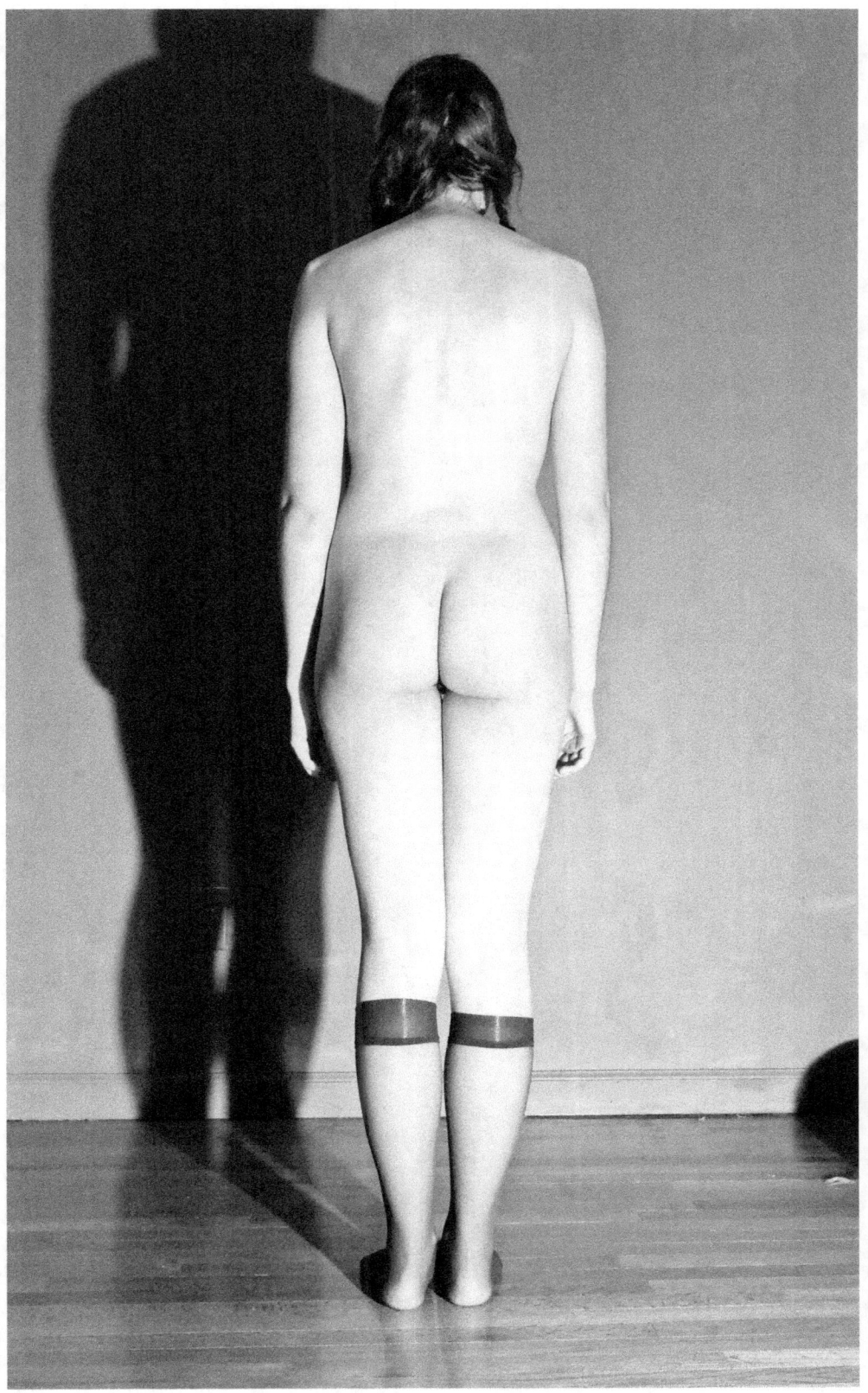

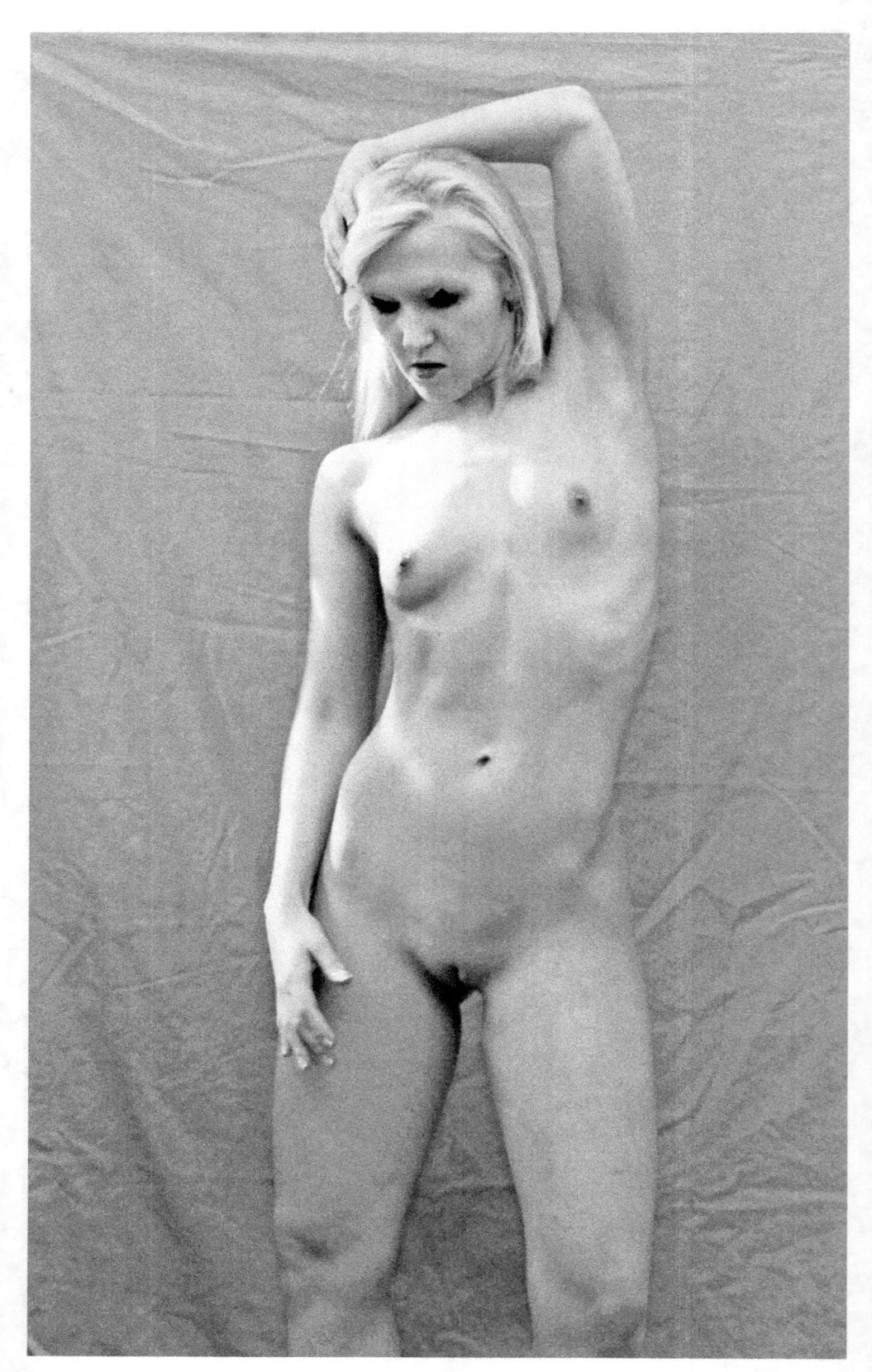

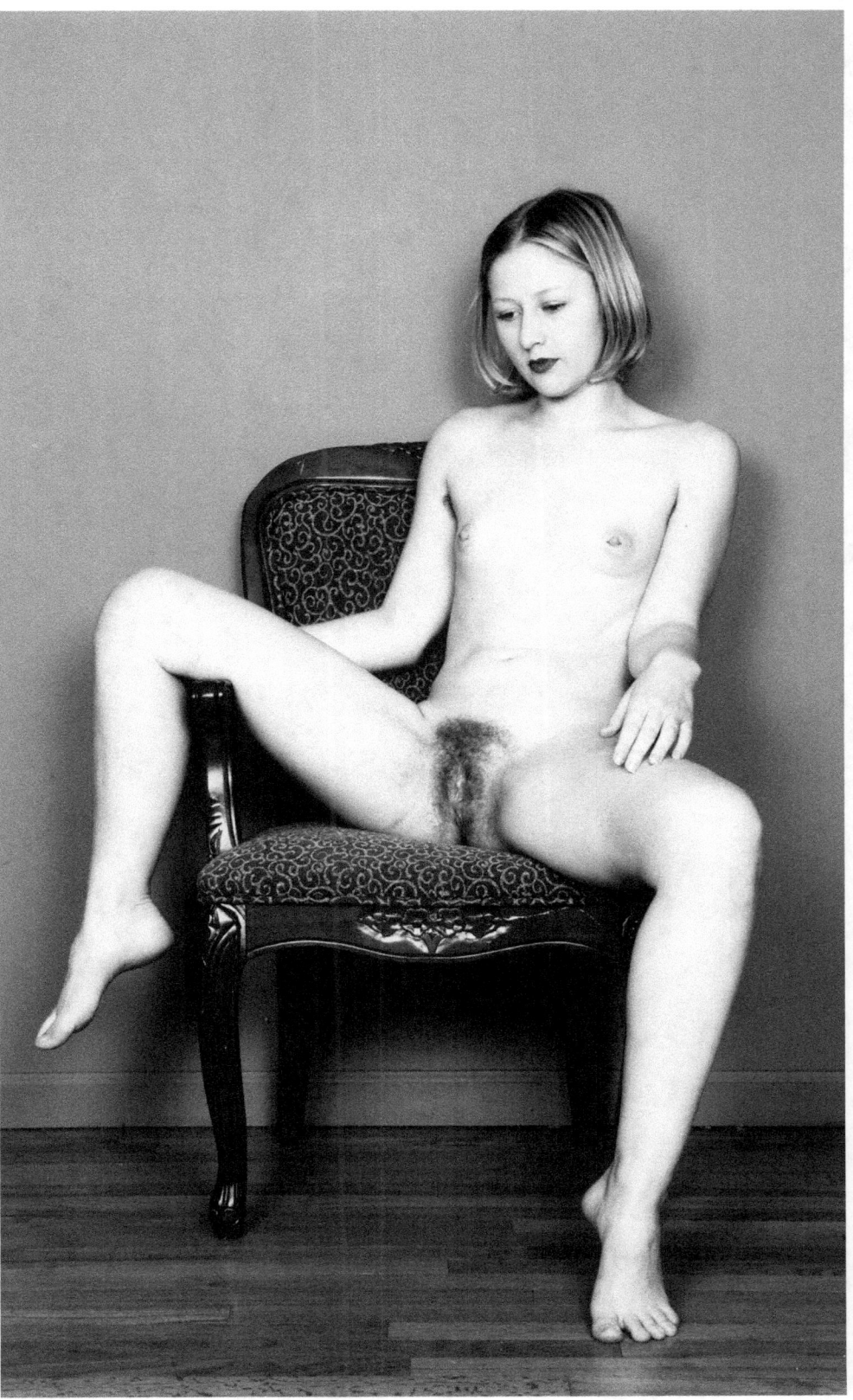

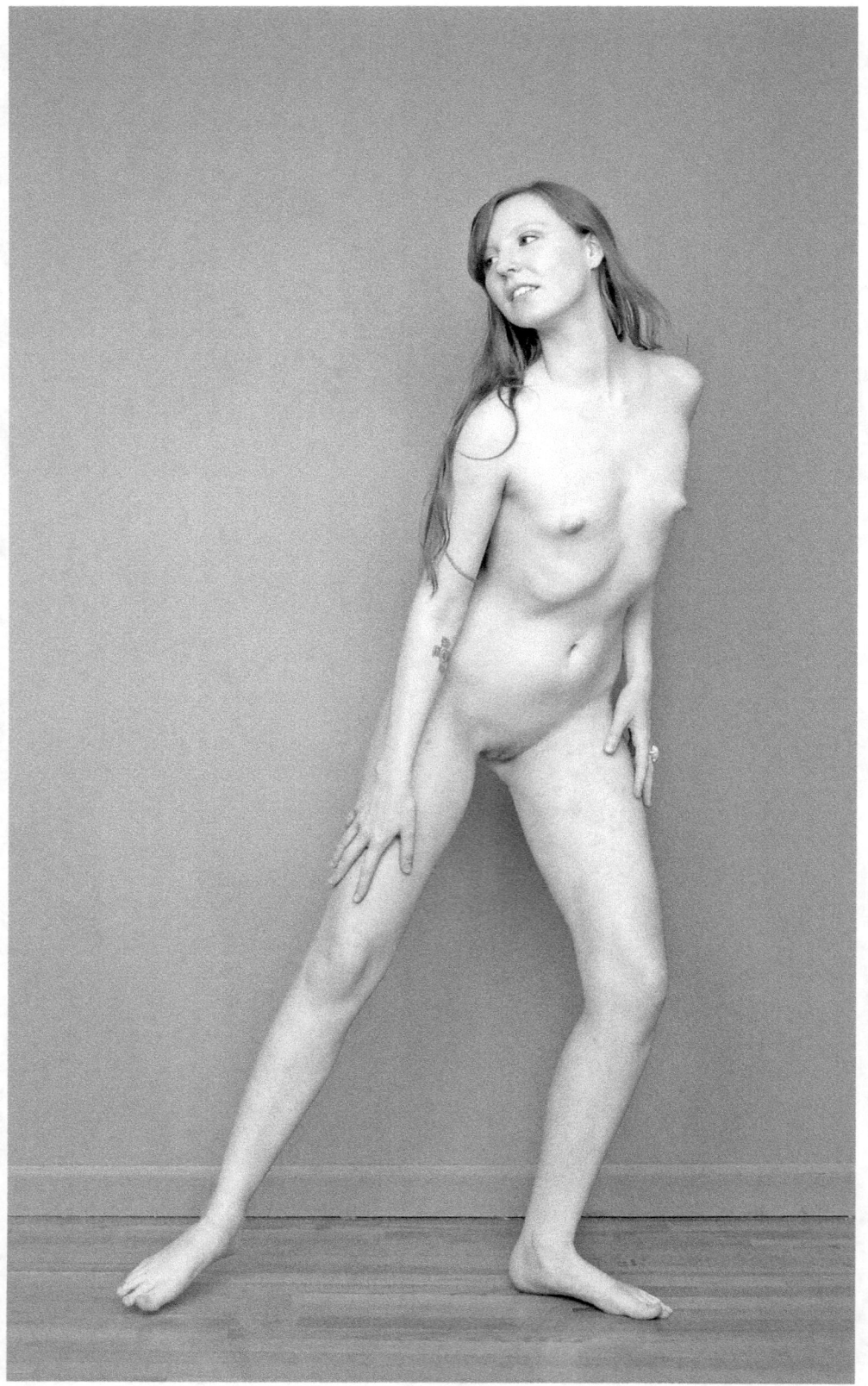

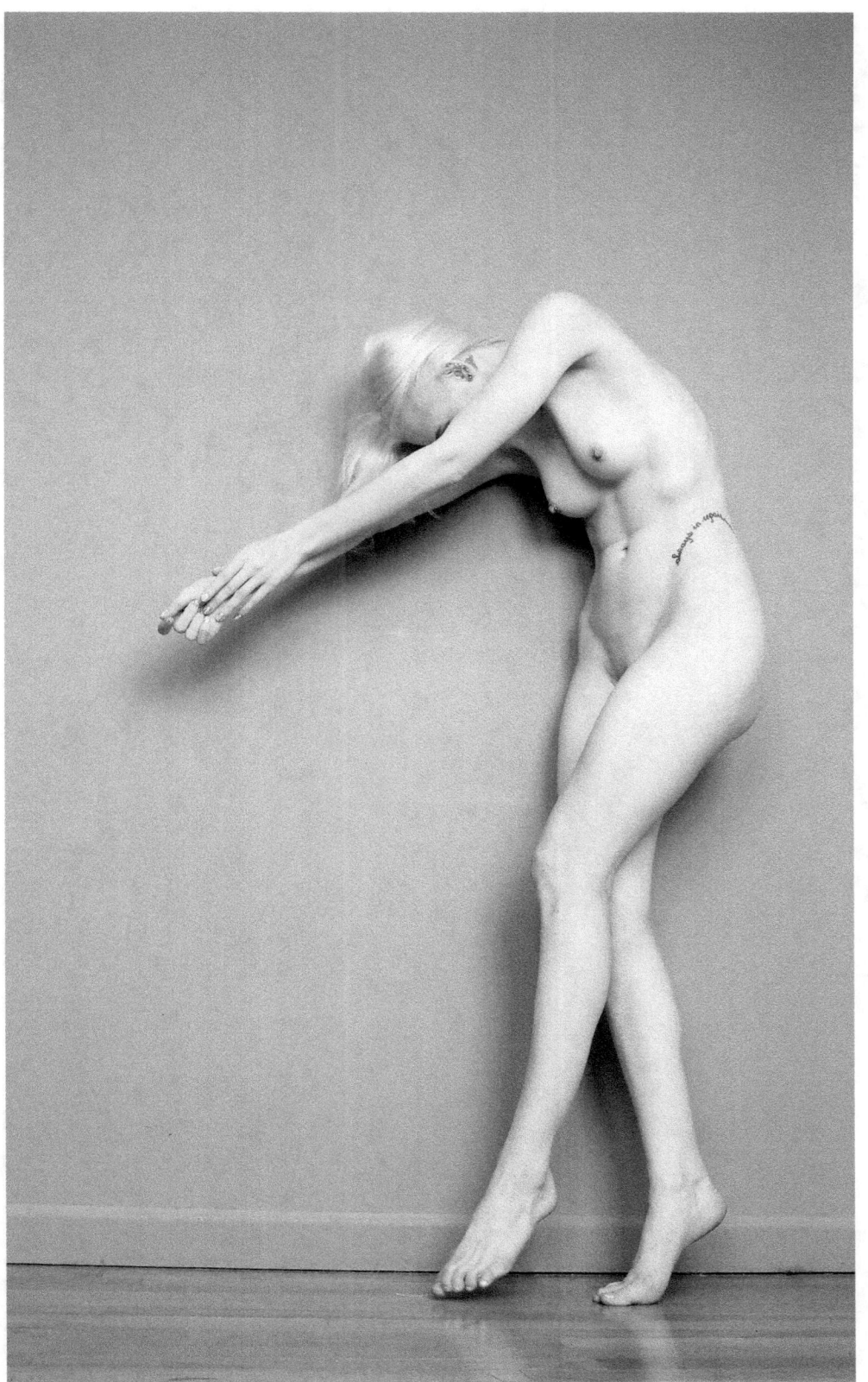

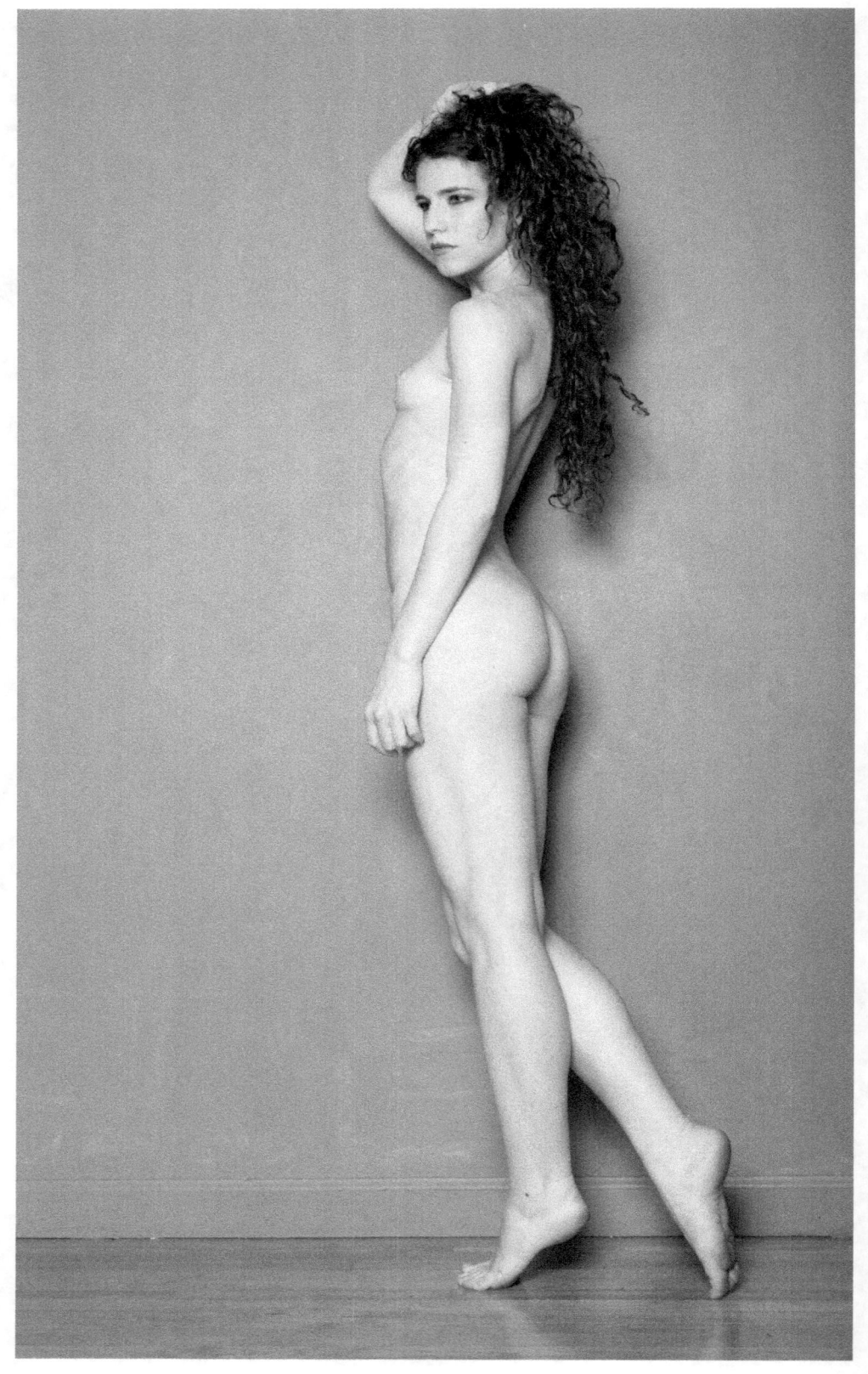

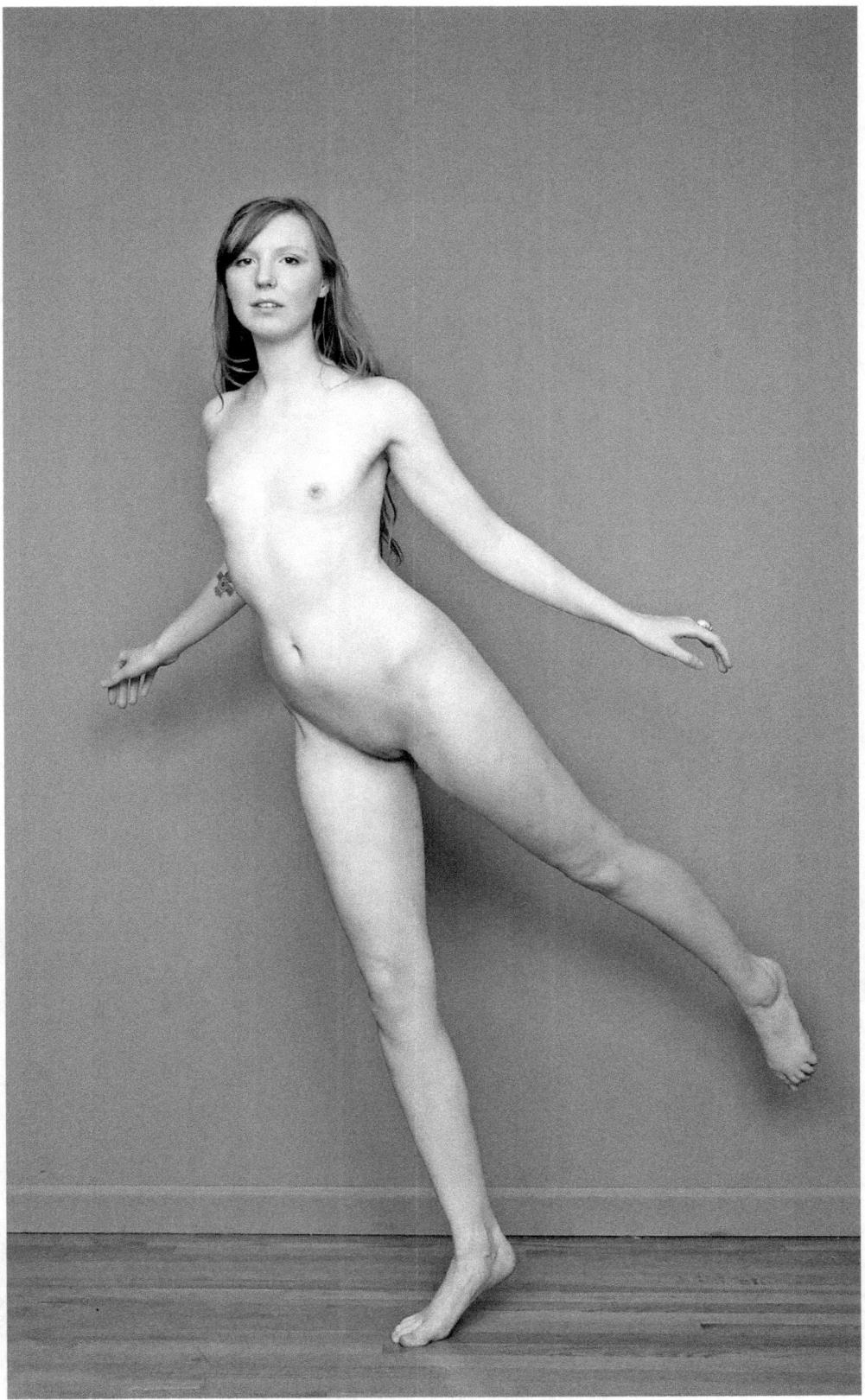

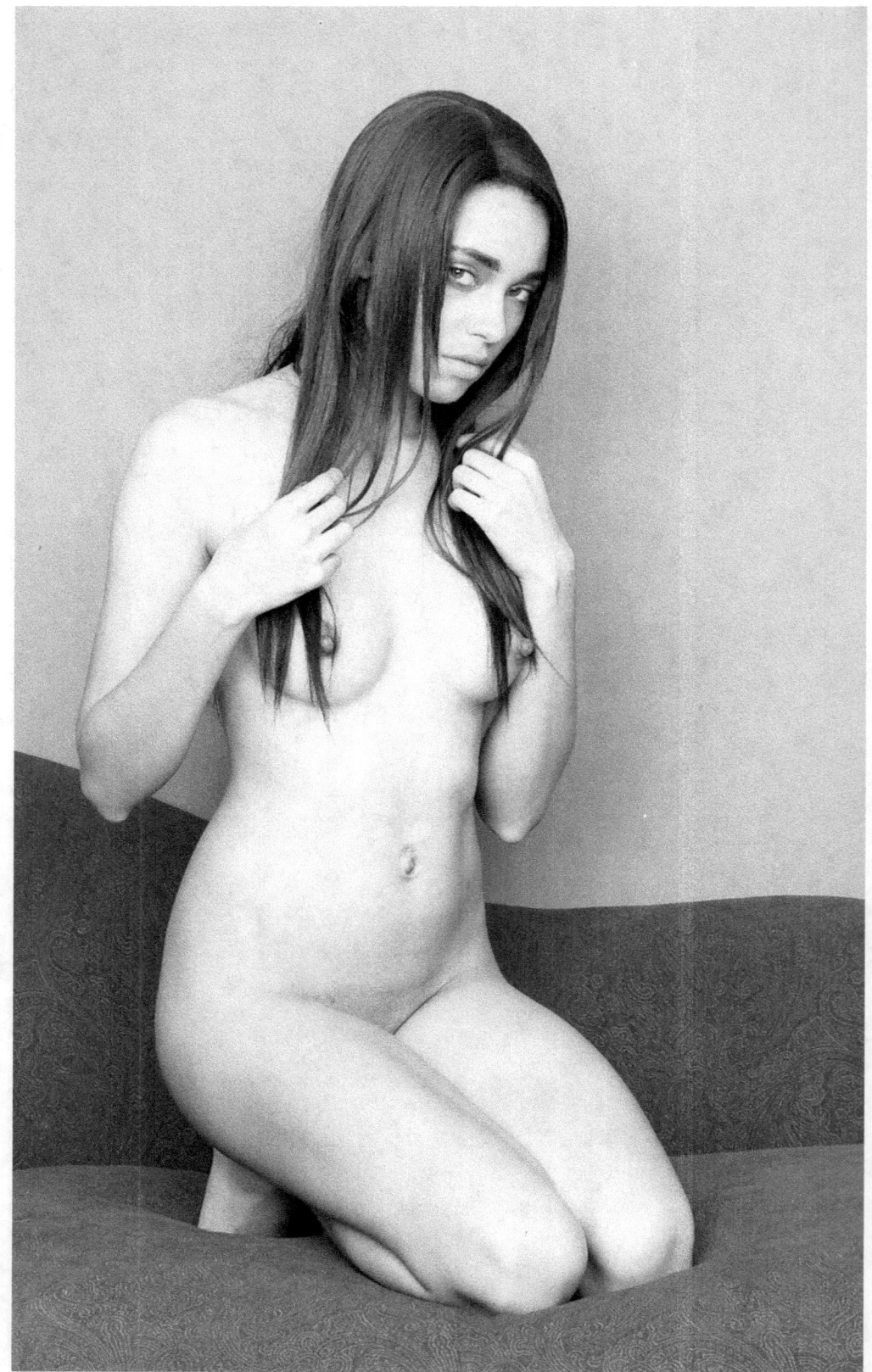

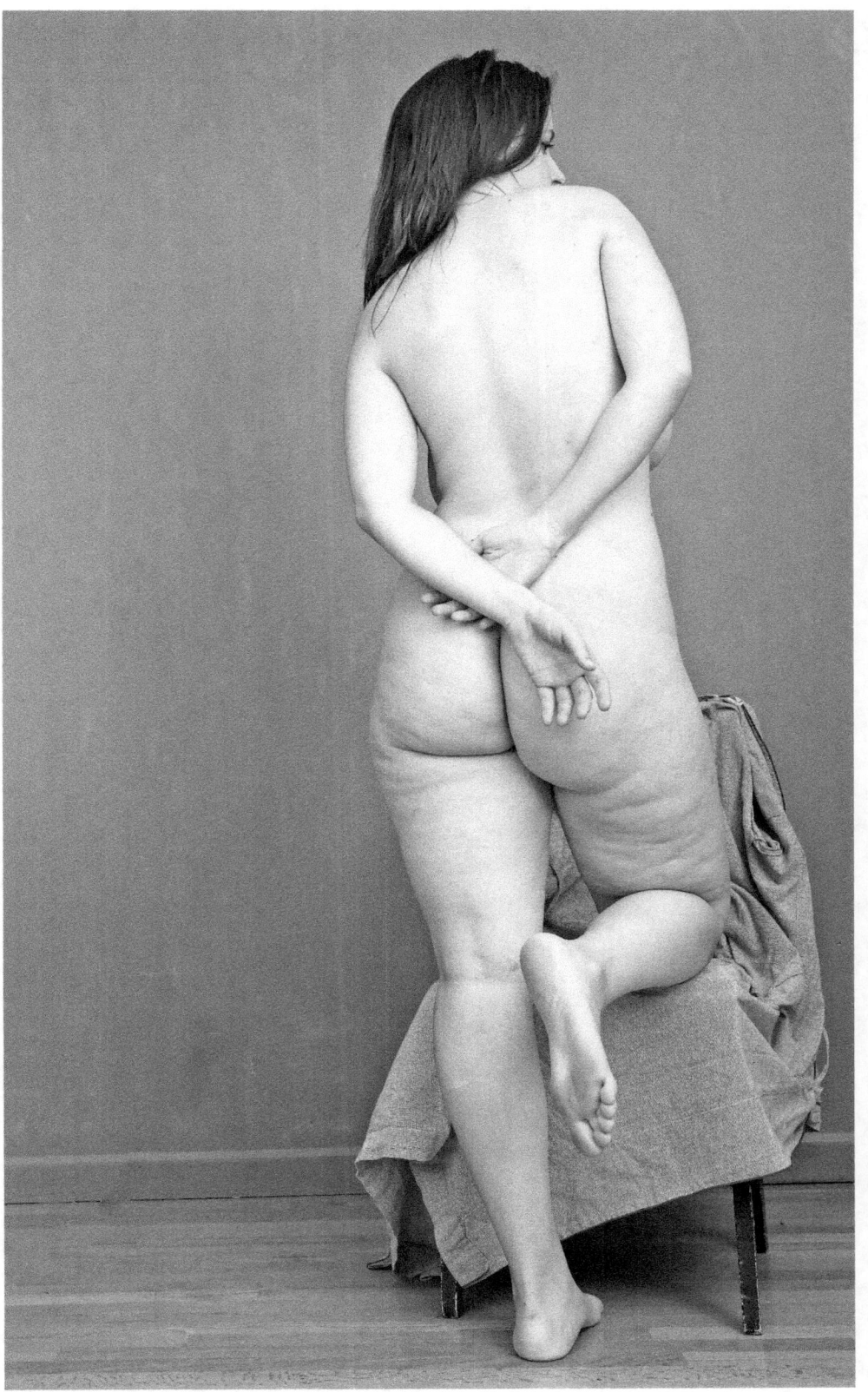

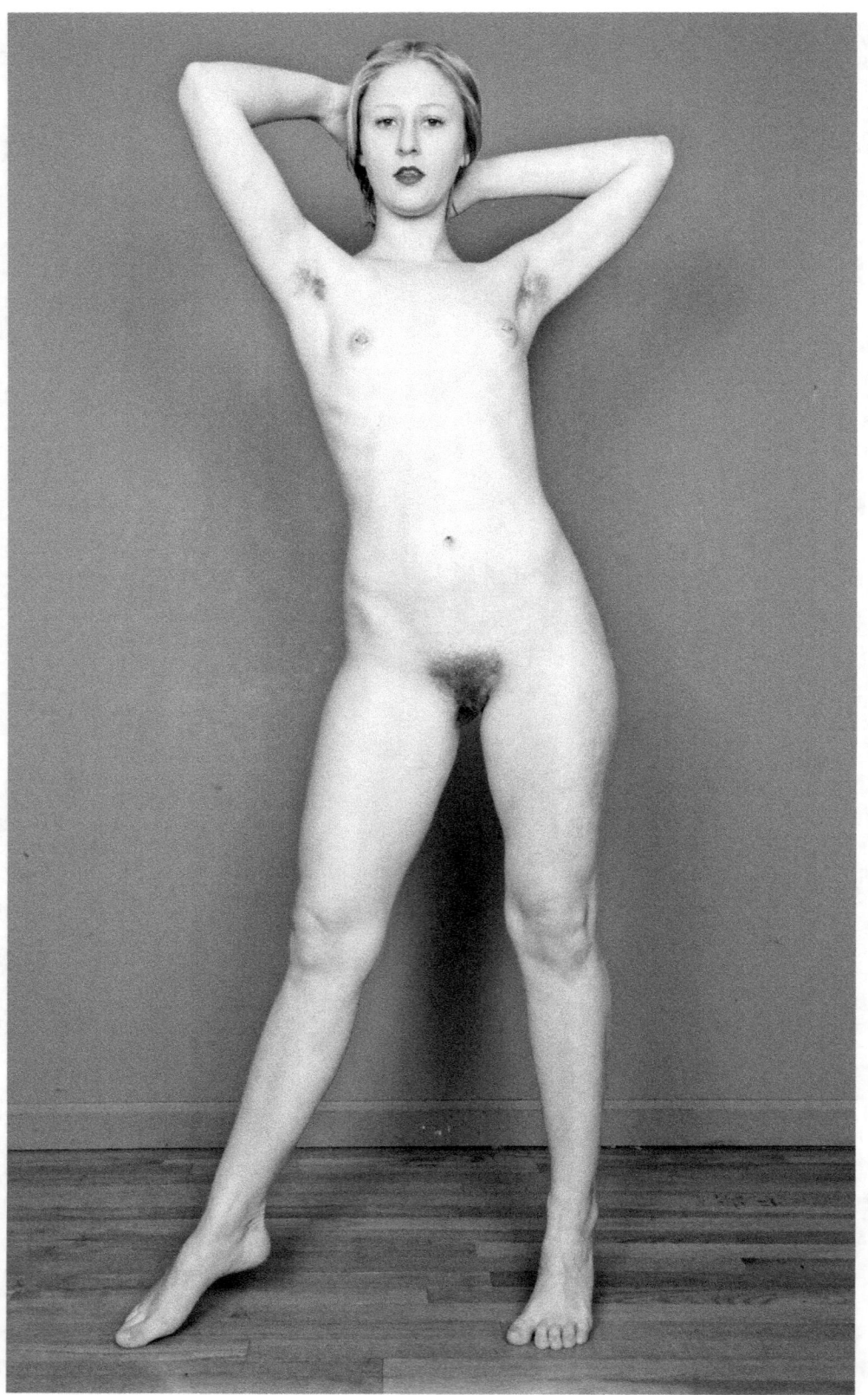

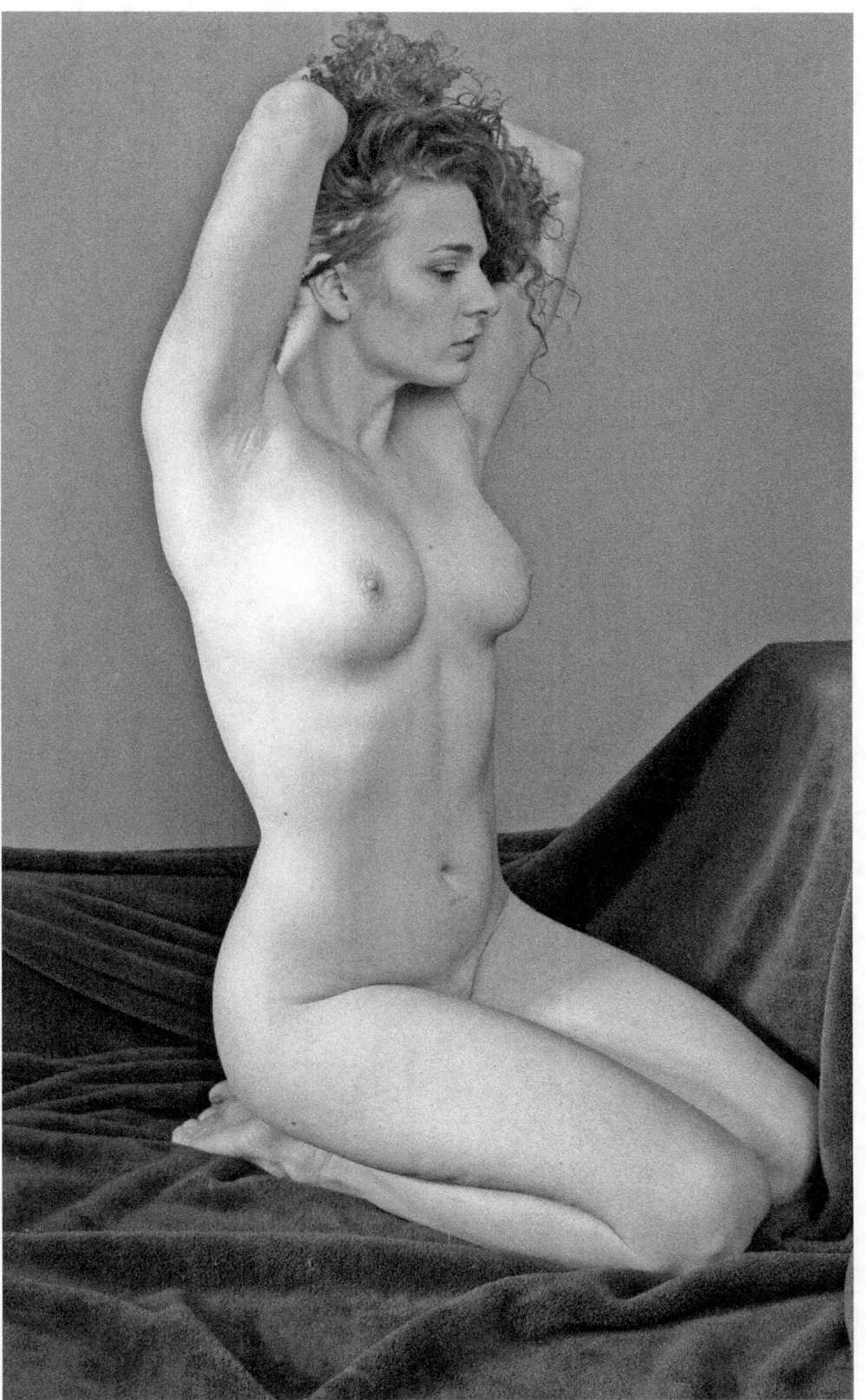

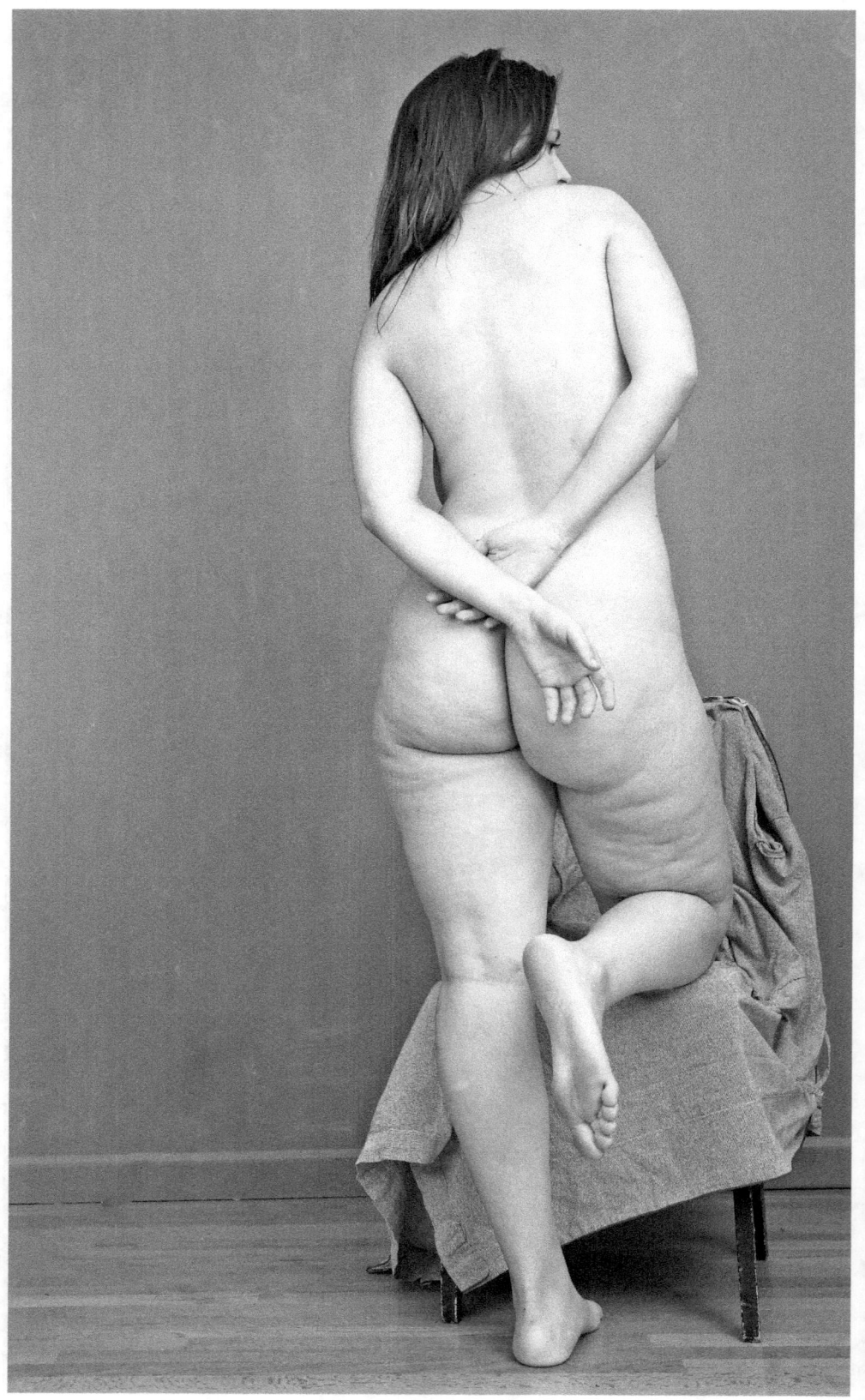

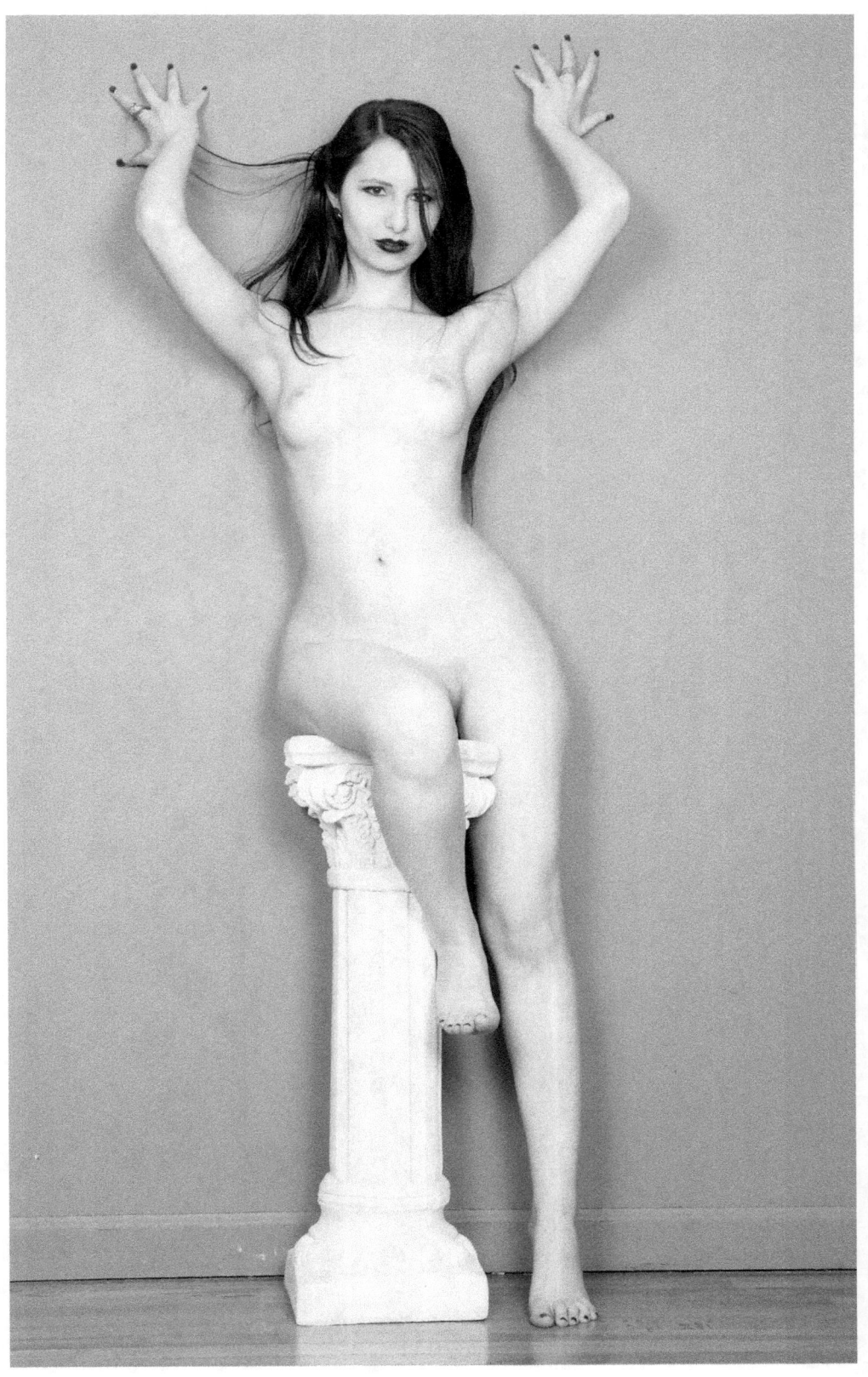

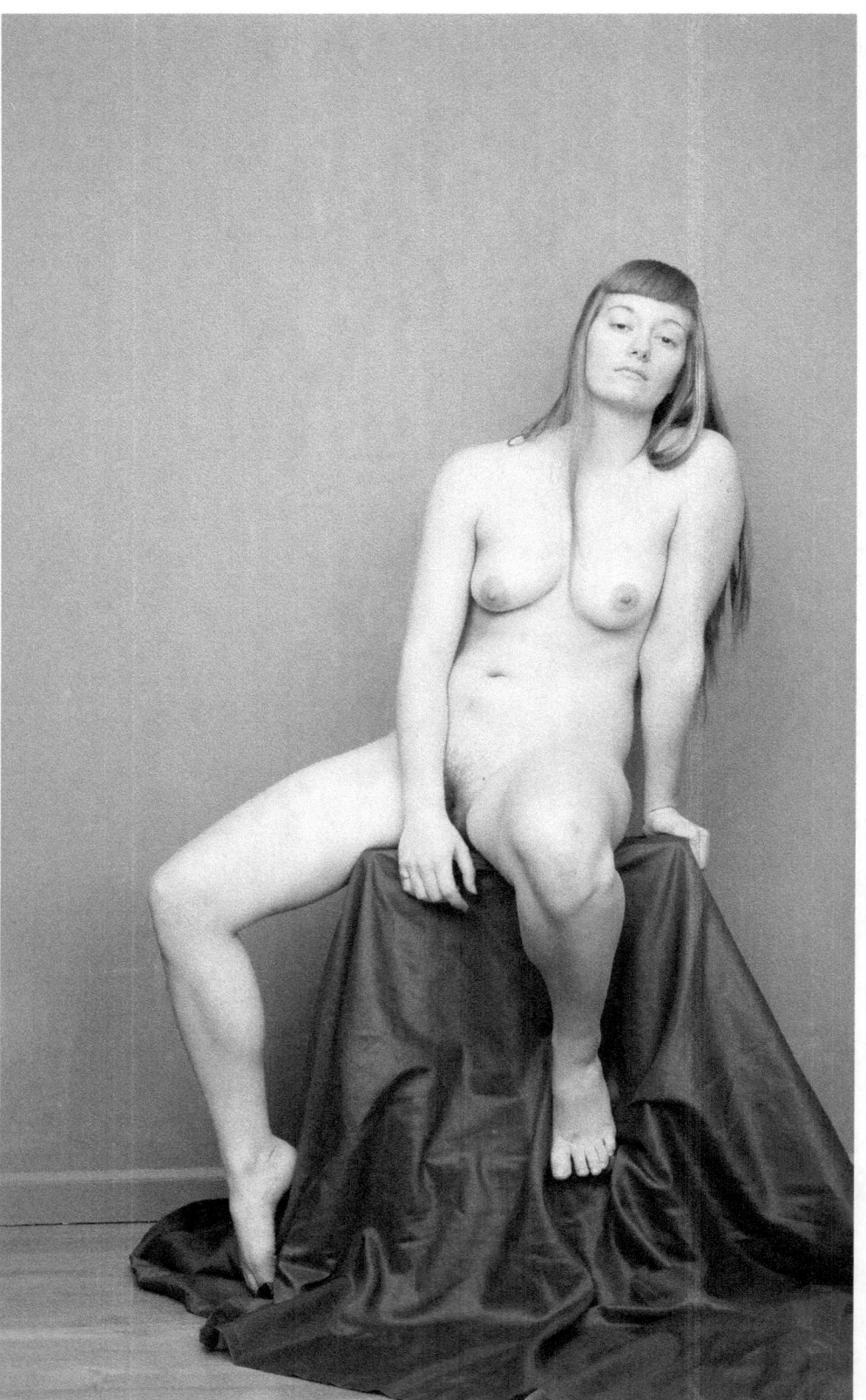

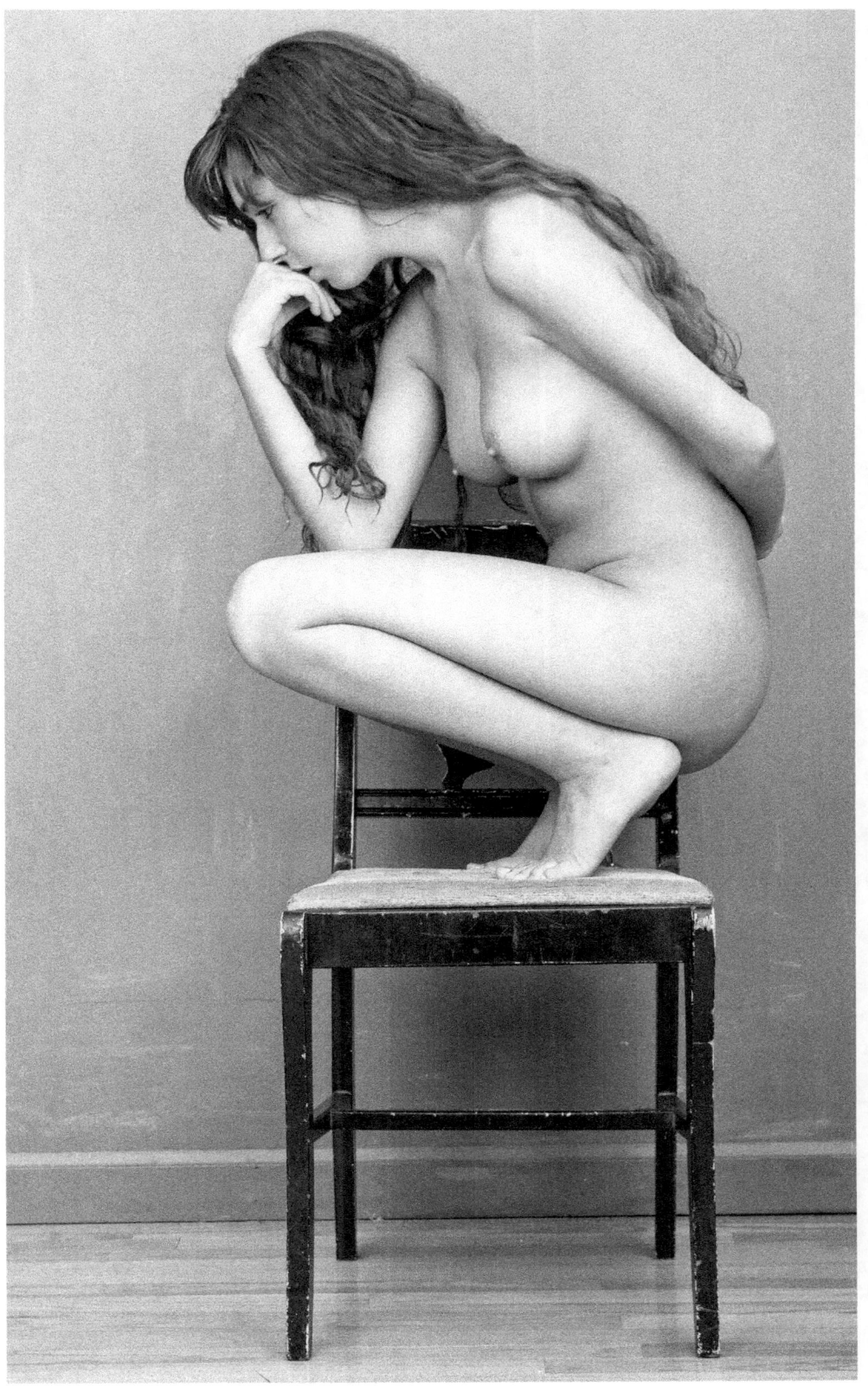

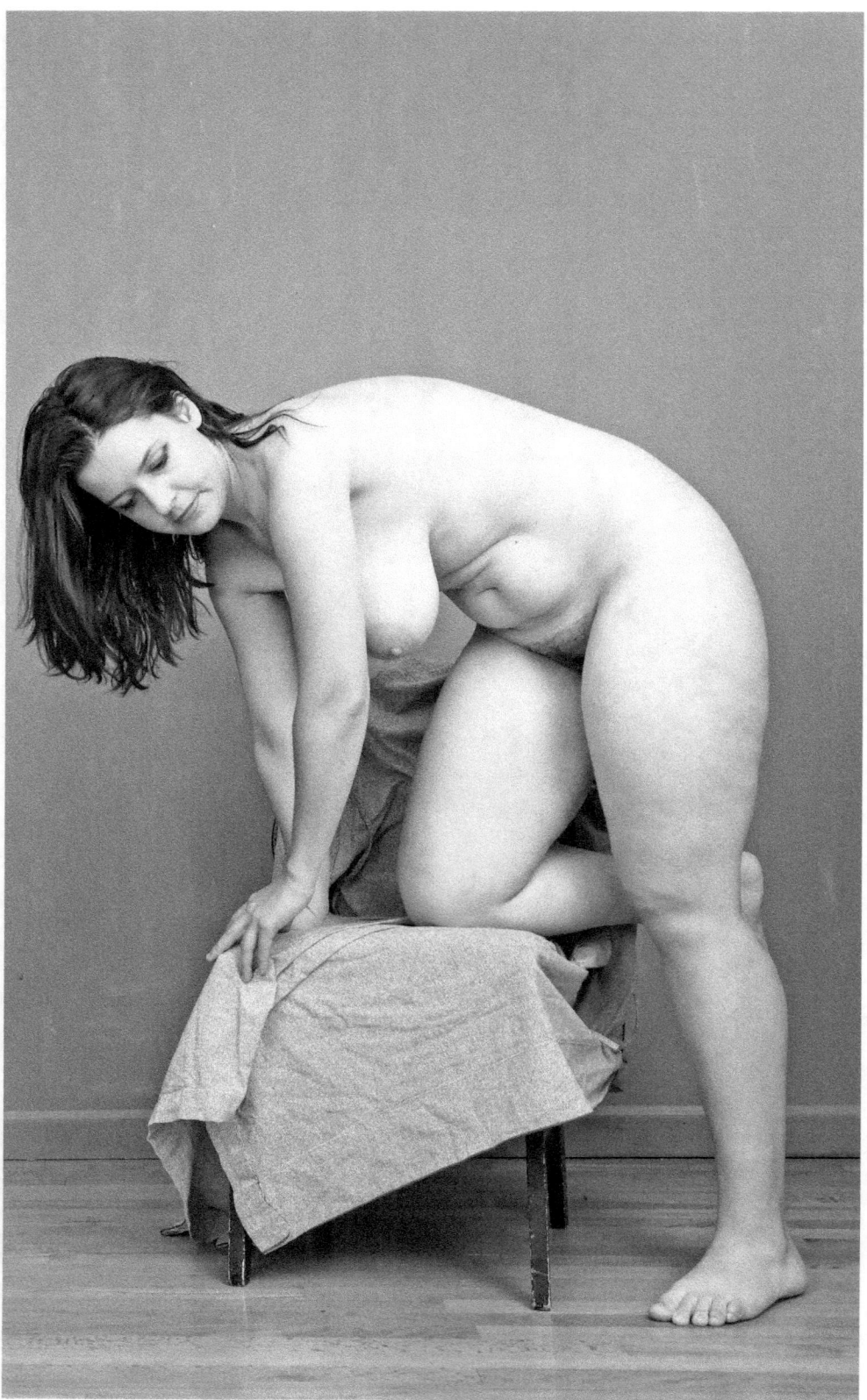

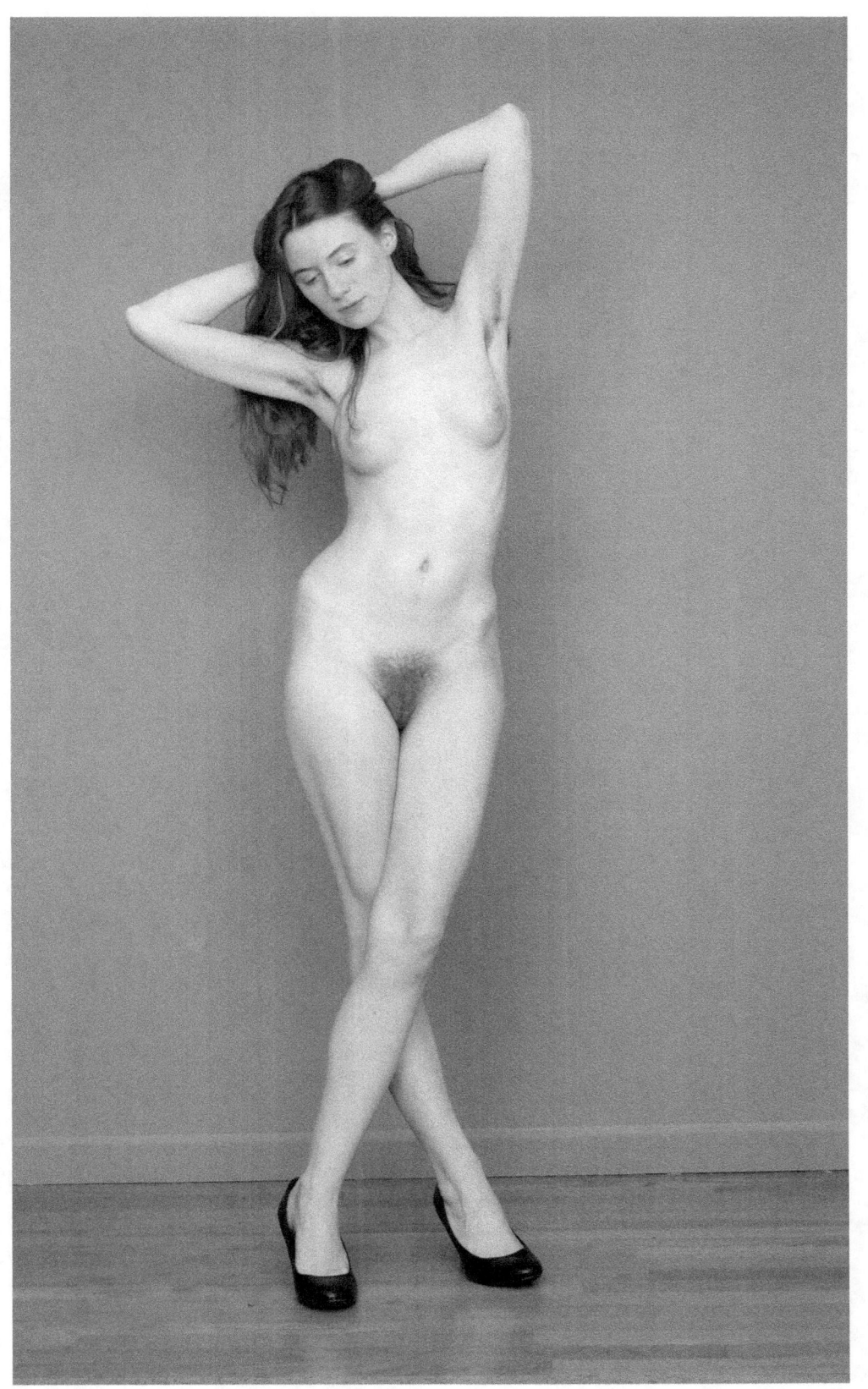

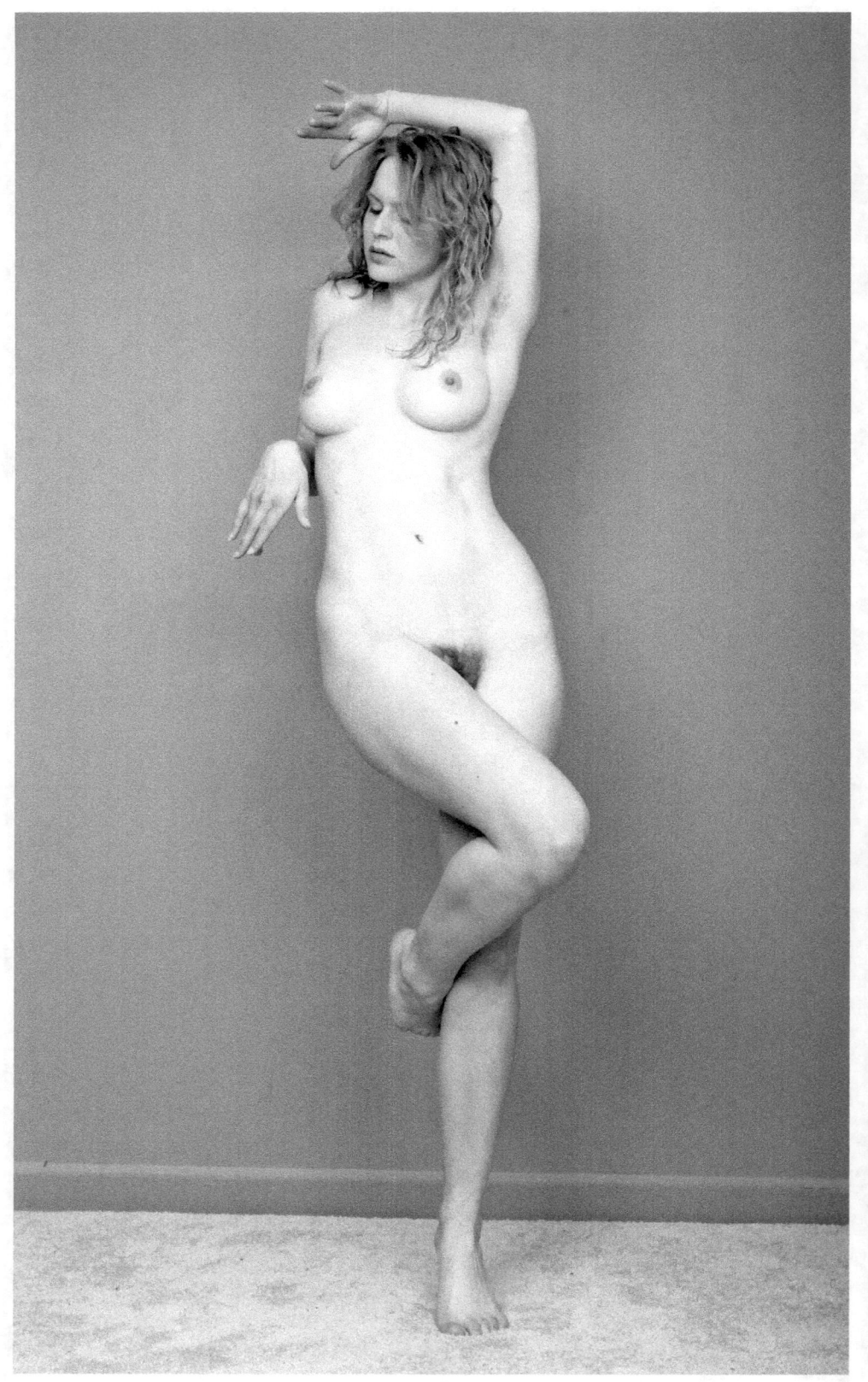

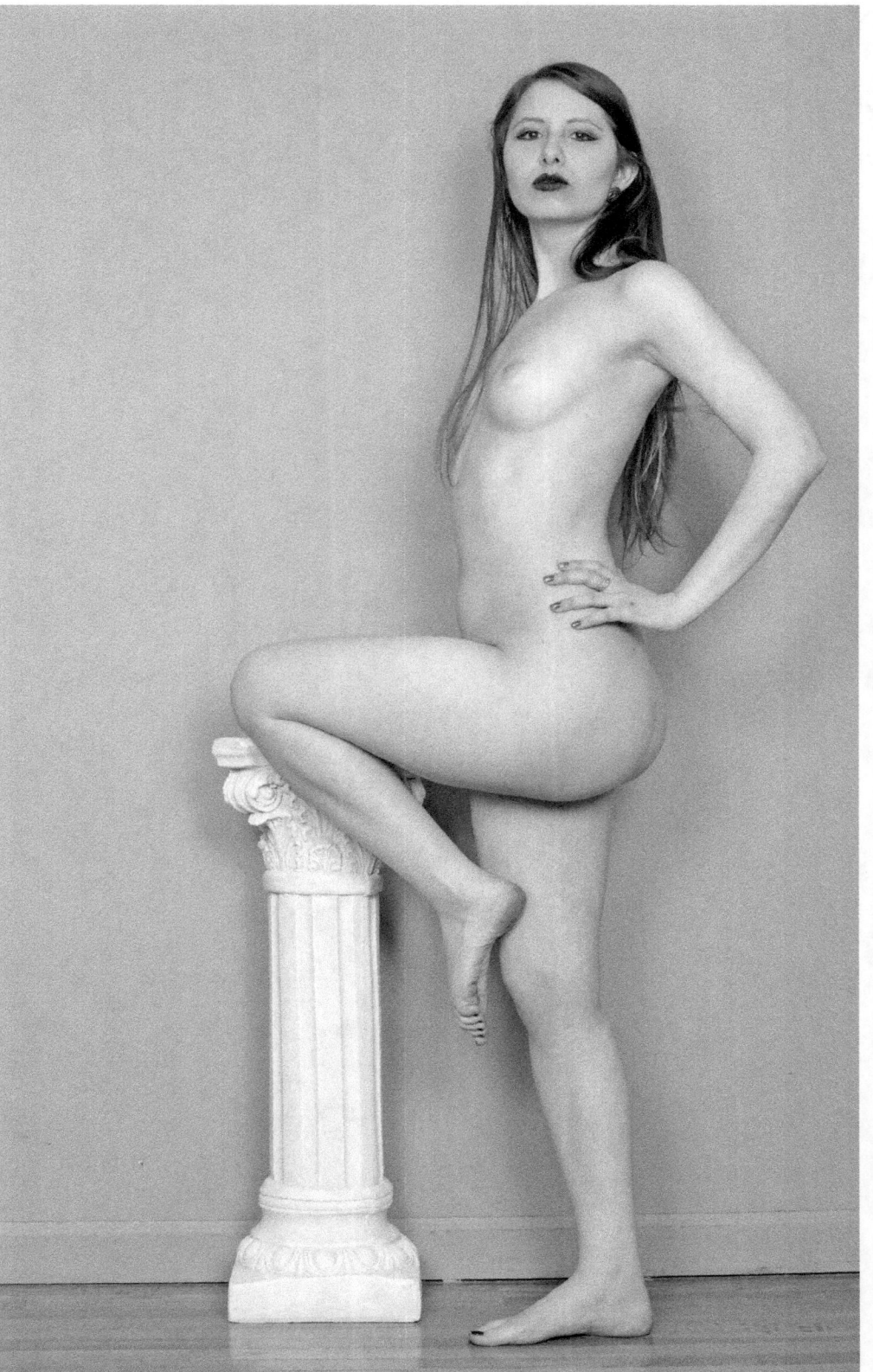

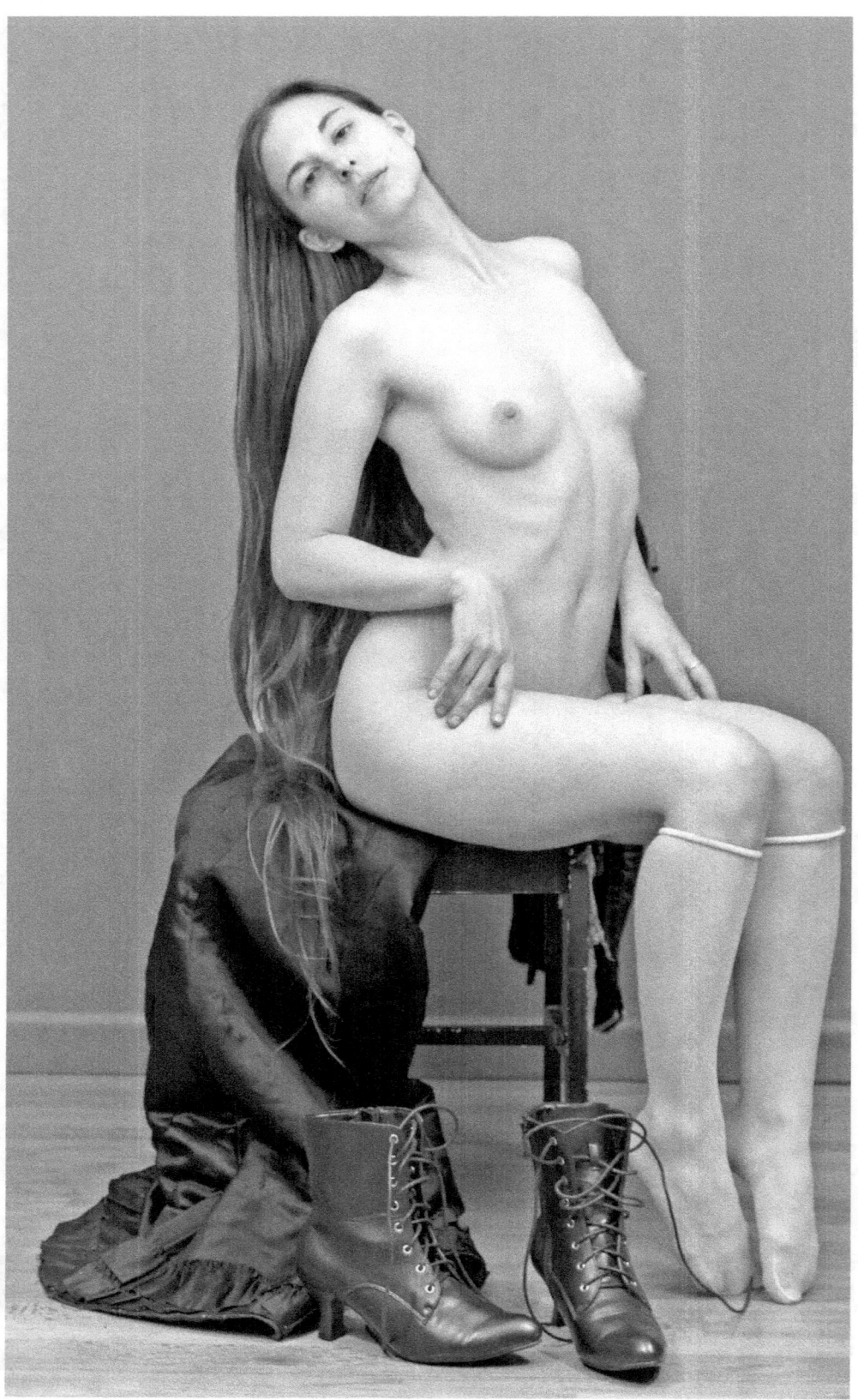

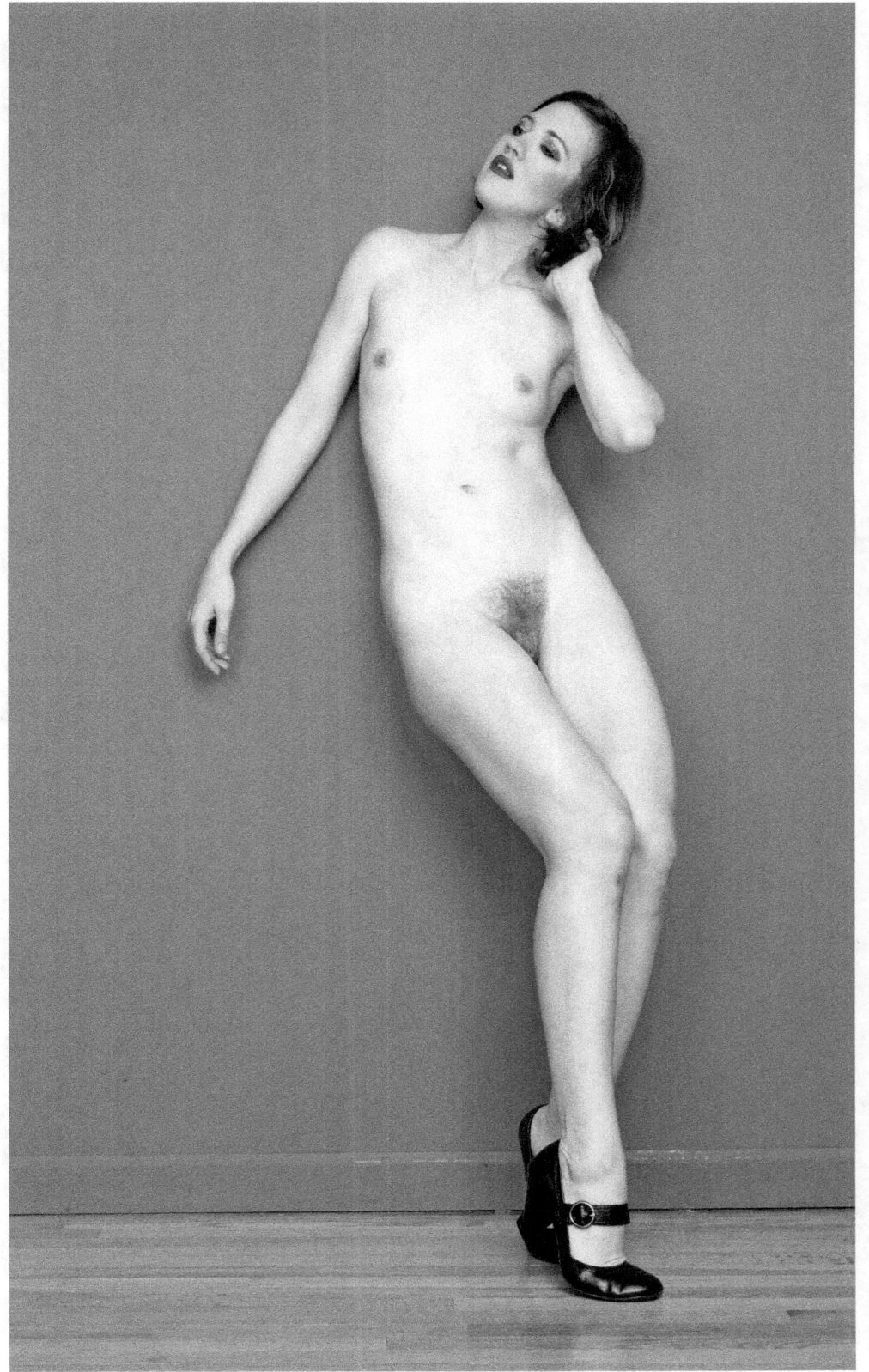

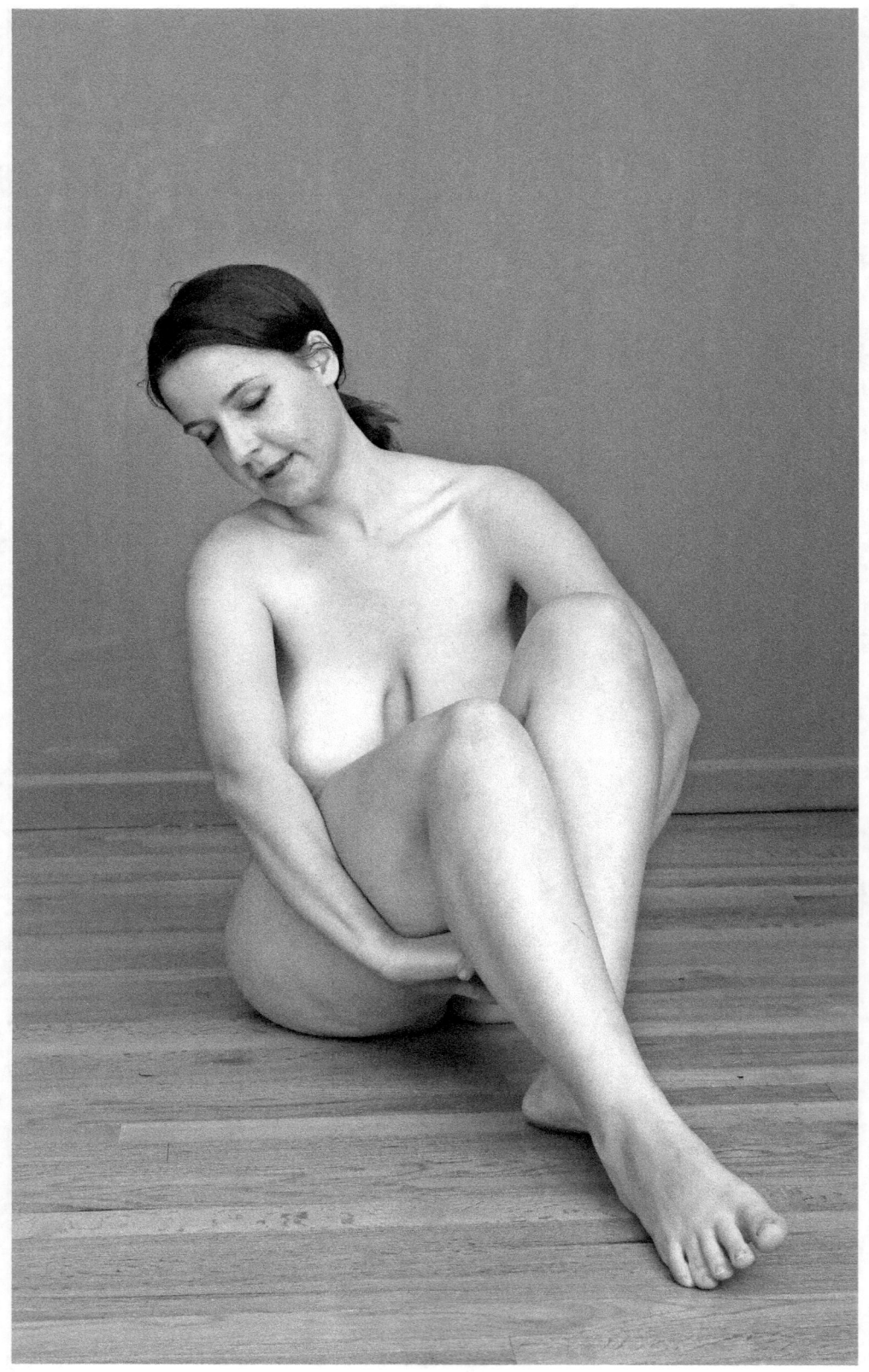

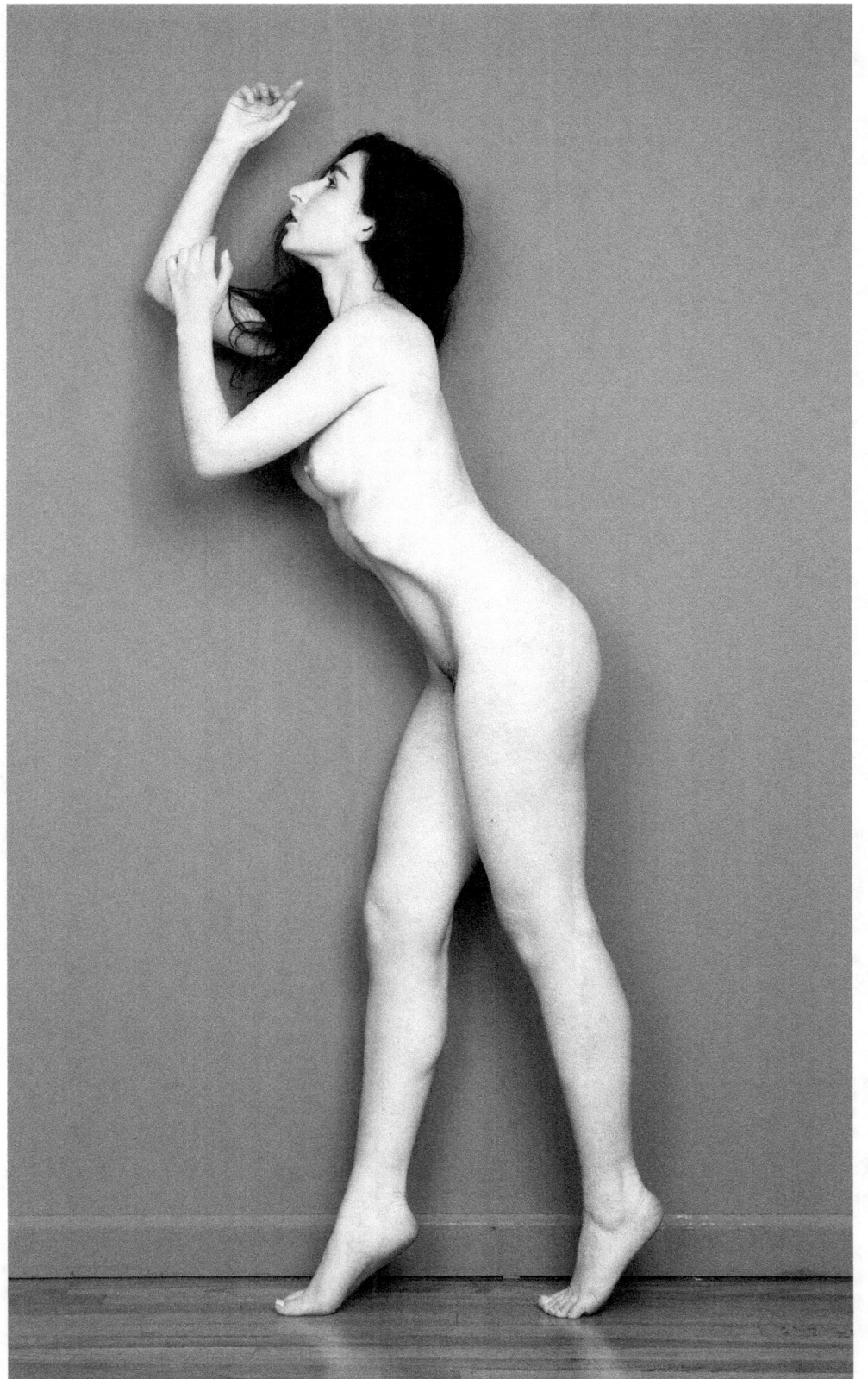

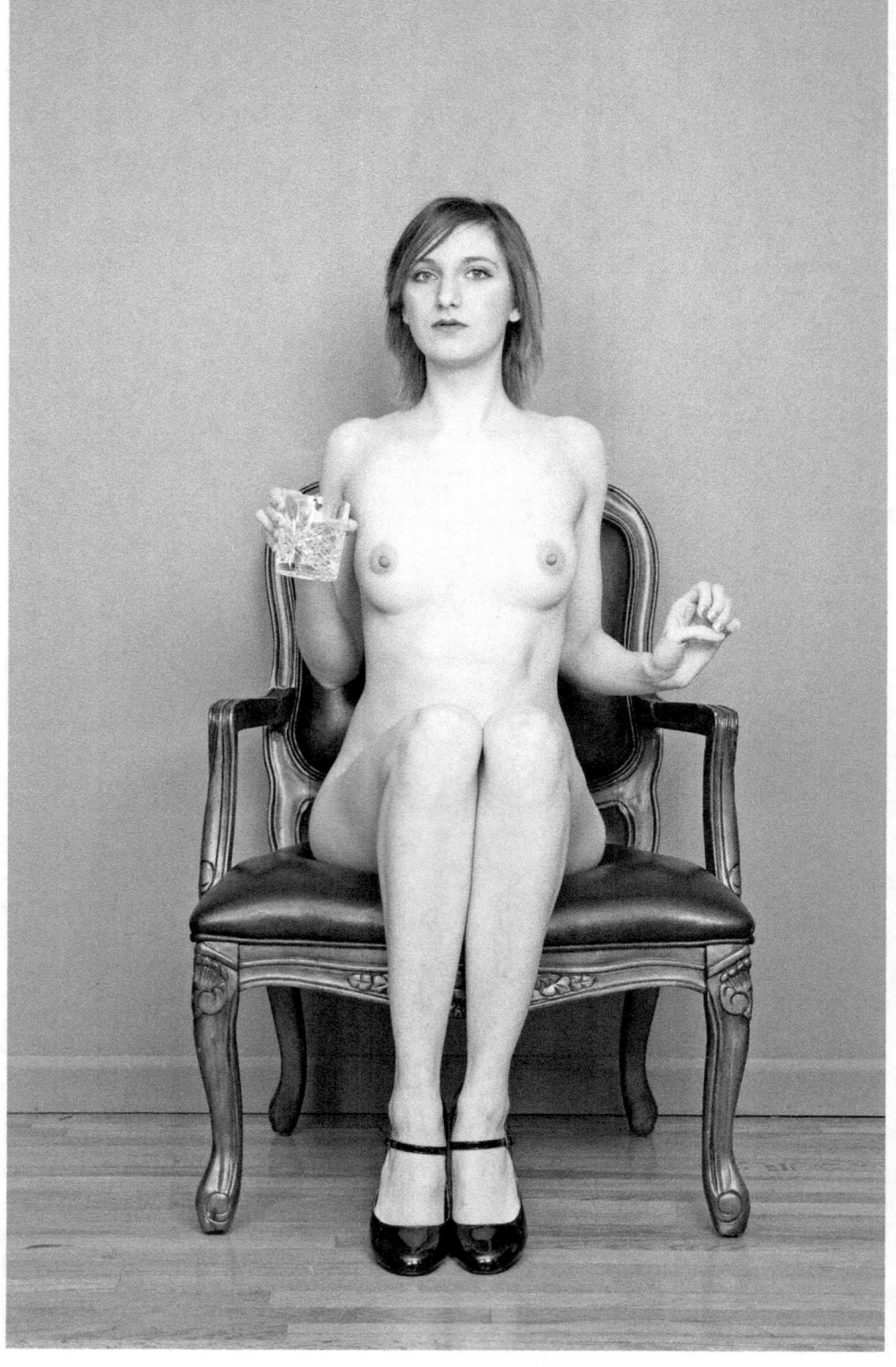

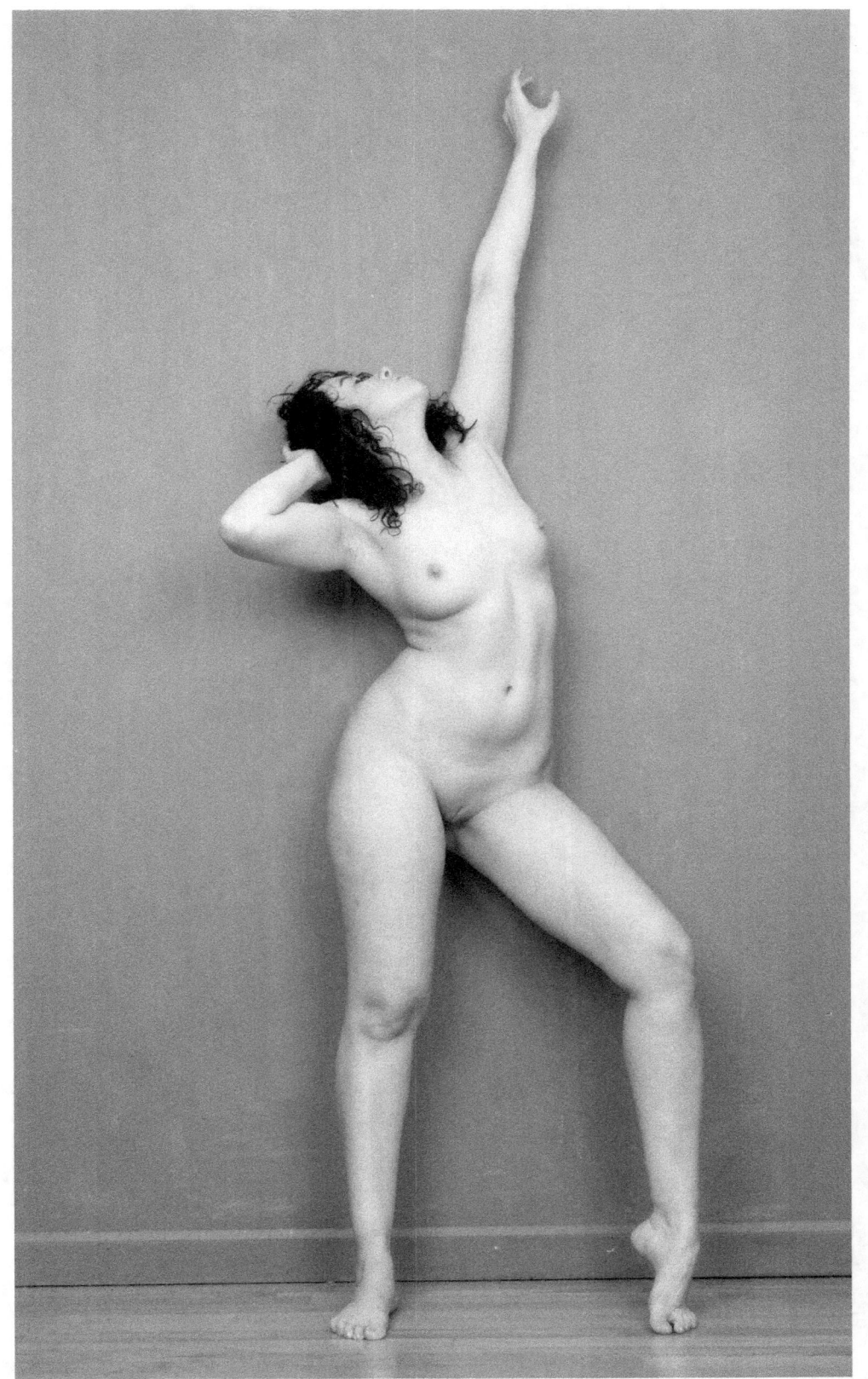

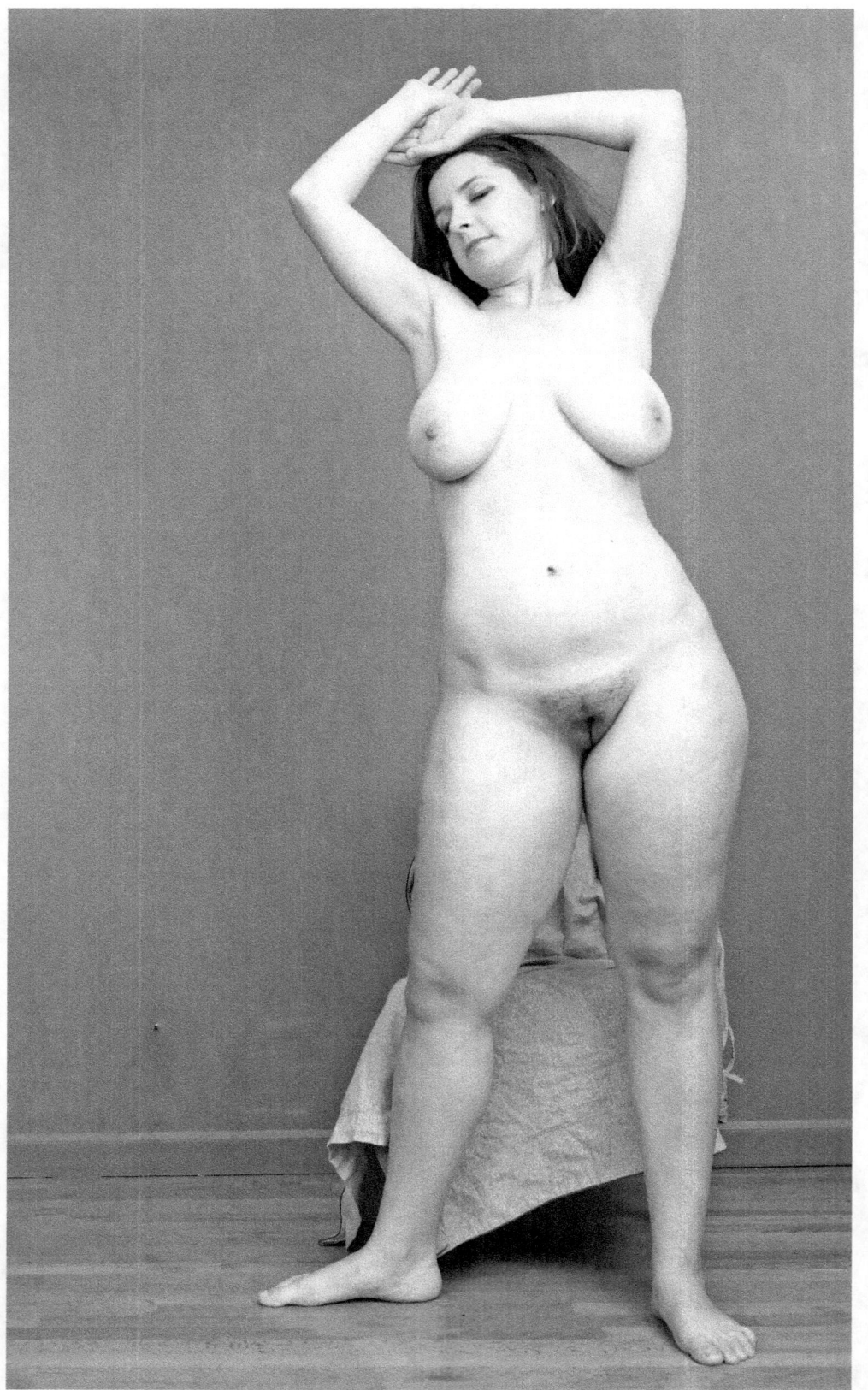

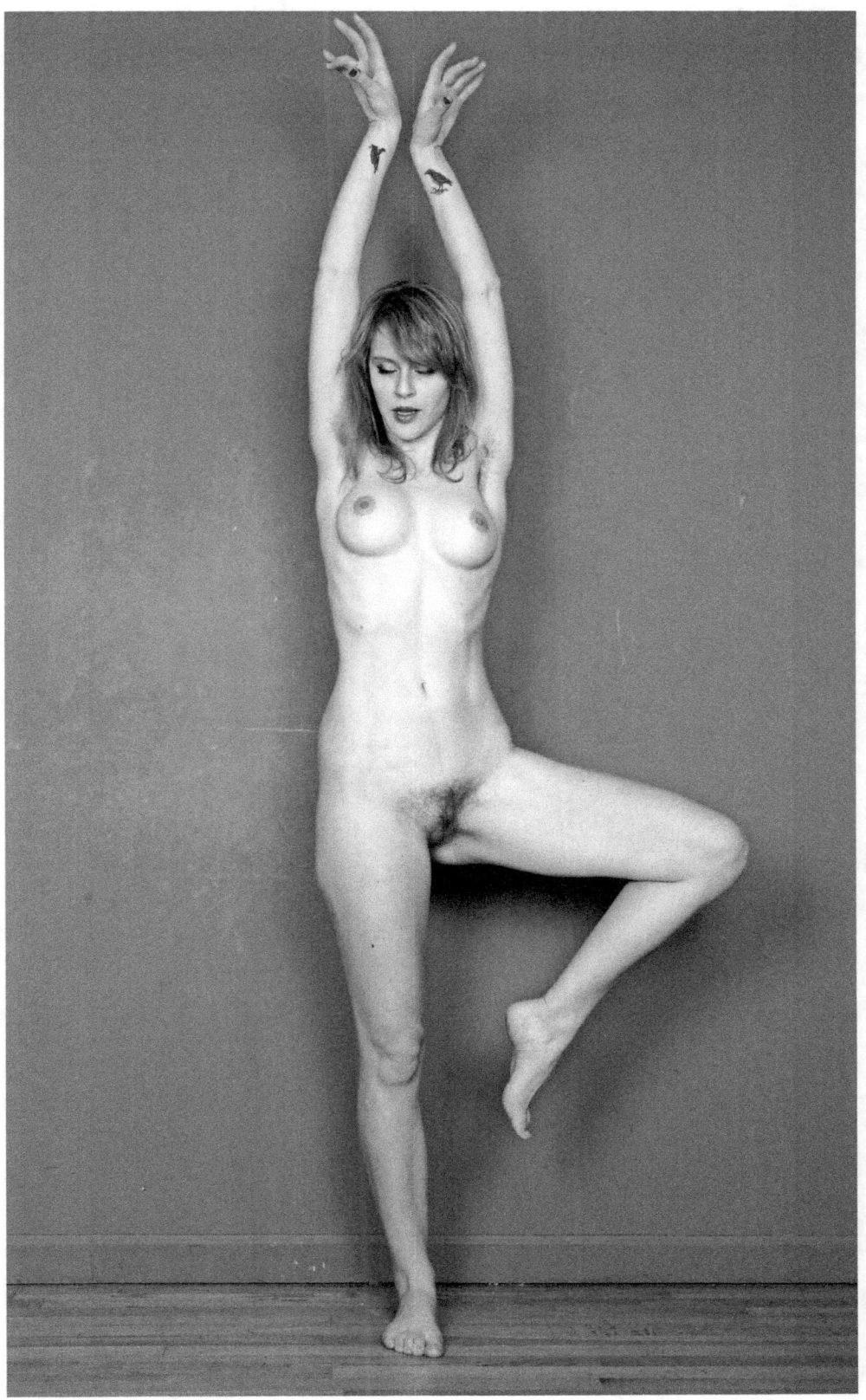

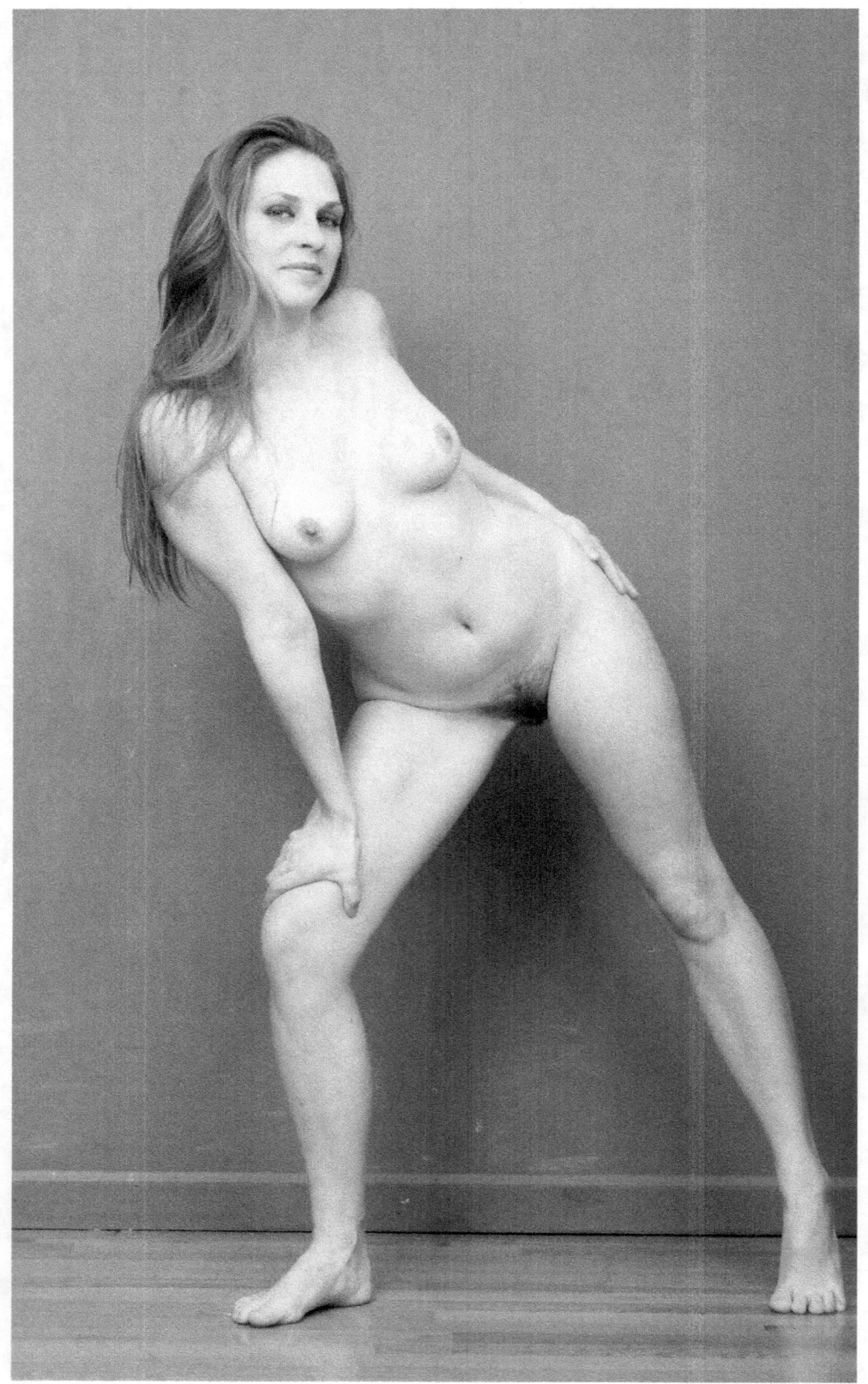

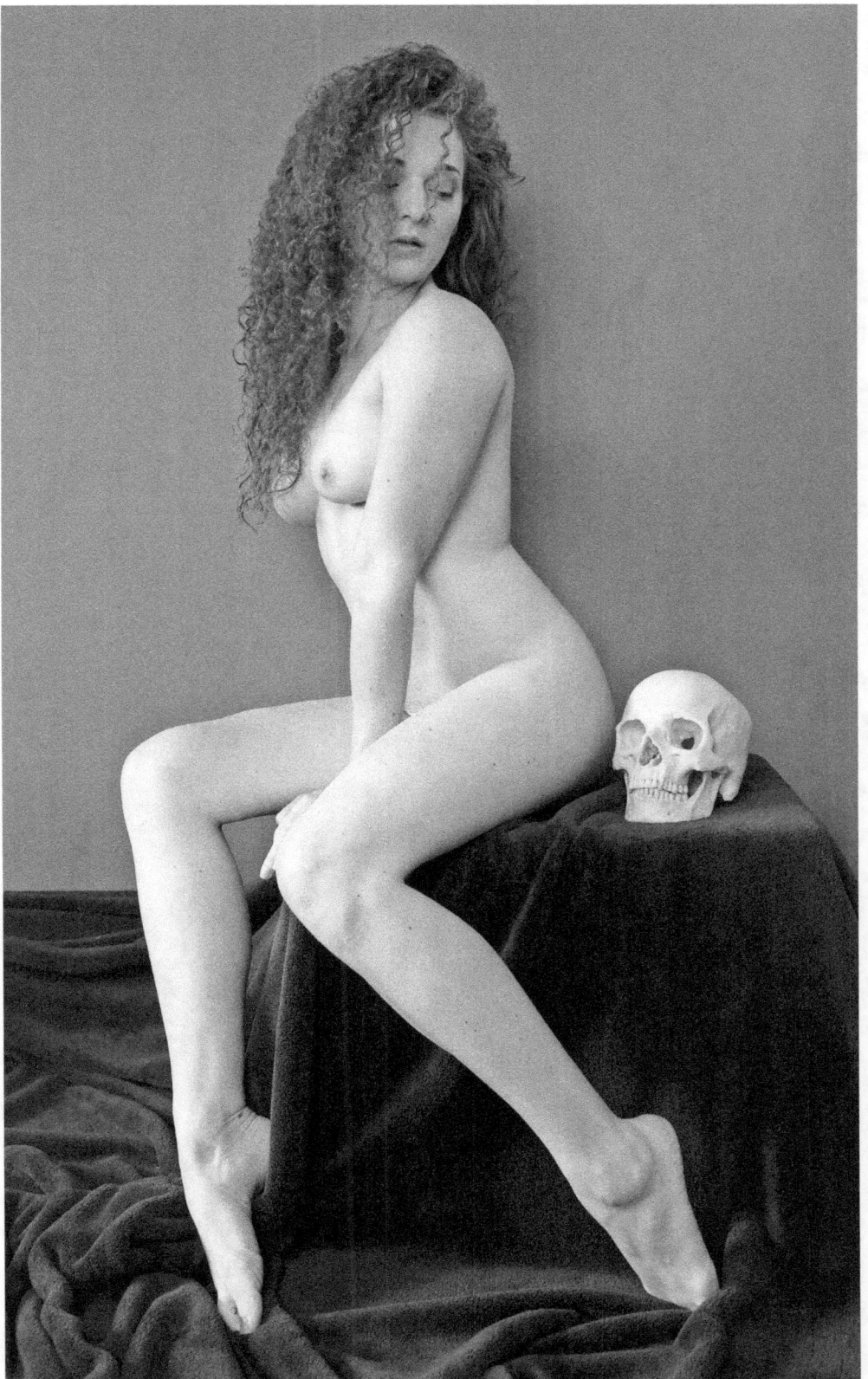

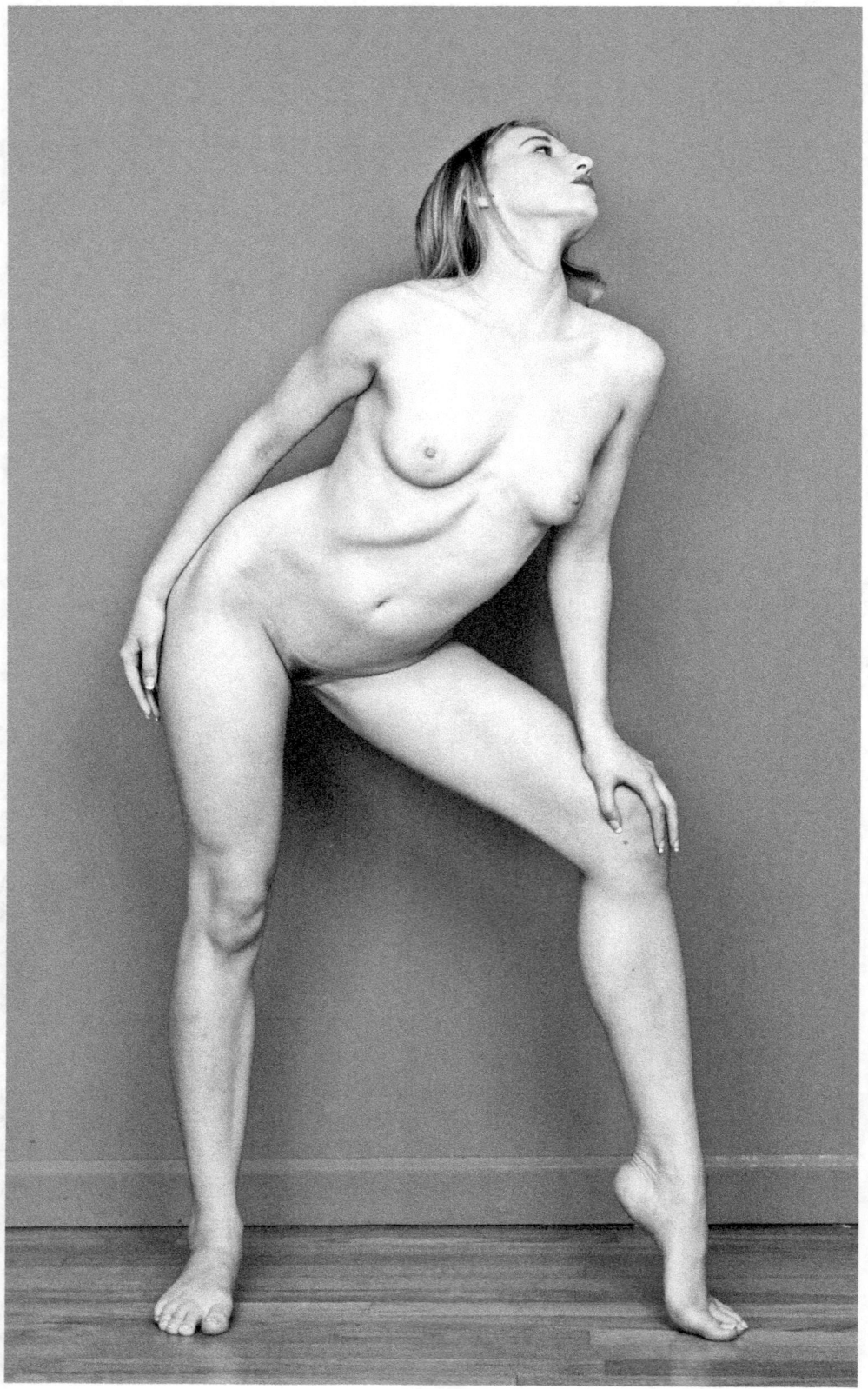

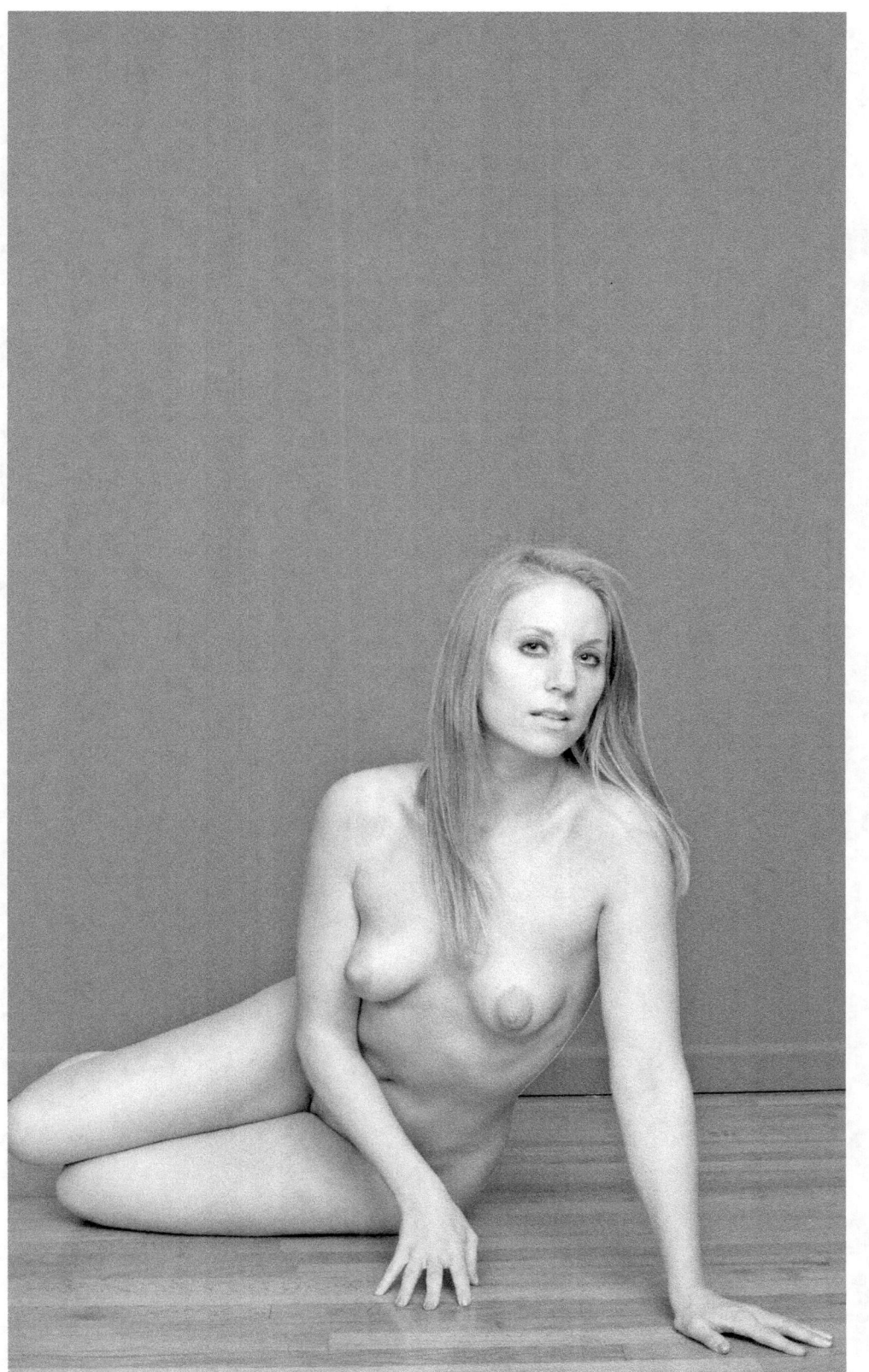

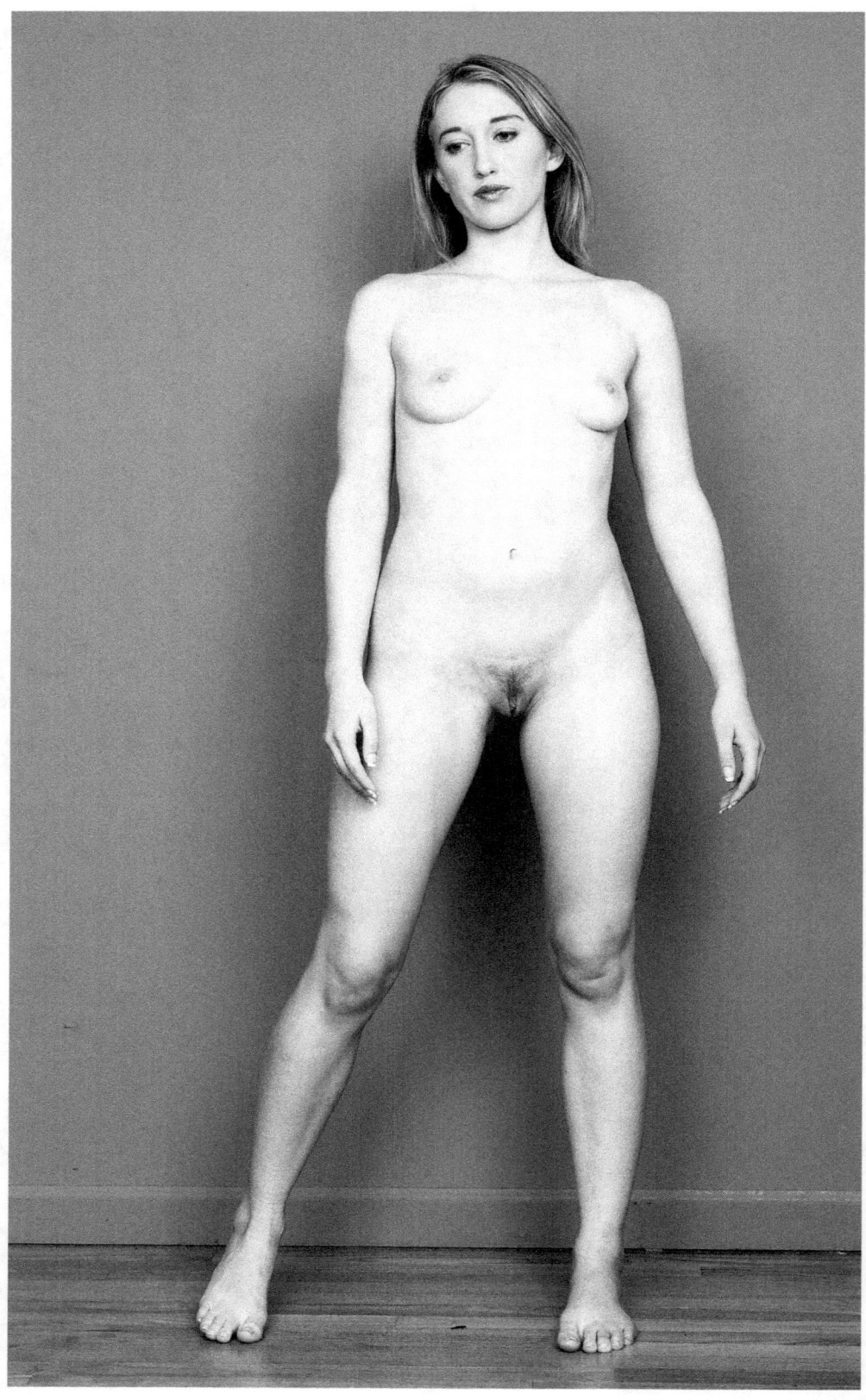

www.ingramcontent.com/pod-product-compliance
Lightning Source LLC
Chambersburg PA
CBHW072221170526
45158CB00002BA/700